ART NOUVEAU

ART NOUVEAU

Grange
BOOKS

A QUANTUM BOOK

Published by Grange Books
an imprint of Grange Books Plc
The Grange
Kingsnorth Industrial Estate
Hoo, nr. Rochester
Kent ME3 9ND
www.grangebooks.co.uk

1-84013-519-0

QUMSIAN

This book is produced by
Quantum Publishing
6 Blundell Street
London N7 9BH

Printed in Singapore by
Star Standard Industries Pte Ltd

CONTENTS

ARCHITECTURE AND FURNITURE

The Art Nouveau Style 6
Belgium and France 19
Britain, Austria and Germany 35
Spain and America 51

JEWELLERY AND METALWORK

Hallmarks of Art Nouveau 67
Art Nouveau Jewellery in France 79
Non-Gallic Jewellery 95
Art Nouveau Metalwork 111

GLASS AND CERAMICS

An Expression of Style 127
European Art Nouveau Glass 139
Art Nouveau Glass in America 155
Art Nouveau Ceramics 171

Art Nouveau Craftsmen and Designers 187
Index 190
Acknowledgements 192

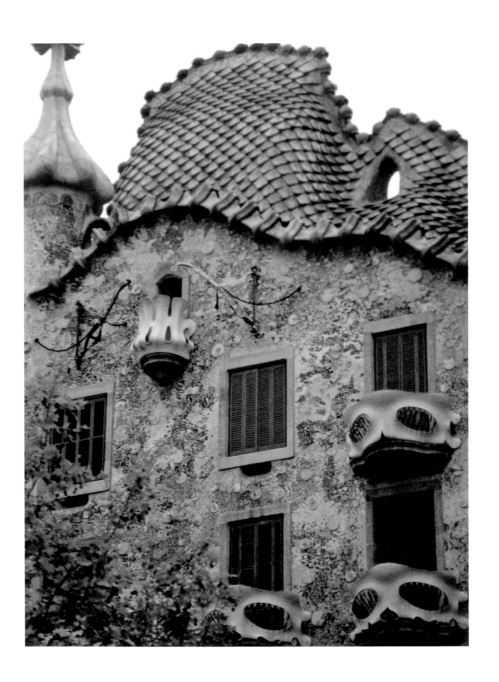

ART NOUVEAU ARCHITECTURE AND FURNITURE

THE
ART NOUVEAU
STYLE

The 19th century had seen enormous changes in society in both Europe and America, with the spread of industrialisation resulting in the creation of great wealth concentrated on the new industrial and commercial cities. The mass production methods of factories not only created a whole new class of workers, but also made a vast range of goods more widely available than ever before. Art Nouveau, which reached its zenith in the early years of the 20th century, began as a reaction against the horrors of mass production, reintroducing skills and craftsmanship which were fast dying out.

Far left: Embroidery by Hermann Obrist. The love of the undulating line is the purest expression of Art Nouveau.

Below: Paris Métro, Victor Hugo, by Hector Guimard, 1900.

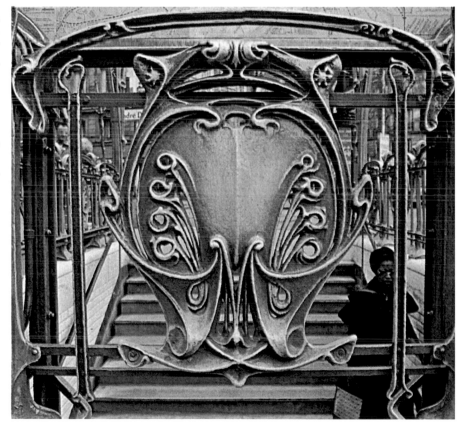

The essence of Art Nouveau is a line, a sinuous extended curve found in every design of this style. Art Nouveau rejected the order of straight line and right-angle in favour of a more natural movement. Whether these lines were used in realistic descriptions of natural forms, or as abstracted shapes evoking an organic vitality, the emphasis was on decorative pattern and also flatness, a surface on which this concern for the linear, the line of Art Nouveau could be exploited. This curving, flowing line brought with it a feeling of airy lightness, grace and freedom.

The characteristic curving forms of Art Nouveau first appeared in England, yet they were to spread rapidly throughout Europe to a wide range of cities, each with a distinctive interpretation of the style: Paris and Nancy in France, Munich, Berlin and Darmstadt in Germany, Brussels, Barcelona, Glasgow and Vienna all became focal points for the style that was soon universal in Europe, and – with centres in New York and Chicago – equally influential in America.

ORIGINS OF THE NAME
The term itself, Art Nouveau, derives from a Parisian shop of the same name run by a

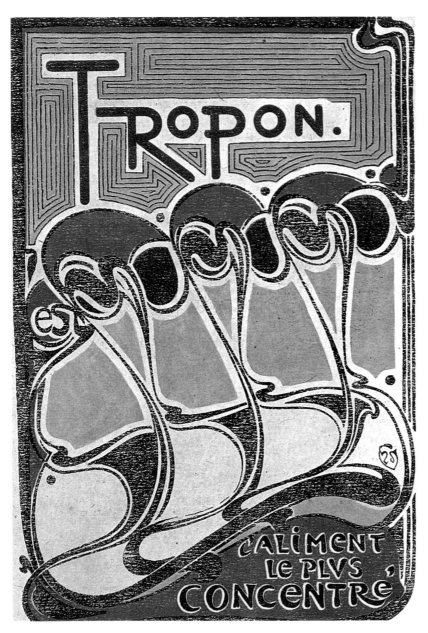

German émigré, Samuel Bing. Bing had been trading for ten years in Japanese art when, in 1895, he reopened his premises as La Maison de l'Art Nouveau and started to show the work of contemporary designers as well as painters and sculptors. The mixture of gallery, shop and showroom became the Parisian base for the new style, encouraging Bing to commission works for the shop and to promote his artists and craftsmen abroad. Another Italian term for the style, *Stile Liberty*, was attributed to Liberty & Co., the London department store that sold the designs of progressive British craftsmen.

SPREADING THE NEW STYLE

Art Nouveau was not restricted to a few enlightened retailers. The style was also spread by the great international trade fairs of the era. The depth of interest shown by the public in the new fashions in art, and particularly the decorative arts, was also reflected in the huge numbers of new magazines and periodicals devoted to these trends which appeared in the Art Nouveau era.

TRADE FAIRS

The international trade fairs were products of the great age of industrialisation, for they were descended from the 1851 London Great Exhibition, housed in the Crystal Palace, which had been held to demonstrate the possible applications of new technology. These exhibitions soon became an increasingly important feature of international commerce, at which the new styles of decorative art could be displayed. Particularly important events in the develop-

Left: The 'Tropon' poster by the Belgian designer, Henry Van de Velde, from 1898.

ment of Art Nouveau were the international exhibitions of 1899 and 1900 in Paris, and of 1902 in Turin, while that of 1905, held in Liège, marked the end of the style's importance.

ART MAGAZINES

In Germany, it was the influential Munich-based journal *Jugend* (youth) which gave the name '*Jugendstil*' to the German version of Art Nouveau. At the same time, however, the widely read English, and later American periodical, *The Studio* also led to the style being called '*Studiostil*'. Equivalent influential publications were *Pan* from Berlin and *Ver Sacrum* from Vienna. The German language periodicals also included contemporary literature, poetry and criticism, but as in all such journals of the time, the main coverage of the new style came not in specific articles but in the actual design of the publication itself. The title-page, typeface and illustrations were all the work of Art Nouveau graphic artists.

Such periodicals had a wide circulation beyond the limited circle of craftsmen, but there existed too, journals such as the influential *Art et Decoration* from Paris which concentrated more exclusively on the decorative arts, and included many photographs. Thus, through exhibitions, shops, galleries and magazines the Art Nouveau style spread rapidly through Europe and America, both feeding off and stimulating the public's interest.

ORIGINS OF THE STYLE

Because of the wide range of regional styles which resulted in a confusion of different

Right: German advertisement for Bing's gallery and shop, La Maison de L'Art Nouveau, which gave the movement its most popular name.

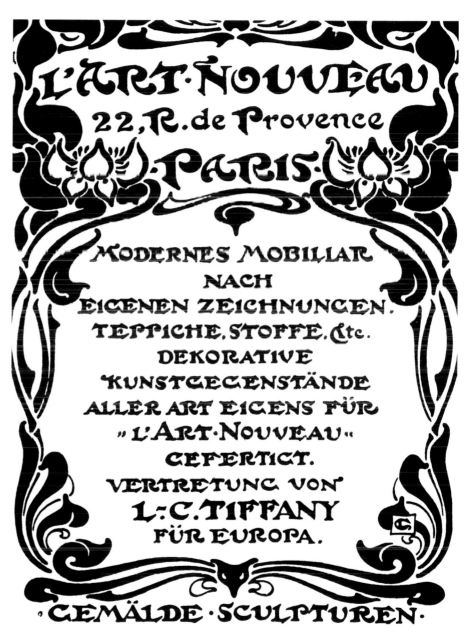

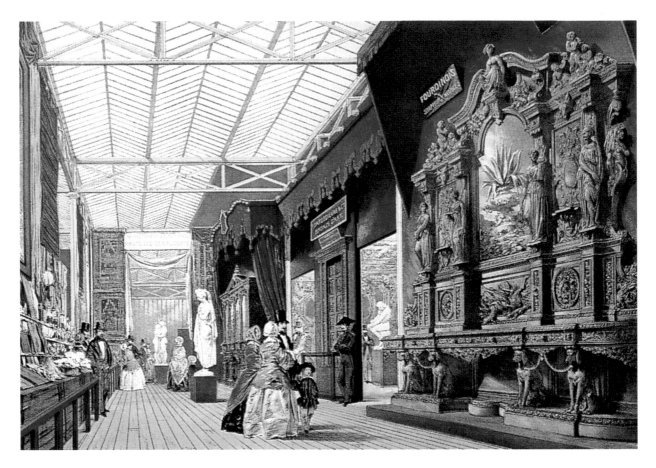

*Above: Part of the French
section of the Paris Exposition
Universelle of 1900. While
technologically advanced, the
quality of design had stagnated
or even regressed. Bombastic,
clumsy, revivalist pieces, such
as this furniture, horrified
critics such as Ruskin and
Morris.*

names for the style – '*Art Nouveau*' and '*Modern
Style*' in France, '*Modernismo*' in Spain, '*Stile
Liberty*' and '*Moderne Stile*' in Italy or even a
reference to a place as with '*Belgische Stil*'
(Belgian Style) in Germany – there was no clear
idea as to common origin, nor shared charac-
teristics, until Art Nouveau was in decline. It is
only with hindsight that a more coherent view
of the period has been formed.

The origins of Art Nouveau lay mainly in
Britain, where the Victorian ornamental de-

signer Christopher Dresser was one of the first
to recognise the potency of eccentric curves.
In 1862 he wrote: 'A section of the outline of
an ellipse is a more beautiful curve than that
of an arc since its origin is less apparent, being
traced from two centres.'

By common consensus, the first true ex-
ample of Art Nouveau design was the title page
by Arthur Mackmurdo (1851-1942) for his
book *Wren's City Churches*, published in 1883.
The floral designs of William Morris and the

Arts and Crafts Movement were also influential in formulating the Art Nouveau look.

MORRIS AND THE ARTS AND CRAFTS MOVEMENT
Morris began his career firstly as a painter, as a follower of the Pre-Raphaelites and their dreamy interpretation of the medieval past. However, Morris had a more practical view of that period when it came to his attempt to recreate its idyll of painters, architects and craftsmen working together, often on the same tasks: in 1861 he founded a company to produce the type of objects he wanted to see in every home. This became Morris and Co., and Morris was able to effect a genuine bridging of the divide between artists and craftsmen by employing his Pre-Raphaelite painter-friends to decorate cabinets and bureaux, and to design tapestries, fabrics and chairs.

The actual appearance of these goods was often reminiscent of medieval models, particularly in furniture, but in fabrics, carpets, wallpaper and decoration the Morris style was derived largely from natural sources, inspired by plant, bird and animal forms. The use of hand-crafted, natural materials made these goods too expensive for ordinary people, yet despite this, Morris still hoped that his products would become widespread enough to improve the quality of the lives of as many people as possible. Like the influential writer John Ruskin, Morris hoped to free the working man from the drudgery of factory labour and, through craftsmanship, enable him to gain pleasure from his work.

The example of the Morris Company encouraged other similar enterprises in Britain, usually referred to under the general term 'Arts

Right: The German magazine Jugend, *with cover design by Otto Eckmann.*

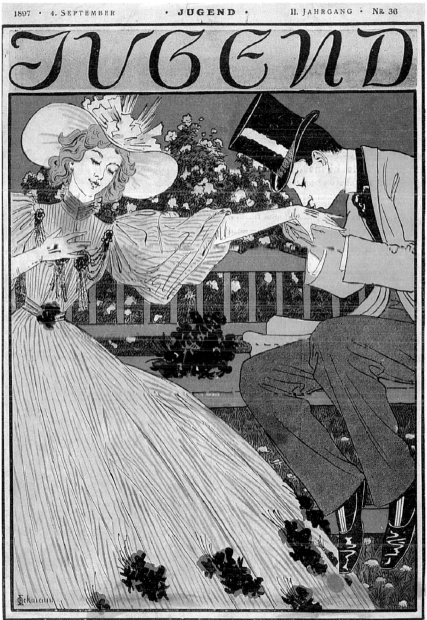

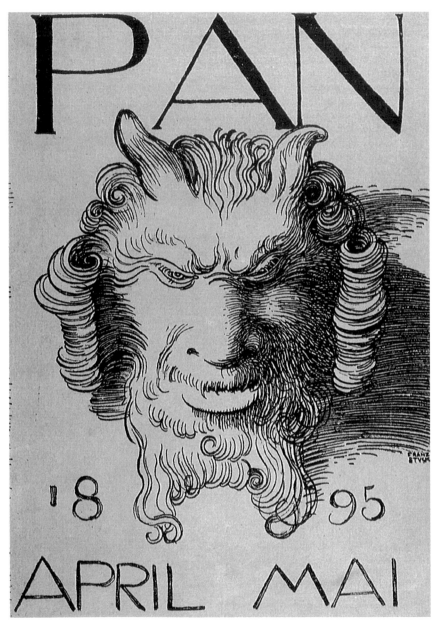

and Crafts Movement'. Chief among these was the Century Guild formed in 1884 by Arthur Mackmurdo. Influenced by the flowing, natural forms of Morris, Mackmurdo developed these shapes into elongated, increasingly elegant patterns, and was the first to produce the characteristic vocabulary of sinuous flame-like shapes that were to be the hallmark of Art Nouveau for the next 20 years.

NATURE AND NATURAL FORMS

Nature was to be the ultimate source book of the Art Nouveau artist, particularly the plant world, for many artists had a scientist's depth of knowledge of botany. Flowers, stems and leaves were chosen for their curving silhouettes. Naturally, lilies, irises and orchids were favoured, although any and every form, from palm fronds to seaweed, offered potential for development into an animated pattern.

Insects and birds of colour and grace lent themselves to the same stylising and refining process – dragonflies, peacocks, swallows, or creatures such as snakes or greyhounds. These decorative possibilities could also be developed from the curves of the female body, particularly when combined with long, loose, flowing hair which could be arranged into a fantasy of curls and waves. As the style developed, the quest for more novel forms grew.

HISTORICAL INFLUENCES

Despite the novel qualities of Art Nouveau, some of its stylistic features can be traced to past styles. The Gothic revival served in some ways as an inspiration, for the fervent examination of medieval art of the 19th century

Left: Pan, *the Berlin magazine which covered the same combination of visual arts and literature as* Jugend *did in Munich.*

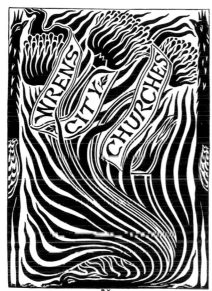

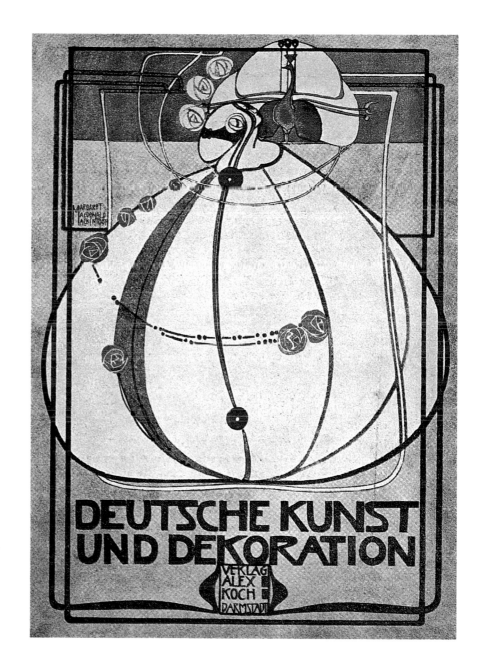

Above. The title page for Arthur Heygate Mackmurdo's Wren's City Churches.

Left: Cover for Deutsche Kunst und Dekoration, *designed by Margaret Macdonald Mackintosh.*

had emphasised the value of curving, organically-inspired shapes seen in the architecture, sculpture and stained glass of the Middle Ages. As appreciation of the Gothic grew, so too did the awareness that this term encompassed a number of different styles, from the chaste, plain lines of its early period to the flamboyant fantasy of later medieval art. It was this form of the style that was to inspire Art Nouveau. The late Gothic style was plundered not to afford pedantic historical detail, but as

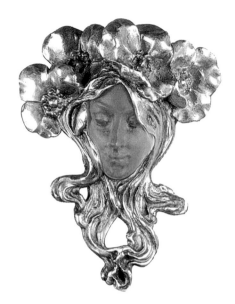

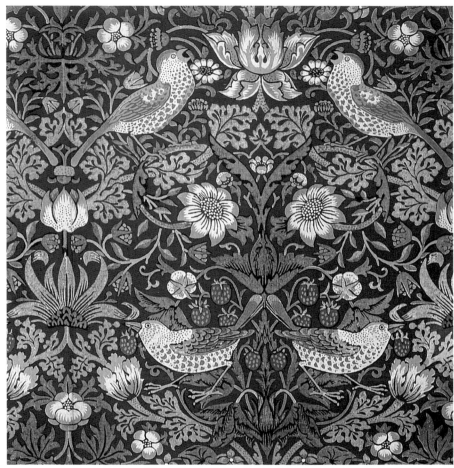

Above: Silver and glass pendant-brooch by René Lalique, c.1900.

Right: 'The Strawberry Thief', a Morris textile design from 1883. Unlike the more abandoned lines of Art Nouveau, the curving natural shapes here are more symmetrically ordered.

a sourcebook for new ideas.

If flamboyant, late Gothic provided an example of the creative use of the past by the Art Nouveau, then so too did the inspired re-examination of the 18th century Rococo style in France. This style had become one of the many open to revivalists of the next century, but rather than resurrect it completely, Art Nouveau observed its forms and characteris-

tics with an independent eye. Rococo had been more broadly associated with the use of capriciously cavorting, light and delicate line as an ornament in all the decorative arts. This was very close to the line of Art Nouveau, and the connection became clear when in France the designers of the regional Nancy school began to incorporate references to Rococo in their work.

The common source of natural forms of plant and wave in both Art Nouveau and Rococo made the blend harmonious. The Rococo taste for light, high-keyed colour in interiors was also pursued by Art Nouveau, in reaction to the heaviness and solemnity of sombre Victorian interiors. While at its strongest in France, Munich had also been an important outpost of Rococo in the 18th century, and it

Above: The flamboyant late Gothic style served as an inspiration to Art Nouveau.

Right: The restless line of 18th century Rococo influenced many Art Nouveau designers.

is no coincidence to find that the lightest, wittiest and most fanciful forms of *Jugendstil* were later to be found in that city in the work of Hermann Obrist (1863-1927) or August Endell (1871-1925).

Some stylistic revivals of the late 19th century were partly inspired by the growing nationalism of the time, which was tinged,

Above: Detail of a Viking wood carving.

Left: Detail of the doors for the Willow Tea Rooms, designed by C.R. Mackintosh.

as ever, by a romantic idea of the past. Some of the revivals of national artistic consciousness also percolated into Art Nouveau and helped to form its many regional variations. An important influence on the Glasgow school and on its most renowned figure, Charles Rennie Mackintosh, was the revival of interest in early Celtic art.

Celtic jewellery and the ancient gospel books of Durrow, Lindisfarne and Kells revealed precisely their elaborately curving and twisting decoration, the combination of stylisation and the natural inspiration that typified Art Nouveau itself. More particularly, the use of lavish ornament confined within strict limits and contrasted with more open areas had strong parallels with the work of the 19th century Glasgow designers.

With its capricious use of past and peculiar mixture of styles, Art Nouveau could not be anything other than a uniquely novel style.

BELGIUM AND FRANCE

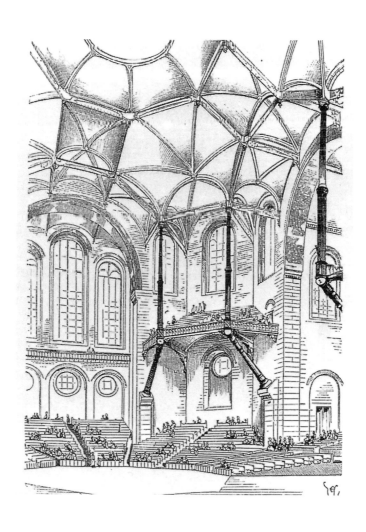

Above: Iron was used not only as a decorative element on the balconies, but as a structural framework.

Right: The iron and glass vaulting of Brighton Railway Station typifies the use of these materials by engineers before they entered the mainstream of Art Nouveau Architecture.

Overleaf: The vaulted hall from Viollet-le-Duc's Entretiens sur l'Architecture.

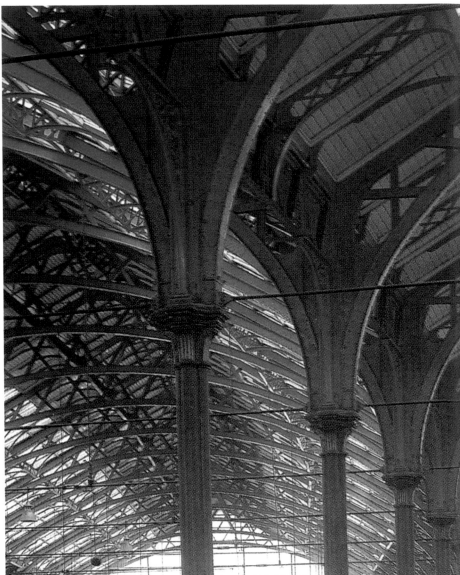

Architecture provides the backdrop against which all the varied creations of Art Nouveau can be set. The interdependence between the fine and decorative arts in Art Nouveau is best seen via the works of the major architects of the time, who required fittings in keeping with their domestic architecture while their fellow craftsmen needed the appropriate setting to display their work. From among the fine arts it is architecture that has the strongest technical craft base, and when the conventional crafts were in decline in the face of industrialisation architects were at the forefront of their revival. Not surprisingly, the leaders of Art Nouveau were also architects: Horta, Guimard, Van de Velde, Behrens, Mackintosh, Gaudí, Gaillard and Grasset.

MODERN MATERIALS FOR A MODERN STYLE
While the architects of the Arts and Crafts movement looked back to a nostalgic pre-industrial era of simple brick and stone homes inspired by the rich traditions of English architecture, the architecture of Art Nouveau began from an opposing premise. Instead of rejecting the industrially produced materials of iron and glass, now more readily available and so dramatically demonstrated in the Crystal Palace erected for the 1851 Great Exhibition in London, the architects of Art Nouveau eagerly embraced the possibilities that these modern materials suggested. Consequently, Art Nouveau architecture was to become an important basis for later 20th century developments, and paved the way for the Modern Movement.

FROM ENGINEERING TO ARCHITECTURE
The use of iron to provide strong and comparatively light frames for buildings was first developed in the architecture of the railways and other related industries. It was clear that its strength would inevitably lead to its use in more traditional architecture too, but in England, where iron had been most dramatically used, the development was tentative. The art critic John Ruskin's distaste for industrial materials was a strong influence and when iron was used, its structural role was hidden as much as possible by the more conventional brick and stone.

GOTHIC STYLE
In France however, the architect and theorist Eugène Viollet-le-Duc had no qualms in recommending the open use of iron work in his writings, realising its suitability for the high vaults of his favoured Gothic style and, very significantly, suggesting ways in which it could be shaped to create foliage patterns to embellish its role as a structural element. Excited by the industrial architecture he saw, Viollet-le-Duc was prompted to write in his *Entretiens sur l'architecture* about the further uses of iron and to produce a design for the combination of iron and stained glass. This combination of materials used to create lightness and colour recommended it to the proponents of the new style, while the exploitation of the initial malleability of iron

Right: A detail of the base of the Eiffel Tower, Paris, showing some of the ornament which embellishes what is still today, a great feat of engineering.

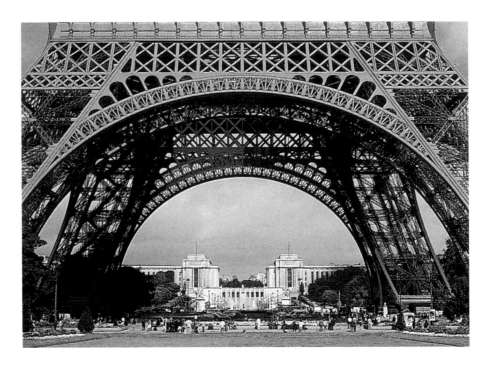

to create naturalistic ornament was to be of the greatest significance for Art Nouveau architects.

GUSTAVE EIFFEL

The great engineer Gustave Eiffel also carried the influence of English engineering to France. Increasingly involved in the design of pavilions at the numerous international exhibitions, Eiffel allowed more and more of the supporting metal frame to be revealed. It was for the Paris Exhibition of 1889 that his most famous and daring creation, the Eiffel Tower, was produced. When this was allowed to remain after the dismantling of the exhibition, the tower became an important, if controversial monument to the possibilities of the new medium. In the manner of Viollet-le-Duc,

Eiffel had also attempted to embellish his engineering masterpiece with some decorative flourishes in iron.

ART NOUVEAU EMERGES

It was in the fast expanding, and highly developed artistic climate of the Belgian capital of Brussels that an architectural style began to evolve in the works of the highly influential architect Victor Horta (1861-1947). Horta's early work had been with his employer, the academically classical architect Alphonse Balat who had built the imposing Musée Royal des Beaux-Arts.

In 1892 Horta began his Tassel House at 6 Rue Paul-Emile. The Tassel House could not contrast more strongly with the ponderous official architecture. In the interior Horta ex-

posed the iron columns in the hall and stairwell that carried so much of the building's weight and refused to conceal them with brick or plaster. The slender forms of the columns were given a treatment entirely Art Nouveau in character. Rather than mould them into conventional Gothic or classical columns, Horta shaped these supports to resemble the stems of some fantastic vegetation. At capital level Horta attached numerous twisting and turning metal fronds, as if the main column had sprouted growths. The design of the metal was echoed in the linear tendril decoration of the walls and ceilings and repeated again in the mosaic pattern of the floor. These features and the pale colour scheme gave the building an air of freshness, vitality and movement.

Right: The gently curving facade and the large windows of Victor Horta's classic Art Nouveau Hotel Solvay. The ironwork of the balconies and window mullions provides the only decoration.

Some of the furniture designed by Horta for the Tassel House was, however, less innovative than the building itself. A buffet, for example, with glazed cupboards at each end surmounted by S-scroll pediments and carrying a pair of candelabra with several curling arms, would not have looked out of place in a Rococo setting. On the other hand, the profusion of curved stretchers and supports under chairs and tables were pure Art Nouveau.

Having mastered the 'whiplash' line in the Tassel House, Horta began to develop his style through a number of commissions. The Hotel Solvay (1894), originally designed as a private residence, is the most successful of his surviving facades. Essentially, it is a gentle curve between two framing bays supported by exposed iron columns and is almost entirely glazed. Horta tried to lighten the effect of his architecture as much as possible with large windows, wide doorways and open stairwells giving an impression of open airy space to his interiors. Now commonplace, it is easy to overlook the immensely refreshing effect that these rooms must have had after the gloom of a Victorian interior.

There is little decoration on the exterior stonework of the Hotel Solvay. Instead, it is the ironwork of the balconies that embellish the building, while their curving effect is continued in the panels of the main door and inside, with the banisters, handles and light fittings all designed by Horta. The latter fall from the ceiling like inverted creepers whose flowers are the shades for the electric light

Above: Horta's airy interiors were achieved by the use of glass ceilings and splendid iron columns.

bulbs. Horta's attention to detail was such that all the fittings in the house, right down to the furniture and the locks for the doors, continued the organic, curvilinear theme.

In 1898-1900 Horta designed his own studio and house, the Atelier and Maison Horta – now the Musée Horta in Brussels. At the same time, his structural and exterior design became increasingly adventurous, and his most ambitious work of this period is the now demolished Maison du Peuple of 1897. A vast social centre, the large auditorium of this building was supported on a metal frame that was entirely exposed – a daring and modern device that was balanced by the smooth curves of the iron ribs, beams and balconies. Built almost entirely of metal and glass, the facade was a sweeping concave of interlaced ironwork and massed elliptical windows.

Horta's style moderated progressively through the 1890s, and by 1905 he had virtually abandoned the Art Nouveau style. His furniture however, is characterised by its abstract forms derived from nature and by its rather thin, spindly structural members. Horta also created the idea of built-in furniture, which became such a typical feature of the Art Nouveau interior that the French writer Edmond Goncourt invented for it the sobriquet 'Yachting Style'; a banquette, for example, would run along one wall, turn a corner and finish as a display case.

VAN DER VELDE

Another Belgian, Henry Van de Velde (1863-1957), first experimented with the Art Nouveau style through typography and book decoration. He progressed to interior decoration with the Hotel Otlet in 1894, and a year later built his own house at Bloemenwerf near Uccle, for which he designed all the furniture himself.

In marked contrast to Horta's flamboyant town house, it incorporated Art Nouveau lines into a rural idiom, with striped gables and shuttered windows. The furniture incorporated features derived from Arts and Crafts practices, and Horta's curvilinear style. Some pieces were made of oak, and some were simply constructed rush seated side chairs. But more elaborate pieces were decorated with carved ornament in a forceful Art Nouveau idiom.

Van de Velde went on to design interiors for Bing's Paris shop, office furniture for the German art critic Julius Meier-Graefe, as well as pieces for the German firm of Loffler, before moving to Germany where he set up the Weimar School of Arts and Crafts which subsequently became the Bauhaus.

THE FRENCH MASTERS

In France, the official training college for architects, designers and fine-art students, the Ecole des Beaux-Arts, represented the old historicising tendency at its coldest and most academic. The compulsion to imitate is encapsulated in Charles Garnier's Paris Opera House, built between 1861 and 1876, which is regarded by its more vehement critics as a worthless exercise in plagiarism. The theories of Viollet-le-Duc regarding the 'honest' use of iron – leaving it exposed rather than hiding it with terracotta and other fake masonry – were to prove particularly influential to French architects of Art Nouveau. Of these, the greatest exponent was Hector Guimard (1867-1942). While Horta limited his plant-like decoration mostly to interiors, and even treated it with a certain coolness, Guimard allowed fantasy to dominate his work. At times

Right: A cabinet by Horta for his own house in Brussels.

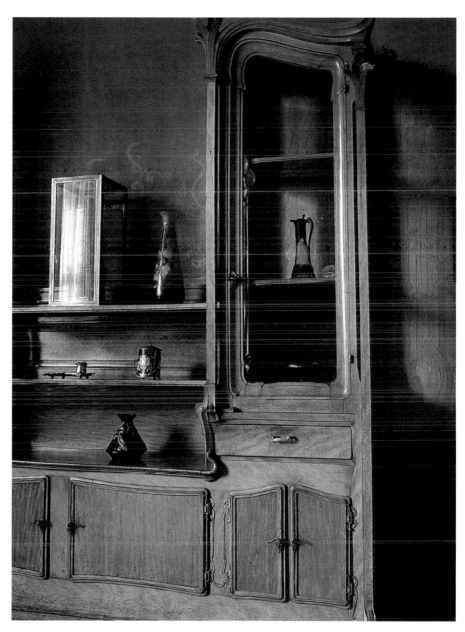

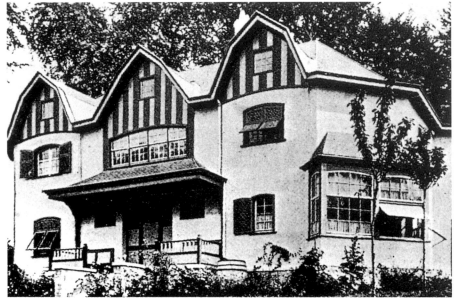

Above: Bloemenwerf, Van de Velde's residence in Uccle, Brussels, 1895-96.

Right: Interior of the Paris shop, La Maison Moderne, designed by Van de Velde for Julius Meier-Graefe in 1898.

he seemed to be deliberately challenging the accepted limitations of his medium, whether it was iron, wood or stone.

Based on the ideas of Viollet-le-Duc, but without using any form of overtly Gothic style, Guimard produced quaint, rustic chalets such as the Castel Henriette, with pitched roofs and a restless sense of movement in the forms of gables, doors and windows. The informality of his out-of-town architecture is also well demonstrated in the Villa Henri Sauvage built for the designer Louis Majorelle, outside Nancy. The house, with its high gables, assertive asymmetry and details of chimney pots and balconies, approaches a fairytale whimsy. Only hinted at here, the verticality of Gothic was often very near the surface of French Art Nouveau architecture, as in the work of Charles Plumet who liked to use steeply-roofed dormer windows and pointed arches, or in the

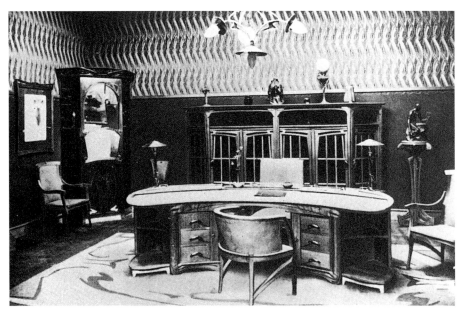

town house that jewellery designer René Lalique created for himself by adapting the vocabulary of French chateaux architecture.

If Guimard's country villas had a sort of rural quaintness, then his Parisian work is more forceful. In building his own house on the Avenue Mozart, he carved the stonework into the most dramatic forms, no longer simply just natural in origin, suggesting trees and plants, but exaggerated into a more artificial fantasy and elegance.

Guimard's concern for detail was equal to that of Horta. In this house as well as in his major apartment block, the Castel Beranger finished in 1898, his designs in metalwork and stained glass are particularly notable. In these he created purely abstract forms, emphasised by the terracotta panels decorating the entrance of the building, which ooze and flow across the walls as if they were still molten.

The furniture that Guimard designed for the Castel Beranger reflects his adherence to the principles of rational design taught by Viollet-le-Duc. Its construction, although visually flamboyant, is always justifiable in terms of strength and utility. The wave-like linear decoration carved in low relief is abstract, but clearly inspired by natural forms.

STYLE MÉTRO

Unlike Horta, Guimard worked in cast as well as wrought-iron, and it was the former that provided the basic material for the numerous Métro entrances and ticket offices he designed from 1900. Inspired works of fantasy, the entrances for the Paris Métro gave Guimard his most public prominence and even resulted in a local variation of Art Nouveau, the 'Style Métro'.

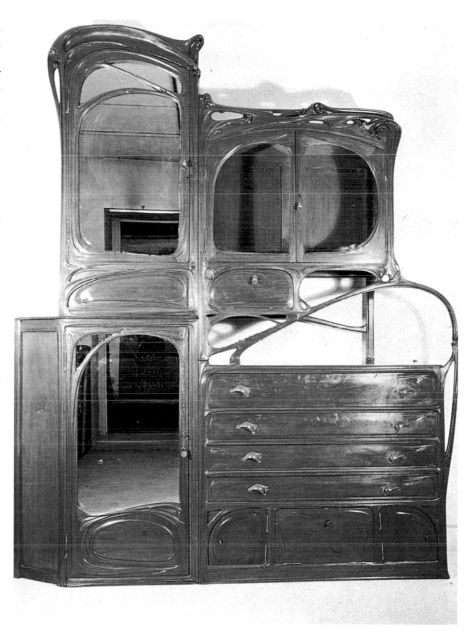

Right: A pearwood cabinet designed by architect, Hector Guimard, c.1900.

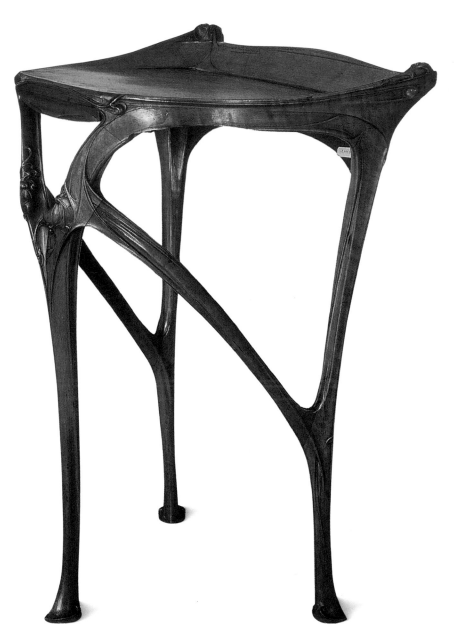

Above: The entrance to Guimard's Castel Beranger, where stone is carved to create the impression of a malleable material.

Left: An occasional table by Hector Guimard showing the same sinuous shapes as his entrances for the Paris Métro.

While the overhead structures of the Métro in the suburbs had been given a thoroughly conventional treatment – incidentally earning a decoration for their architect – Guimard was commissioned to produce shelters and archways for the entrances to the underground sections. These were so startlingly Art Nouveau that they provoked considerable controversy.

In keeping with the modernity of the new underground railway, Guimard restricted himself to the use of iron, enamelled steel and glass. The iron elements were produced in a large number of standard parts, making their

assembly into a huge variety of arches and pavilions a tribute to Guimard's inventiveness and versatility. The treatment of the ironwork was typically curvilinear, with barely a straight line to be seen in the whole design. Lamps sprouted from metal branches and the word 'Métropolitain' itself was carefully composed into harmonious Art Nouveau forms. Some of these amazing ironwork shapes, although organic in feel, had an angular tension strangely reminiscent of bones, and lacked the fluid grace of much of Guimard's interior designs, and of French Art Nouveau as a whole.

MÉTRO

While best known for the Métro entrances, Guimard's masterpiece was in fact the Humbert de Romans concert hall, built in 1898 and destroyed just seven years later as Art Nouveau quickly went out of fashion. Its crowning glory was a domed roof composed of steel ribs supporting a cupola pierced with windows of yellow stained glass.

ARCHITECTS: DESIGNERS AND CRAFTSMEN

Art Nouveau furniture bears all the variety of the regional styles of the movement. True to the spirit of Art Nouveau, few craftsmen specialised exclusively in furniture, and most had been trained in other arts or crafts. Most Art Nouveau furniture makers had been, or remained, architects, concerned to extend their control over the interiors of their buildings. The same tensions between ornament and structure, form and function were as evident in furniture-making as in architecture.

Right: The sculptural forms of the Paris Métro entrance by Hector Guimard, 1900.

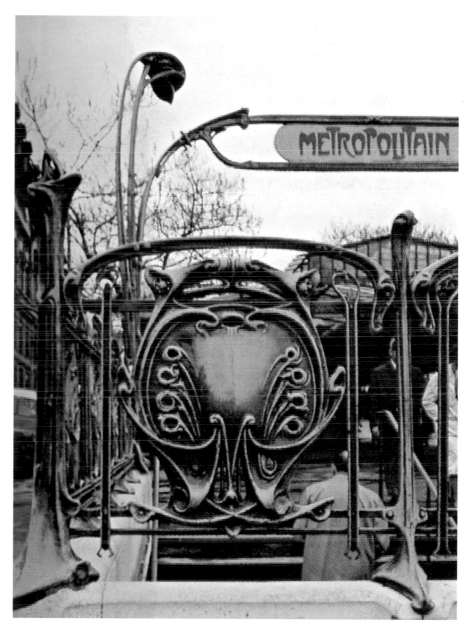

Right: Side chair in walnut by Eugene Gaillard, c.1900. The forms are inspired by nature, but are not in direct imitation of it.

Far right: Console table by Georges de Feure. The forms are pure Art Nouveau but the gilding betrays an 18th century inspiration.

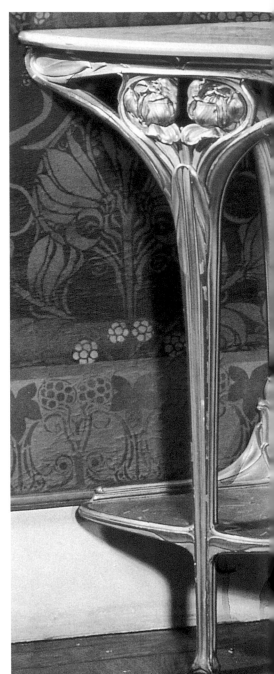

LES SIX

In 1897 a group of artists calling themselves *Les Six* held an exhibition in Paris which included furniture designed by the architect Charles Plumet and the brothers Pierre and Tony Selmersheim. Their work was Art Nouveau in style, often with a strong flavour of the Rococo in its sinuous lines and gilt metal fittings which often alluded to natural forms. Another member of Les Six, the sculptor Alexandre Charpentier, (1856–1909) was a furniture designer who achieved his main effects by the treatment of wood, with gilt-bronze reliefs and colour. The wood was carved to give it a molten, sometimes almost liquid, appearance; the relief panels, handles and lockplates represented female nudes; and the wood itself – usually hornbeam – was waxed to give it a yellow tint, somewhere between gold and honey.

Jean Dampt, another sculptor who belonged to the group, was a disciple of John Ruskin and an admirer of the English Arts and Crafts Movement. His furniture is Art Nouveau with Neo-Gothic touches.

SAMUEL BING'S GALERIE DE L'ART NOUVEAU

In Paris, Samuel Bing's Galerie de l'Art Nouveau was the principle showcase for Art Nouveau furniture, as for other crafts. Reflecting the nationalism fashionable at the time in France, Bing encouraged the crafts-men who worked for him to study the great French tradition of 'grace, elegance, purity and sound logic', and principally the refined poise of 18th century work. Bing showed a great range of work but he favoured a nucleus of three furniture makers: Eugène Gaillard, Georges de Feure and Edward Colonna.

Gaillard represents the functional side of Art Nouveau furniture; he studied the problem of function in design and produced pieces of an increasingly light, almost classic, simplicity. His chairs were concerned with comfort, had moulded backs, sometimes padding at the shoulders, and leather or fabric-covered coil-sprung upholstered seats.

THE PARIS WORLD'S FAIR

Georges de Feure, a painter and poet, was something of a dandy. He was a keeper of grey-

hounds, which he admired for their fine Art Nouveau lines. He brought more colour and decoration to his furniture, with gilding and coloured lacquer, as well as the kind of carved detail rare in Gaillard's work.

The third, Edward Eugène Colonna, had emigrated from Cologne to America where he worked under Tiffany, before returning to Europe to continue his career in Paris. Colonna's furniture, like de Feure's, was part of a larger output including porcelain and fabrics, and had a delicate, attenuated elegance also close to de Feure's style. When Bing was honoured with his own pavilion devoted to Art Nouveau at the 1900 Paris World's Fair, these three designers were given the task of decorating and furnishing it

THE NANCY SCHOOL

Aside from Guimard and his contemporaries working in Paris, France had a second school of Art Nouveau architects working at Nancy in Lorraine in eastern France, at a colony led by the designer Emile Gallé (1846-1904). Its outstanding achievement in architecture was the Villa Majorelle of 1900, which was designed chiefly by Henri Sauvage.

Nancy was historically the home of the glass-making industry and Gallé, heir to a small ceramic and glassware business, became the leader of the Art Nouveau revival of the city's main industry. In the 1870s Gallé had travelled to England and had been caught up in the growing enthusiasm for the decorative arts. He also studied the oriental collection at the Victoria and Albert Museum in London and, with his new found knowledge of Chinese and Japanese techniques, he returned to Nancy.

Gallé also possessed a specialist's understanding of botany and entomology, his other amateur passions. Thus he was equipped with

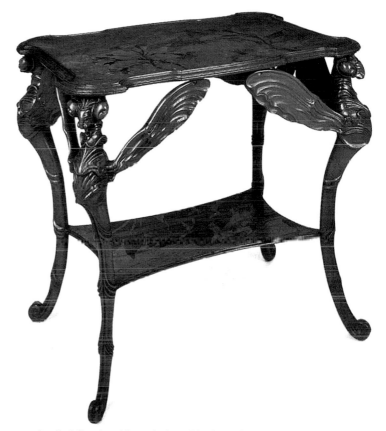

a very detailed first-hand knowledge of leaf, flower and insect forms, which, when combined with the decorative, abstract tendency of the Japanese, combined to form the Art Nouveau blend. A third ingredient, Rococo, was already evident in Nancy, which had many fine houses and decorations in that style.

GALLÉ AND FURNITURE DESIGN

In 1884, after some years designing in glass and ceramics, Gallé started designing and producing furniture. At first his designs were somewhat ponderous but were invariably en-

Above: A rare use of fantastic grotesques by Emile Gallé. Characteristically, the whole table leg is given over to their form.

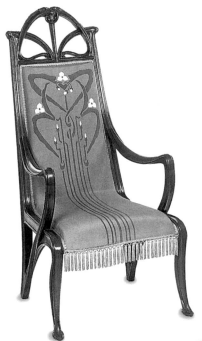

livened with vivid natural details. Success came at the 1889 Paris International Exhibition, where Gallé was acknowledged as an innovator, who had created a new style in reaction to the unimaginative revivalism of most contemporary French furniture.

Gallé's work became increasingly lighter and more ornate. Natural forms were not restricted to details; whole arms, legs and backs were carved in plant or insect forms, curving and twisting to animate the whole and seeming to defy the nature of the wood itself. Although stylised, those graceful shapes were always clearly identifiable plants of species

Left: An armchair, c.1900 by the Nancy cabinet maker, Louis Majorelle.

Below: A carved fruit wood and marquetry tray c.1900 by Emile Gallé.

known to Gallé. His favourites were local plants including cow-parsley, water lilies, orchids and irises, though he also used exotics, such as bamboo.

Gallé preferred soft woods, of which he had a very thorough knowledge, to facilitate the creation of his effects, which included his remarkable revival of the art of marquetry. Most of the surfaces of Gallé's furniture became fields for the most intricate inlays featuring plants, insects or landscapes in what could become an overloading of effects. So fine was the craftsmanship though, that Gallé's own willowy signature could be reproduced on his pieces.

MARQUETRY

Gallé's mastery of marquetry opened the way to the expression of poetry and literary themes in his furniture. He liked to include suitable quotations and, as a mark of the fusion of the arts and crafts in Art Nouveau, he gave some pieces names in the manner of paintings or music. A console he created became *Les Parfums d'Autrefois* (Perfumes of the Past) and his last masterpiece, a bed he designed while dying of leukaemia, *Aube et Crépuscule* (Dawn and Dusk). This latter piece is evidence of Gallé's increasing restraint in his late style, simplifying forms and eradicating much of the over-intricacy of his earlier work, as well as being a tour-de-force of marquetry. The dark shadows of dusk are enveloped in the drooping wings of the fantastic insect on the headboard, while at the foot of the bed, the rising wings of another huge insect are depicted in lighter woods and mother-of-pearl.

Second to Gallé at the Nancy School was Louis Majorelle (1859-1929). Majorelle began designing in an 18th-century style until Gallé persuaded him to inject more vitality and naturalism into his work. His pieces are,

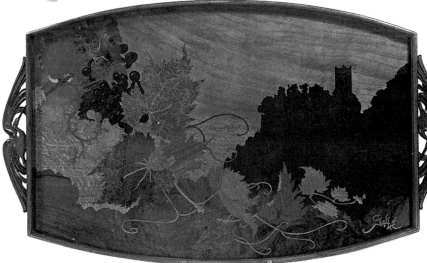

nevertheless, rather more solid than Gallé's, partly because he favoured the use of harder, more exotic woods. The more sculptural elements in Majorelle's pieces were in the ornamentation, which, still partly inspired by the baroque and Rococo, he added in gilt, copper or bronze. Majorelle equalled Gallé in his use of marquetry, but generally his style differs in its smoother lines. Majorelle was consequently able to make a successful transition to the simpler style of the 1920s.

CABINET MAKERS

Other cabinet makers in Nancy worked for either Gallé or Majorelle, and occasionally both. Victor Prouve (1858-1943) specialised in marquetry work for both masters as well as designing his own pieces. Eugène Vallin (1856-1925) worked for Gallé and produced pieces of far greater weight than those of his master. Vallin's work eschews intricate natural detail and instead concentrates on broad, swaying, linear rhythms anticipating the end of his career when he took up architecture and used cast concrete for his effects. Jacques Gruber produced designs for Majorelle and was also Professor of Decorative Arts at the Ecole des Beaux-Arts in Nancy. His furniture shares the same flowing forms as that of Vallin, and is removed from Gallé's Rococo touches.

Through a range of Art Nouveau furniture it is possible to see designs stripped down to the most elegant bare curves, as well as those which are adorned with carving, brass, gilt or ivory. A similar contrast exists between designs that are obviously designed for comfort and utility, and those that come close to sacrificing both these concerns for the sake of effect. What gives coherence to this variety are the irrepressible curves and sense of idiosyncratic inventiveness. Occasionally these had

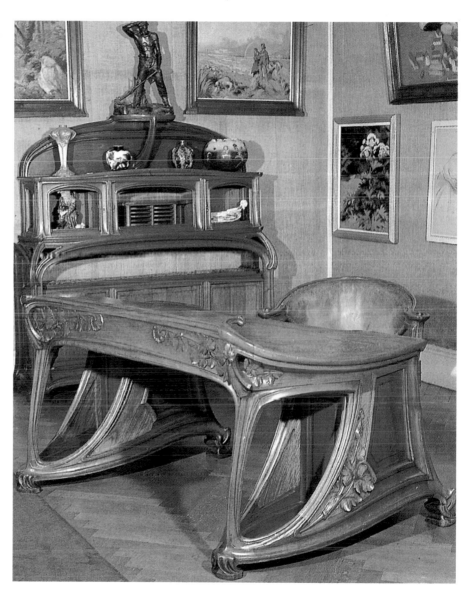

Above: Office suite by Eugene Vallin in exaggerated Art Nouveau style.

to be curbed especially when designs were intended for mass production. The attention to detail and the manipulation of the materials generally meant that Art Nouveau furniture was unsuited to any mode of production other than that of the individual craftsman. As in the Arts and Crafts Movement in England, the Art Nouveau designer was forced to accept the fact that his work was primarily an expensive luxury for an élite. Factory-produced Art Nouveau furniture inevitably lost much of its natural vitality and was a coarsened version of the hand-worked equivalent. Art Nouveau architects might have been eager to embrace the new materials of iron and steel, but when they turned to designing furniture their style was fundamentally unsuited to modern production techniques.

Below: Furniture designed as part of a unified environment by the Parisian Georges Hoentschel.

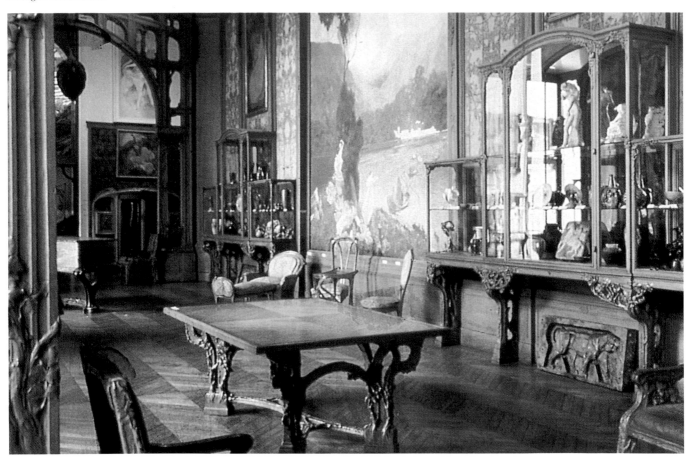

BRITAIN, AUSTRIA AND GERMANY

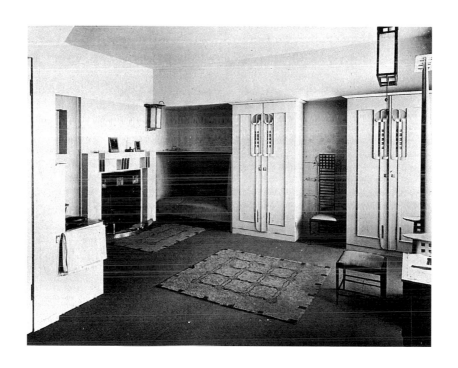

Unlike the French and the Belgians, the architects and designers of Britain, Austria and Germany used the languid curves of Art Nouveau with great austerity, and in harmonious counterpoint to grid-like patterns of horizontal and vertical lines.

Overleaf: Interior of Hill House, Dunbartonshire, Scotland designed by C.R. Mackintosh, 1904.

Below: Oak side chairs by E.W. Pugin, c.1870 conform to the principles of simplicity and clear construction advocated by his father, the architect and critic A.W.N. Pugin.

THE INFLUENCE OF THE ARTS AND CRAFTS MOVEMENT

From the 1860s onwards Britain rose to a prominent position in European decorative arts. The founding of Morris, Marshall, Faulkner & Co. in 1861 had been the beginning of a new movement in reaction to the allegorical flourishes of design in the 1851 Great Exhibition. The Arts and Crafts Movement, absorbing the tenets of the Gothic Revival, was committed to honest and simple design for domestic use. Inspired by the teachings of John Ruskin and Pre-Raphaelite artists, the majority of the designers were professional architects. It was also an intellectual movement, which successfully captured the imagination of the time.

Arts and Crafts furniture laid stress on the honest presentation of materials, structure and production, taking as its highest principle

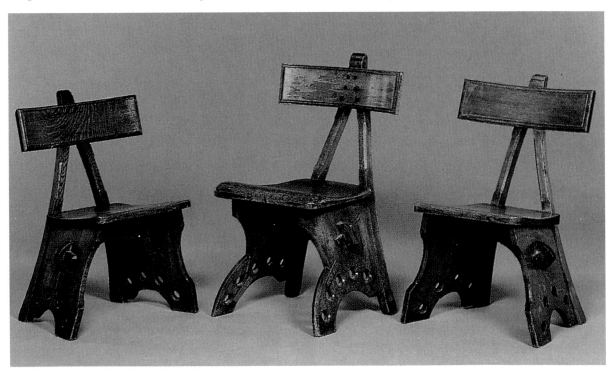

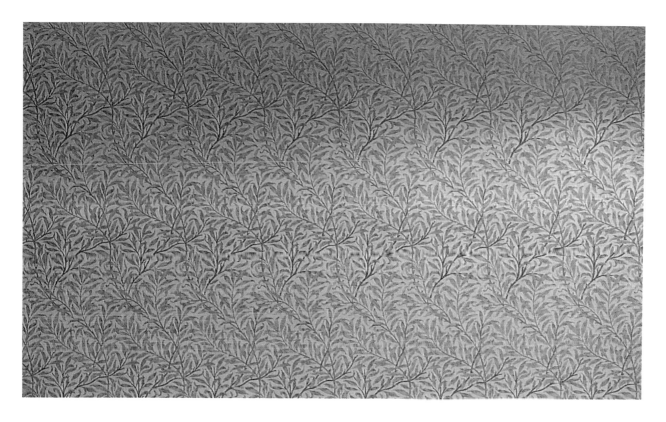

Ruskin and William Morris's belief that only the highest good could come from man transforming his own environment with his own hands. The machine was despised, as was any decorative idiom which slavishly copied past styles. Handicrafts flourished, especially in the fields of embroidery, metalwork, stained glass and art pottery.

All over the country handicraft guilds were founded to involve both the working man and the hitherto unemployable young lady in the practical creation of their own environment. The most influential of these guilds were the Century Guild founded in 1882 by Arthur Mackmurdo, the Art Workers' Guild founded in 1884, Charles Robert Ashbee's Guild of Handicraft formed in 1888, the same year as the Arts and Crafts Exhibition Society, and, in 1900 the Birmingham Guild of Handicraft.

SPREADING THE STYLE

The original impetus of the Arts and Crafts ideals gave rise to considerable activity which was chronicled in the pages of *The Studio*. The magazine was frankly propagandist for the movement, and through its pages the inspiration of British design was made known in Europe and America. In 1898 the Grand-

Above: 'Willow Boughs' wallpaper, designed by William Morris in 1887. Such a wallpaper emphasises the flatness of the wall and avoids a false illusion of depth.

Right: The Honeysuckle Room at Wightwick Manor. Carpets, wallpaper, tiles and furniture by Morris & Co.

Duke of Hesse commissioned designs from Charles Ashbee and M.H. Baillie Scott for furniture, made by the Guild of Handicraft, for the artist's colony set up at Darmstadt. Britain's lead was beginning to take effect abroad.

Yet despite leading the way in the decorative arts, Britain, however, was to strongly oppose any new influences such as Art Nouveau, and remained firm in her adherence to the simple functional lines and country morals of the Arts and Crafts Movement. Innovative artists such as the Glasgow Four, who were acclaimed abroad, were to be virtually ignored by both critics and public alike at home.

CHARLES RENNIE MACKINTOSH AND THE GLASGOW FOUR

The Glasgow Four were Charles Rennie Mackintosh, his wife Margaret, Herbert MacNair and Frances Macdonald (Margaret's sister, who married MacNair), all of whom studied at the Glasgow School of Art in the early 1890s.

Mackintosh (1868-1928), an architect, had produced his first furniture designs in the early 1890s and this early work already shows an avoidance of reference to period design and a sparseness in the absence of applied decoration. Mackintosh's designs were dictated by the problems of the arrangement of interior space and he laid stress on vertical elements, his high-backed chairs giving a variety of height within a room, despite the acknowledged criticism of their impracticality.

In 1896 the Four were invited to send fur-

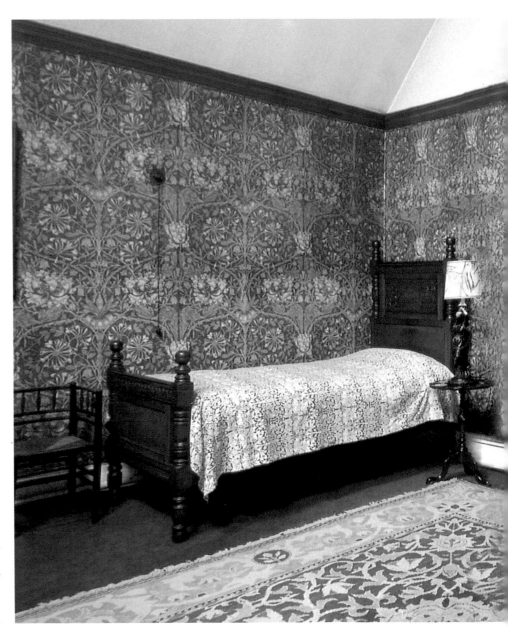

niture, craftwork and posters to the Arts and Crafts Exhibition Society show where their work, especially the posters, met with a puzzled and shocked reaction. The editor of *The Studio,* however, made a visit to Glasgow and in 1897 published two appreciative articles on their work. This was quickly picked up in Europe and the following year the Darmstadt magazine *Dekorative Kunst* contained an article on the Glasgow School.

MACKINTOSH AND VIENNA

Earlier in 1895, work from Glasgow Art School had been sent to the Liège Exhibition where it was received enthusiastically, although Mackintosh himself never favoured the Belgian and French excesses of Art Nouveau. It was in Vienna that he found like minds.

In 1900 he visited the 8th Vienna Secessionist Exhibition, which was devoted to the work of foreign designers, including Mackintosh and his wife, Charles Ashbee and Henry Van de Velde. There he met Josef Hoffmann with whom he was to remain in contact for many years, warmly supporting the decision to found the *Wiener Werkstatte.* Mackintosh received two commissions in Vienna, including the design of a music room for the banker Fritz Waerndorfer, who was to finance the Werkstätte, where a dining room was commissioned from Hoffmann. Mackintosh also exhibited successfully at the Turin Exhibition of 1902. It must have been a sore disappointment to Mackintosh to find his work received so sympathetically abroad while being almost ignored in Britain. Despite being a very influential figure in late European Art Nouveau, Mackintosh's architectural career is largely confined to the Glasgow School of Art, the series of tea rooms designed for Miss Cranston and a handful of private

Above: Scottish architect and designer, Charles Rennie Mackintosh (1868-1928).

strate his remarkable creation of a distinctive style totally removed from the influences of the preceding century.

MACKINTOSH'S ARCHITECTURE

Mackintosh's first important commission came in 1896, when he won a competition to design a new School of Art for the city of Glasgow. At first sight the building which he constructed over 12 years bears little resemblance to Art Nouveau works elsewhere.

The asymmetry and the hint of the turrets evident in the front entrance refer to Mackintosh's early enthusiasm for the Gothic revival. In the starkly-mullioned great windows of the north-facing studios and the apparent simplicity of the whole, there is evidence of the uniquely British Arts and Crafts architects with their Tudor references.

IRONWORK

Yet Mackintosh is a figure of European significance in Art Nouveau, and his importance extends beyond the local. The curving stonework in the centre of the main facade, and the stylised elongation of the windows of the west front display the refinement of Art Nouveau, and the connection becomes stronger in the details of the building. The carving over the entrance has the curving, Celtic lines of Art Nouveau graphics and metalwork of the Glasgow school, and the ironwork indulges in more abstract curves. This is used to contrast with the harder lines of the stone background in a way reminiscent of Horta's Hotel Solvay. The ironwork, resembling buttresses against the main studio window, is rounded off in intricate, loosely-bound knots of metalwork, almost like enlarged pieces of jewellery. The strange decorations on the railings at street level, and the bundles of arrow shapes

houses for Scottish patrons, notably Hill House, Helensburgh (1902) built for the publisher Walter Blackie. These projects, where he designed almost every element, from cutlery for the tea rooms to rugs for Hill House, demon-

supporting patterned dishes, derive from Japanese heraldry, which emphasise the wide internationalism of Mackintosh's references and his affinity with the orientally-inspired refinements of Art Nouveau.

The simplicity and elegance of Japan are again recalled in the interior of the school's library, completely designed by Mackintosh. He was reluctant to experiment with structural ironwork, so wood is used throughout to support the galleries. Mackintosh's fascination with beams and joints was a typically eclectic Art Nouveau fusion of his Japanese and Gothic interests, and is seen again in the open rafters elsewhere in the building. The use of dark stained wood also gives the library an oriental sobriety. By opening out a continuous airy central space, Mackintosh created slender, vertical beams, which are echoed in the delicate light fittings. It was a variation on one of the great themes of Art Nouveau architecture: the open, light and spacious interior, in this case lit by the long, triple bay windows of the west facade.

MACKINTOSH'S FURNITURE

In furniture, as in architecture, it was Mackintosh's work that dominated British Art Nouveau. Mackintosh's furniture is intended to be seen as part of a whole interior design with secondary work often produced by other artists and designers. Mackintosh's designs show a virtuosity which is breath-taking, if sometimes self-indulgent. It is easy to understand why his furniture was not well received in England where it was regarded with suspicion for being too stylised or 'aesthetic'.

Right: Library, Glasgow School of Art, Glasgow, Scotland, 1877–99, 1907–09, Charles Rennie Mackintosh.

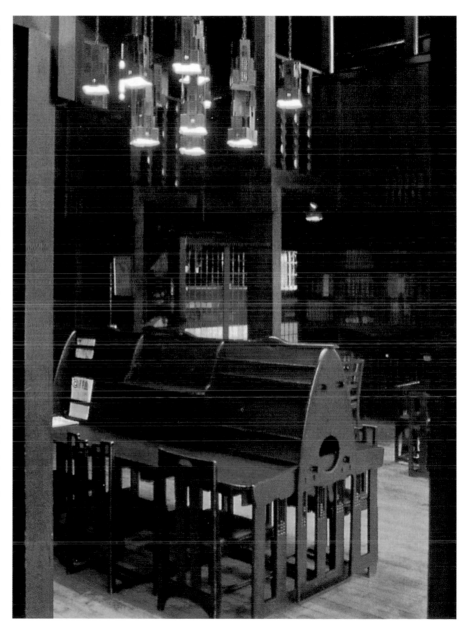

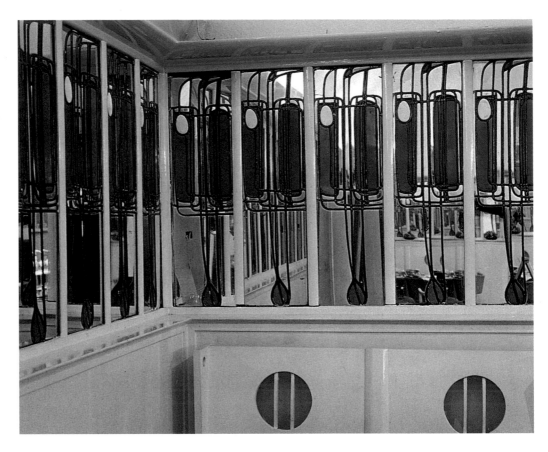

Right: Wall panels and mirrors with stylised plant motifs for Miss Cranston's Willow Tea Rooms in Glasgow, designed by C.R. Mackintosh in 1904. For this project, Mackintosh designed almost every element, from the cutlery to the furniture.

Simplicity was sacrificed to sophistication, tradition was flouted and scant respect was shown for materials. As in his architecture, he concentrated upon the extremely elegant, exaggerated verticals, particularly in the backs of his chairs which could be exceptionally tall and slender. These were cut into ovals, grids or ladderbacks that descended down to the floor. Curves might occur, but with Mackintosh they were primarily used to underline the rigidity of the verticals.

Furniture was made from various woods,

including oak, cypress, pine and mahogany, which were rarely left untreated. Mackintosh felt uncomfortable with the natural grain of the wood and attempted to minimise it by deep, dark staining and eventually by lacquering or ebonising it into matt black. He explored a converse neutrality by painting other pieces white to act as a suitable background for lilac and silver harmonies. On lighter furniture, Mackintosh stencilled stylised designs.

While he received great recognition in Germany and Austria (especially among the

architects of the Secession) Mackintosh's greatest achievement may have been to point a path forward from the decorative excesses of Art Nouveau, which found itself fading in popularity after the first five years of the 20th century and was laid to rest by the horrors of World War I.

GERMANY AND JUGENDSTIL

Jugendstil (Youth Style) was the German term for Art Nouveau. In Munich during the 1890s, a number of architects, painters and sculptors

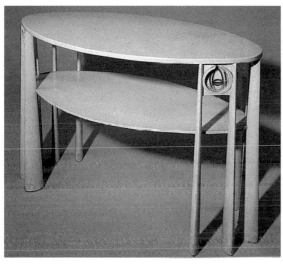

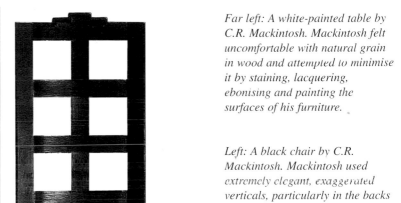

Far left: A white-painted table by C.R. Mackintosh. Mackintosh felt uncomfortable with natural grain in wood and attempted to minimise it by staining, lacquering, ebonising and painting the surfaces of his furniture.

Left: A black chair by C.R. Mackintosh. Mackintosh used extremely elegant, exaggerated verticals, particularly in the backs of his chairs which could be exceptionally tall and slender. They were often cut into ovals, ladder-backs that descended to the floor, or, as in this example, into grids.

including Hermann Obrist (1863-1927), August Endell (1871-1921), Richard Riemerschmid (1868-1957), Bernhard Pankok (1872-1943) and Bruno Paul (1874-1954) turned their attention to the applied arts. In 1897, these five, among others founded the *Vereinigte Werkstätte für Kunst im Handwerk* (United Workshops for Art in the Handicrafts). Obrist and Endell designed furniture in flowing natural forms that were determined by a theory of interaction between physical appearances and psychological reactions. Obrist's furniture was made of oak, and Endell's of elm, while Pankok's designs, which were also based on natural forms, were made of oak, pearwood, walnut and spruce.

NEO-GOTHIC STYLE

Richard Riemerschmid's earliest experiments in furniture were some pieces he designed for his own apartment in 1895. They were in the Neo-Gothic style, made of stained and painted pine and decorated with elaborate wrought-

Right: The Atelier Elvira, 1897-1898, Munich (now destroyed) by August Endell.

Bottom: Table and chair with stencilled back, c.1901 by C.R. Mackintosh.

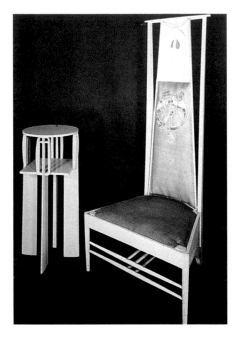

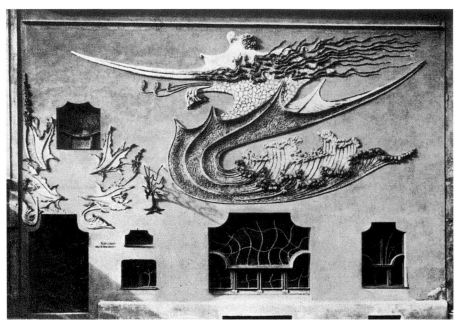

iron hinges and foliate ornament carved in low relief. However, Riemerschmid's style was to change, as a result of seeing an exhibition at Dresden in 1897 of Van de Velde's furniture. His abstract Art Nouveau style made a great impact on all the Munich artists, including Bruno Paul, whose work was characterised by elegant curved lines and was free of any ornamentation. The following year Riemerschmid designed an oak side-chair, its back-rest carried on supports which descend in a sweeping curve to the feet of the front legs.

THE DRESDEN WORKSHOPS

One of the intentions underlying the work of the Munich artists was to create furniture cheap enough for a far larger public than could afford the hand-built furniture produced by the leading avant-garde designers of Paris, Nancy and Brussels. When selecting the forms their furniture would take, the Germans took into account the new wood-working machines being developed at the time. The leader of this tendency was Karl Schmidt, Riemerschmid's brother-in-law, who had trained as a cabinet maker and in 1898 opened the *Dresdner Werkstätte* (Dresden Workshops). At an exhibition of industrial art held in Dresden in 1899-1900, Schmidt showed an apartment of two living rooms, a bedroom and a kitchen, inexpensively furnished with simple modern furniture. Five years later, the *Dresdner Werkstätte* produced a range of machine-made furniture designed by Riemerschmid.

THE GERMAN WORKSHOPS

In 1902 Adelbert Niemeyer, an artist, and Karl Bertsch, an upholsterer, founded a workshop

Left: An oak sideboard by August Endell, c.1900. Endell believed that the shape of an object could induce feelings of serenity.

Below: Dining chair designed by Richard Riemerschmid, c.1900.

in Munich for the manufacture of furniture and other items of interior decoration. In 1907 the workshop merged with the *Dresdner Werkstätte* and the two became known as the *Deutscher Werkstätte* (German Workshop). This should not be confused with the *Deutsche Werkbund* which was an association of designers, craftsmen, manufacturers and retailers promoted by the German government and founded in the same year. Niemeyer continued to design furniture for the *Deutsche Werkstätte* until his death. Other designers who occasionally worked for the Dresden concern include Baillie Scott and the Austrians Josef Hoffmann (1870-1956) and Kolomon Moser (1868-1918).

THE DARMSTADT DESIGNERS

Having been frequently illustrated in *The Studio* magazine, Baillie Scott's work was well known on the continent. These illustrations had caught the eye of the Grand Duke Ernst Ludwig of Hesse-Darmstadt, who in 1897 had had a drawing room and a dining room in his palace at Darmstadt furnished by Baillie Scott and Charles Ashbee. The Grand Duke encouraged the establishment of an artist's colony in Darmstadt and donated some land for it. Seven artists were invited to join the colony and by 1900 their homes were being built. For his house, Peter Behrens (1868-1940), an architect who had been working in Munich during the 1890s, designed furniture which was close in style to the work of Van de Velde. Josef Maria Olbrich (1867-1908), although from Vienna, was another Darmstadt colonist who created furniture for his own and other artist's houses in a style which was a successful blend of organic shapes and geometrical ornament.

AUSTRIA AND THE SECESSIONISTS

In Austria the Art Nouveau style was called *Sezessionstil*, after the Vienna Secession which was formed in 1897 both as a reaction

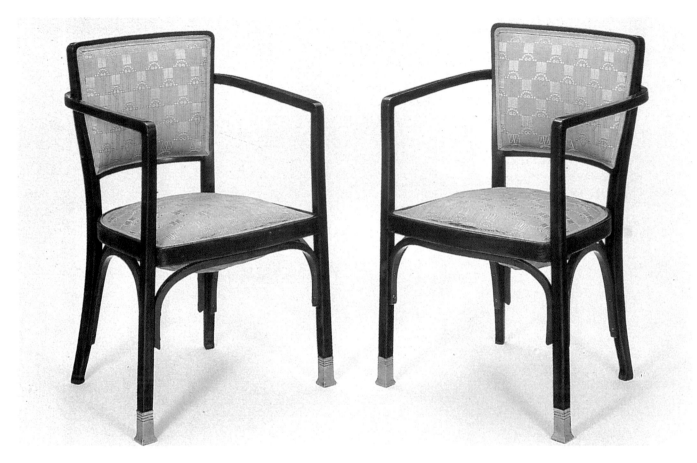

Above: Chairs by Kolomon Moser of the Viennese Secession movement, showing the great restraint of the style, partly inspired by Charles Rennie Mackintosh.

against the tired revivalism of academic artists and as a celebration of modernity. It was therefore almost inevitable that the work of its members should directly reflect the influence of the Art Nouveau style which by then was fully developed in Western Europe. Beginning as something of a local variant on Art Nouveau, this late flowering of the style was to prove a turning point between Art Nouveau opulence and 20th century austerity. Even in their earlier works, the Austrian

architects preferred a framework of straighter lines to set off the opulent curves of Art Nouveau. They were particularly appreciative of these qualities in Mackintosh's style, which helped to form their own, and of the English Arts and Crafts architects, who by this stage were opposing the sensuality of Art Nouveau.

OLBRICH AND THE SECESSIONHAUS
Just as the Arts and Crafts practitioners had lauded the merits of simplicity and honesty

in architecture and design, so too did the group of Austrian architects, painters and sculptors who seceded from the official artists' organisation and held their own exhibitions in the Secessionhaus designed by Josef Maria Olbrich in 1897-99. As a founder member of the breakaway group, Olbrich felt it necessary to make a strong architectural statement. The main structure of the building – reputedly inspired by a rough sketch by the painter Gustav Klimt – is substantial, and complete with concrete facing, but the detailing with animal and vegetable life is an all-important aspect of the building, particularly on the tracery of the iron dome. Like the spires of Cologne's medieval cathedral, the perforated structure lightens the 'weight' of the building. Much of the Secession's work in all art forms, achieved this type of effect through well-controlled contrast, rather than by an unbridled release of free flowing forms.

OTTO WAGNER'S ARCHITECTURE

One of the older Secessionists, Otto Wagner (1841-1918) was an influential writer and theorist. His architectural career had not brought him a great deal of public success, but the Secession supported his pupils Olbrich and Josef Hoffmann. In 1899 Wagner himself became a full member of the Secession, largely severing his connections with much of his own generation and the Vienna Akademie's school of architecture.

MAJOLIKAHAUS

The year before, Wagner had publicly shown his allegiance to the Secession style by his treatment of the facade of an apartment block he had designed, aptly dubbed the 'Majolikahaus'. In essence, this consisted of

Above: A poster advertising one of the annual exhibitions held by the craftsmen of the Vienna Secession.

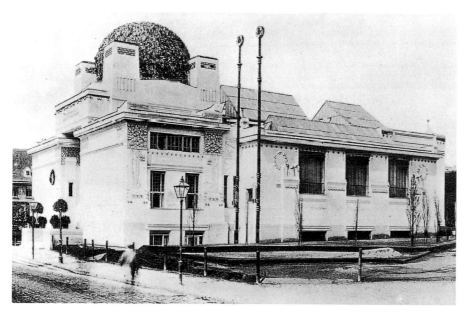

Left: The Exhibition Hall of 1898 designed by Josef Olbrich for the Secession in Vienna.

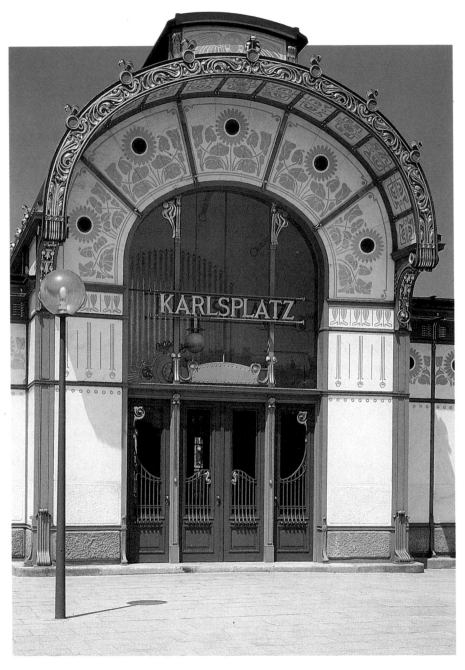

a completely regular grid of windows, devoid of any architectural or sculptural decoration. However, to counteract the austerity Wagner decorated the whole facade with brightly-coloured majolica, floral patterned tiles that seem to grow up from the second floor, and gradually enveloped the whole building in the light, sinuous lines of Austrian Art Nouveau.

STADTBAHN

Before the establishment of the Secession group, Wagner, with Olbrich as his assistant, was appointed architect to the new Viennese underground and suburban railway, the Stadtbahn. The design of the Stadtbahn stations immediately invite comparison with Guimard's work for the Paris Métro. Wagner's stations lack the free-flowing fantasy of Guimard, yet they have a rather Rococo grace and lightness, with abundant floral detailing, which is the closest point in Austrian architecture to the French style of Art Nouveau.

The speed with which Art Nouveau was acknowledged was equalled only by the speed with which it came under criticism. Wagner's Post Office Savings Bank, built between 1904 and 1906 in the centre of Vienna, reveals a completely new aesthetic, based soundly on 'truth to materials'. With austere ornamentation, its structural components such as rivets and nuts provide a wealth of decoration. Here Wagner created a building using up-to-date methods of construction and materials such as steel, aluminium, glass and concrete to create a large, airy main hall. To the contemporary eye, the interior of the building must have appeared somewhat spartan, but in the attention to every

Left: The magnificent Karlsplatz Station of the Vienna Stadtbahn (subway train), designed by Otto Wagner.

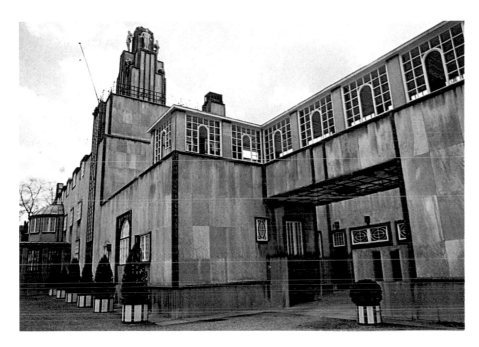

Left: Exterior view of the Palais Stoclet, Brussels, designed by Josef Hoffmann and begun in 1905.

detail of furniture and fitting, the light, glass roof and particularly the elegant tapering piers supporting the gently curved vault, all suggest the remaining echoes of Art Nouveau.

THE WIENER WERKSTÄTTE

Wagner's former pupil, Josef Hoffmann, appreciated craftsmanship and believed that ornament had an important role in architecture. Together with Kolomon Moser (1868-1918), Hoffmann established the *Wiener Werkstätte* (Vienna Workshop), a workshop dedicated to the production of functional but beautiful objects.

Hoffmann's Purkersdorf convalescent home (1903) reveals structural sincerity; his designs for the Palais Stoclet in Brussels (1905-11) however, allowed him to put his theories fully into practice. Stoclet, a wealthy financier, commissioned Hoffmann to build a palatial home

that should also serve as a suitable setting for his art collection and for entertaining. What Hoffmann designed was a house of great distinction, combining elements of formality (strong horizontals and verticals) with great informality (an irregular floor plan and a facade that did nothing to hide the irregularity of the room arrangement within). The very asymmetry of the design coupled with the unusual shapes and positions of the windows points strongly to Mackintosh's work.

HOFFMANN'S FURNITURE

Many of Hoffmann's furniture designs also show the influence of Mackintosh, but he maintained a high level of personal inventiveness. Characteristic of Hoffmann's furniture are lattice-like chair backs and table aprons, and small spheres of wood for decoration at points of

structural significance. Hoffmann's style gradually became more retrospective, using some Neo-classical and Biedermeier (an informal 19th century style) forms.

The same influence is evident in the furniture created by two other *Wiener Werkstätte* designers, Otto Prutscher and Josef Urban (1872-1933). While some of the pieces designed by Moser were richly decorated with marquetry or inlaid metals, others, like Mackintosh's in Glasgow, were simply painted white.

ADOLF LOOS

The Viennese architect Adolf Loos (1870-1933) did not join the Secession and criticised its members for the ornament and deliberate artiness of the furniture they designed. Loos greatly admired Roman architecture and

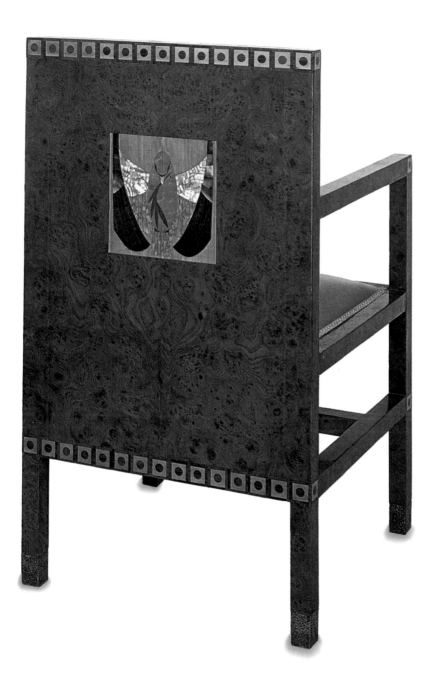

inherited from his stone-mason father a deep respect for 'raw' materials.

He travelled to the United States in 1893, the year after Louis Sullivan had published his *Ornament in Architecture*. Three years later Loos settled in Vienna, bringing with him a belief in the rejection of ornament (summed up in his essay 'Ornament and Crime' of 1908). Perhaps because of his outspoken stance, large scale commissions were slow to arrive, his most notable piece during this early period being the Kartner Bar of 1907. The apparent harshness of its geometric order is dissolved by the richness of shiny metals and lavish leather seating. Loos also designed bentwood chairs manufactured by Thonet for the Café Museum. He had been impressed by the work of the English Arts and Crafts Movement and several pieces he designed were of simple, panelled construction, marked by elegant proportions and a judicious disposition of simple reeding and metal fittings.

Loos designed a house for the Steiner family in Vienna in 1910 and this commission provided him with the opportunity to manifest his principles. The house is outstanding, not least because it is one of the first examples of domestic architecture to use reinforced concrete. Externally the building consists of smooth, flat walls of solid geometric blocks pierced by plate-glass windows (which are mainly horizontal) and a flat roof. Internally, the same geometric order prevails, but around an essentially traditional plan.

Loos went on to design many private villas before settling in Paris where he designed a house for the Dadaist, Tristan Tzara, in 1926.

Left: Armchair veneered in amboyna wood, designed by Kolomon Moser in 1904.

SPAIN
AND AMERICA

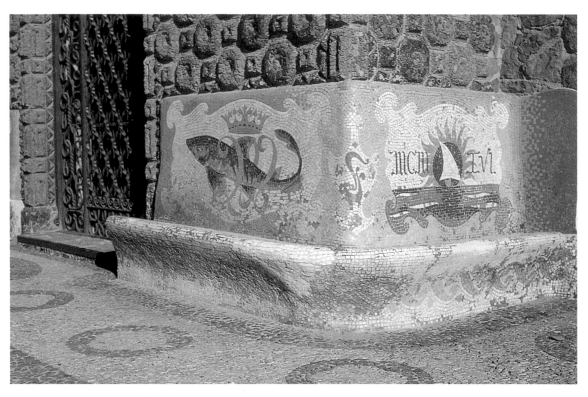

Above: Details of the polychromatic decoration which incorporates the Güell family monogram and coronet, by Catalan architect Antoni Gaudí.

Overleaf: The interior of Gaudí's mansion for Don Eusebio Güell. The interior shows the architect's interest in the ornate Gothic style, as well as Moorish-inspired design. They combine to produce a unique variation of the Art Nouveau style.

One of the strongest features of Art Nouveau was its very diversity. The remarkable set of characters, linked by common Art Nouveau traits, sets the short-lived movement apart from the homogeneity of previous styles, arid and easily transferred from master to pupil. The blossoming of Art Nouveau in Brussels, Glasgow, Paris, Munich, New York, Barcelona and so many other centres was a unanimous rejection of excessive uniformity.

GAUDÍ AND MODERNISMO

In both Belgium and France there were a number of architects working along similar lines, and Art Nouveau could lay claim to being a movement of sorts. In Spain Antoni Gaudí (1852-1926) worked in virtual isolation, and his only direct influences came from reading the works of Viollet-le-Duc, Ruskin and others. Yet Gaudí was arguably one of the most original and accomplished of all Art Nouveau architects.

Born in Tarragona, Gaudí moved to

Barcelona, the capital of Catalonia, around 1869, where he met his main patron, Eusebio Güell. Aside from the Neo-Gothic theories of Viollet-le-Duc, he was influenced by traditional Moorish and Moroccan styles, and by a mission to create a new Catalan architecture. His buildings were consequently more exotic than those of his contemporaries in northern Europe. In Gaudí's work one confronts one of the strangest variations of Art Nouveau, so firmly embedded in the peculiar local conditions that it is almost possible to see it as a purely local style. Indeed it even had its own name, *Modernismo*.

CATALAN TRADITION

Catalonia in particular had its own traditions. It was the wealthiest and most modern part of Spain, with its own industries and the thriving port of Barcelona, and was immensely proud of its trading history. These were vital to Catalan identity at a time when the central government in Madrid was attempting to integrate the region more completely into Spain, partly by discouraging the use of the native Catalan language. In this context of spirited Catalan patriotism, Gaudí began his architectural career as a Gothic Revivalist, but more specifically as a revivalist of the local Gothic style. This had its own element of fantasy, which Gaudí managed to emphasise through his study of the Moorish architecture of southern Spain and North Africa. To this, Gaudí added his knowledge of Viollet-le-Duc's work, with its light, almost tent-like forms of iron-supported Gothic vaults. He was also inspired by John Ruskin's ideals of the unity

Right: Inside Gaudí's Church Santa Coloma de Cervelló, for which he also designed the furniture.

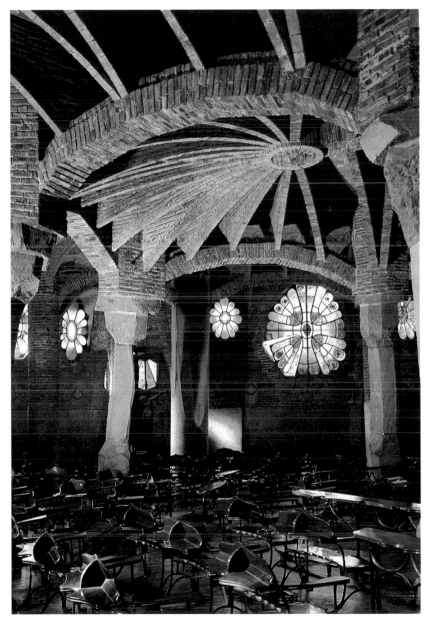

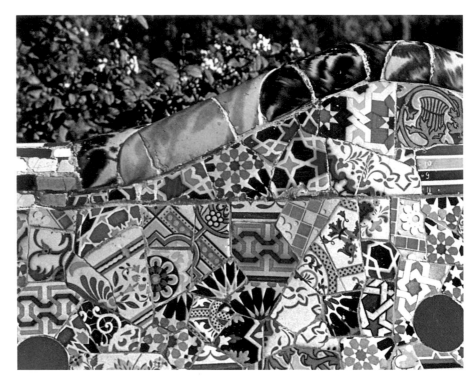

Right: Mosaic decoration at the Parc Güell include broken tiles and old crockery.

Below: The ceramic mosaic-covered 'snake-bench' in the Parc Güell, designed by Antoni Gaudí.

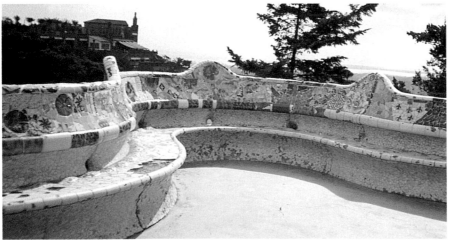

of the arts and architecture making use of colour and carving more for its effects.

EARLY PATRONAGE

Gaudí was fortunate enough to have an outstanding patron for much of his work in the local shipping magnate Don Eusebio Güell, whose wealth allowed for very ambitious schemes. Gaudí's development was slow at first: his first work was the Casa Vicens, a city mansion built between 1878 and 1880, in which the most striking feature was the two massive parabolic arches of the portals filled by wrought-iron railings and gates modelled on a pattern of palm fronds. This was some of the most free-flowing ironwork decoration seen before Horta and Guimard.

Five years later he started the Palacio Güell, an extravagant town house in which the decorative ironwork was accompanied by polychromatic glazed tiles and banded brickwork, and in which the first of Gaudí's twisted roof protuberances appeared.

The Chapel of Santa Coloma de Cervelló, begun in 1898, incorporated a fantastic, rather nightmarish interior in which the jagged asymmetry was enhanced by leaning monolithic pillars, uneven vaults and a variety of raw textures and materials. This theme was continued in the Parc Güell of 1900, while Gaudí took the principles of Art Nouveau to their architectural extreme in two apartment blocks begun in 1905, the Casa Battló and the Casa Milà.

THE PARC GÜELL

Perhaps inspired by the flowering of Art Nouveau in the rest of Europe, Gaudí's work of the 1890s began to develop into something unique, much more than just the sum of his early influences. Equally liberating must have been the scale on which he was invited to work by Güell.

A development of worker's houses did not get very far, but the centrepiece of a parallel scheme for a middle class neighbourhood, the Parc Güell, exists today as a municipal park. The Parc Güell could be seen as a rare opportunity for the *Modernismo* artist to display his art against its source. Since this was a landscaping commission, Gaudí was able to employ the stylised, sinuous forms of Art Nouveau against the very natural shapes of the trees and flowers that had, in part, inspired them.

Serpentine paths did indeed weave throughout the park, but the centrepiece was a vast covered market roofed under a forest of mas-

Above: The 'snake bench' frames a public space which is supported by a series of columns.

Left: Detail of the wall of Gaudí's Parc Güell. The whole complex was designed at the behest of local ceramics manufacturer, Eusebio Güell. Gaudí's solutions are as potent expressions of the Art Nouveau style as seen anywhere in Europe.

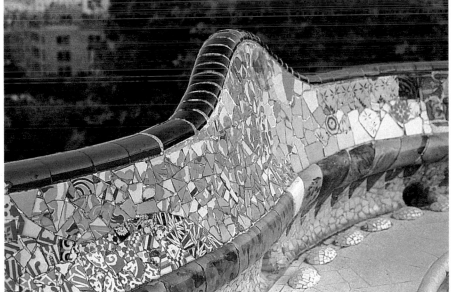

sive columns. On the plateau created above this area, Gaudí placed benches arranged in an almost continuous, undulating line from which the view of the city could be enjoyed. The backs of the benches were decorated with a mosaic of broken tiles arranged, either in patterns or haphazardly, to create a dazzlingly colourful display.

The same theme was continued on the roofs of the pavilions within the park, and, with further grottoes and concrete buttresses seemingly in the form of petrified treetrunks, the overall effect of the park is that of a strange mix of the subterranean and the maritime, perhaps appropriate for a city set between the sea and the mountains.

CASA BATTLÓ

The forms used within the fantastic realms of the Parc Güell have justly been likened to enormously magnified versions of the Art Nouveau creations of Horta and Guimard, amplifying the air of strange, in this case, oversized, biological mutations. An interest in polychromatic effects gained through a combination of media, as in the Parc Güell, was a frequent concern of Art Nouveau with characteristic ensembles of wood, metal and stained glass.

This interest was pursued by Gaudí in his Casa Battlo apartment block of 1905-7. The commission involved remodelling an existing block and the emphasis was inevitably on the facade. Gaudí had to contend with rectangular windows, already a part of the building and totally at odds with the shapes of Art Nouveau. In order to distract attention from them, as well as exploit the shimmering light

Left: The amazing and unique staircase of the Casa Battló with its bizarre vertebrae silhouette.

of a coastal city, coloured tiles were used again to create a flowing pattern throughout the facade, which was finished with a steep roof of titles coloured orange to blue-green. The brilliant colour effects enabled Gaudí to move away from the more symmetrically-composed facades of the neighbouring houses. By means of a rather exotic turret and the fabric-like folds of the roof, the Casa Battló also managed to rise above its companions in the street.

The base of the building was reworked by using a stone cladding whose flowing lines and softly modelled protuberances seemed closer to underwater life than to architecture. Some of the remaining windows on the upper storeys received bizarrely shaped iron balconies, somewhat resembling fish skeletons.

THE CASA MILÀ

While the Casa Battló was concerned with a rather two-dimensional presentation, the Casa Milà apartments, completely designed by Gaudí, received a much more plastic, virtually sculptural treatment. Rapidly named 'La Pedera' (the quarry) by the locals, Casa Milà seems to allude to many natural sources. Like a cliff face or a rock outcrop eroded by the wind into a collection of grottoes or tunnels, it seems to have been converted to human habitation only at some late stage in its history.

Even in plan, the Casa Milà appears like some cellular organism rather than the work of an architect, and the internal structure, was indeed, only resolved at a late stage by the use of partitions.

As Gaudí's career developed, it is possible that he increasingly abandoned architectural drawings and worked at first-hand with his

Right: The Casa Milà, with its wrought iron balconies that recall tangled seaweed.

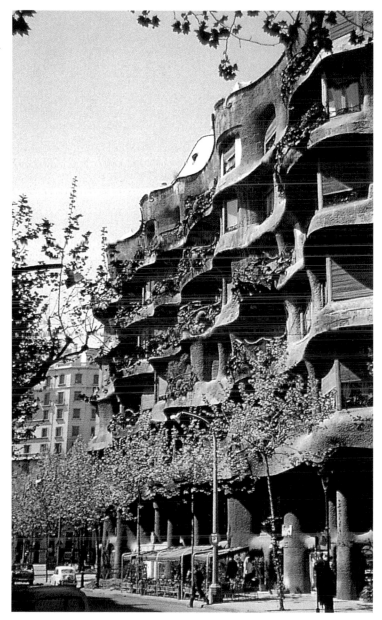

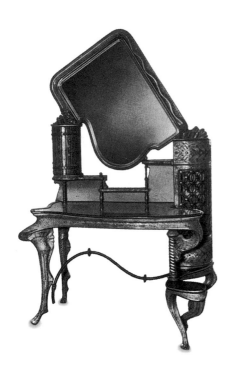

Above: Dressing table designed for the Palacio Güell, Barcelona by Gaudí, 1890.

Right: The honeycomb surface of the (still unfinished) Cathedral of the Sagrada Familia in Barcelona.

craftsmen, like a latter-day William Morris. Certainly he became much less reliant on iron and glass than Horta or Guimard, as is evident in the Casa Milà. Instead, the effect of erosion is produced by careful carving of each block of the stone facade. In total contrast to this softness is the ironwork of the balconies which is moulded into intricately twisted plant forms, like seaweed hanging from the cliff face before the next wave breaks upon it.

SAGRADA FAMILIA

Gaudí's great Barcelona church, the still-to-be finished Sagrada Familia, occupied him for his entire career, and like the Casa Milà, it is an example of extreme Art Nouveau fantasy enlarged into monumental three dimensions. It is also a typical combination of the reactionary and revolutionary, stemming from Gaudí's extremely devout Roman Catholicism, here given a form of unique novelty: Gothic seen through Art Nouveau eyes of the late 19th century.

GAUDÍ'S FURNITURE

For many of his buildings Gaudí designed equally extraordinary, idiosyncratic furniture. Among surviving examples are pieces designed for the Chapel of Santa Coloma de Cervelló, the Casa Calvet, built from 1898-1904 and for the Casa Battló.

The style of the furniture is consistent: organic 'shell-and-bone' forms are the most obvious. One extraordinary piece, (the authenticity of which is doubtful, however), is an ornate prayer stool believed to have been part of the furnishings for the Casa Battló. The rich 'acajou et bois de loup' base of the stool, with upholstered platforms for the knees and elbows, was surmounted by an edifice of stained glass embellished by five large gilt-

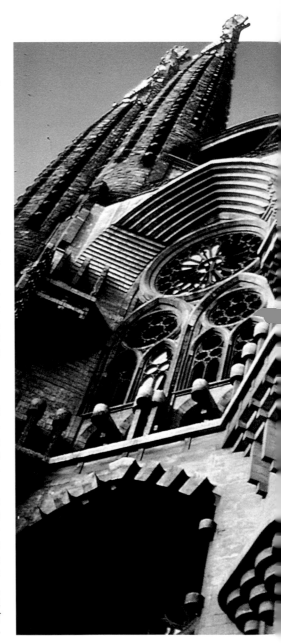

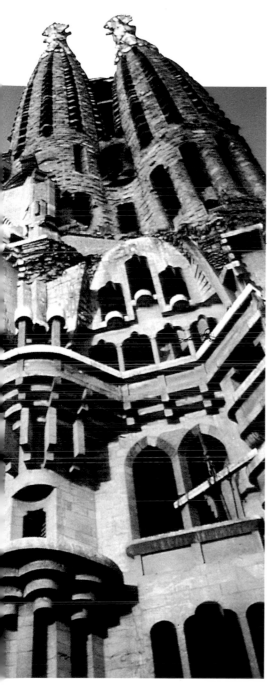

bronze roses. Although very Spanish in feel, the piece bears little resemblance to known examples of Gaudí's furniture.

ART NOUVEAU IN AMERICA

In the main, the decorative arts in America in the 19th century took their lead from Europe, whether from Greek classicism or Louis-Quinze, and these revivalist tendencies were also adopted in architecture. But the United States led the world in technical virtuosity and in the far-sightedness of many of its designers and patrons.

Contemporary movements in Europe tended to reach America somewhat anachronistically and haphazardly. The Gothic Revival of Ruskin reached America merely as a style to be adopted by a few designers, and lacked both the emotional and nationalistic fervour of the English movement. The opening up of Japan, however, and the resultant Aesthetic Movement, did capture America's artistic imagination.

ARTS AND CRAFTS IN AMERICA

By 1890 the most important foreign importation of style was the Arts and Crafts Movement of Morris and Ruskin. Many Americans had visited England and met Morris personally before returning home, fired with his ideals, dedicated to handicrafts and the rejection of the machine in art. Publications such as *International Studio, House Beautiful, The Ladies Home Journal* and *The Craftsman* spread the word to an even wider audience.

The Arts and Crafts Movement was important in America not only for the fine workmanship it encouraged from individuals, but also for the growing awareness it developed among Americans that they should also find a truly national art. But

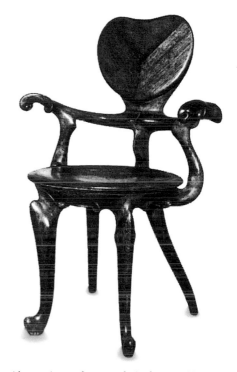

Above: A wooden armchair designed by Gaudí for the Casa Calvet, Barcelona, in 1902.

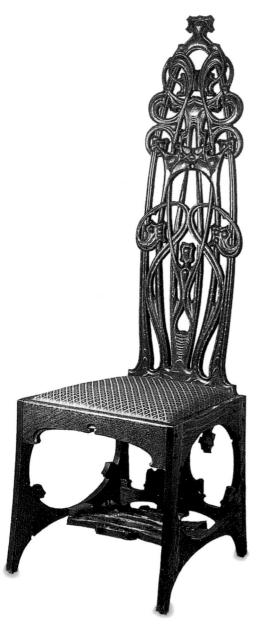

THE ROYCROFT SHOP IN EAST AURORA

Left: Oak chair by the American designer Charles Rohlfs, 1898.

Above: Print of the Roycroft Shops of Hubbard's crafts community in East Aurora, near Buffalo, New York.

the concepts of national art did, in fact, differ across the country. On the East Coast, Morris-inspired communities were founded and furniture and other decorative items were made which had a direct resemblance to the British movement. On the West Coast, however, the climate and the landscape led to different interpretations. Morris's romantic return to the medieval European past was supplanted in California by the recognition of its own past in Spanish-Mexican and Native American culture.

CRAFTSMEN COMMUNITIES AND WORKSHOPS
One of the first to assimilate European trends in design was Charles Rohlfs who opened a small workshop in Buffalo in 1890. His work reflects both the 'Mission Style' of California and Art Nouveau in elaborate carving and detailing, mainly in oak. Rohlfs often lectured at the Roycroft community at East Aurora, which had been started by Elbert Hubbard in 1895.

Roycroft was run along business lines, beginning with a press and book bindery, and gradually incorporating other crafts. Around 1901, the furniture shop was started. Solidly and honestly made, generally in oak or mahogany, early works were heavier versions of chairs by Morris & Co., while later pieces

resembled the Craftsman style of Gustav Stickley (1857-1942).

STICKLEY AND *THE CRAFTSMAN*

Following his debt to Ruskin and absorbing the principles of his architecture, in 1901 Stickley founded *The Craftsman* magazine in which he upheld the social aims of the British Arts and Crafts designers and called for a truly democratic national art. Stickley believed in a quasi-psychological view that more simple surroundings would lead to spiritual regeneration, especially in industrial cities, and his solid, severe furniture seems to reflect his social aims.

THE CHICAGO SCHOOL

A genuine American style was to be forged through the work of Louis Sullivan (1856-1924) and Frank Lloyd Wright (1867-1959) in Chicago. Sullivan had introduced Art Nouveau forms in a system of architectural ornament, holding that the outward form of a building should be expressive of its function. Sullivan's best work was for office buildings, but his ideas were taken and expanded by Wright into residential buildings.

Wright believed in integral design for his houses, and his furniture was designed to solve specific problems within a particular interior, as in the Hanna House where the polygonal furniture reflects the hexagonal design of the house. Each house also had a particular ornamental theme and any added decoration was to echo that chosen motif; decoration for Wright generally relied on positioning geometric shapes.

Perhaps the most important centre of Arts and Crafts activity was Chicago. In an area

Right: A cover of The Craftsman *magazine.*

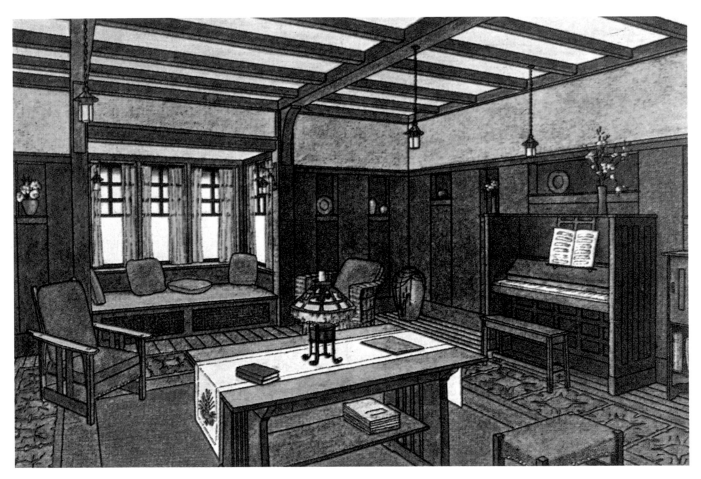

Above: A Craftsman living room as illustrated in the magazine, The Craftsman *which was founded by Gustav Stickley in 1901.*

most affected by frontier concepts, a style had to be evolved which no longer took its lead from the commercial and organisational centres of the East Coast, rooted as they were in European traditions. The Midwest relied on modern machines and means of communications for its survival, and could, even in the 1890s, ill afford to espouse the microcosmic ideals of the Arts and Crafts Movement. The

movement did, however, supply the impetus for a freedom of style.

LOUIS SULLIVAN

Louis Sullivan was the leader of the innovative group of architects based in the booming city of Chicago and his importance as a pioneer of 20th century architecture extends well beyond the isolated decade or so of Art

Above: Stickley is best known for his strong sturdy designs intended to evoke the 'simple life' of the early pioneers. This fall front, wooden desk is typical of his work.

Left: A redwood side chair by Frank Lloyd Wright for the Paul R. Hanna House (The Honeycomb House) in Palo Alto, California, 1937.

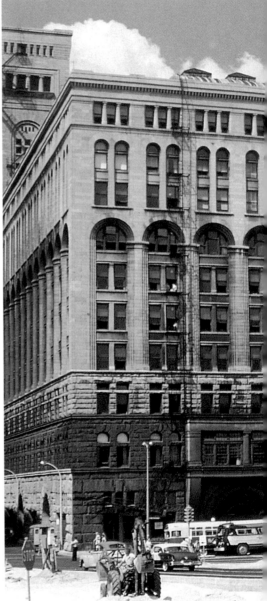

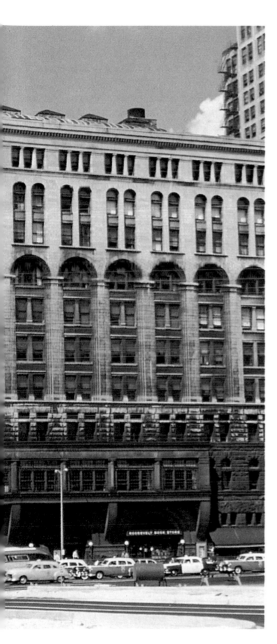

Nouveau. Sullivan led the movement towards the exploitation of the new steel-framed structures, which, with the development of the elevator, enabled him to produce some of the most successful early skyscrapers.

STRUCTURAL SKELETON

Sullivan's architecture is more concerned with expressing the structural skeleton of a building, by allowing a very simple grid-form to appear as the basic design, and by hollowing out the ground floor until it rests on just a few reinforced columns. These innovations of Sullivan's were eventually to become commonplace in modern architecture throughout the world.

ORNAMENTATION

Yet Sullivan remained very much a man of his time in his attitude towards the embellishment of his buildings. His theories on the subject were highly developed, and he saw the contrast between the rectilinear and the curvilinear as parallel to the division between intellect and emotion. Throughout his architectural career he tried to maintain a balance between the two.

The actual form of his ornament was often reminiscent of oriental abstractions from nature, but just as frequently he used more overt natural forms of intertwining leaves and branches which became very much a Chicago version of Art Nouveau: home-grown, but with very strong formal links with the style as it had developed in Europe.

The bar interior of the great Auditorium Building, a complex of opera house, hotel and offices, shows an opulence of detail and the involvement of the architect in every small feature which is characteristic of Art Nouveau. Nor was Sullivan averse to turning his bare exposed vertical beams, part of his grid facade, into rather exotic tree forms by using a flourish of foliage at the top, as in the facade of the Gage Building of South Michigan Avenue in Chicago.

More frequently, Sullivan preferred to contain very lush and flowing natural ornament within quite rigid limits, as in the Wainwright Building in St. Louis, where it serves to articulate the horizontal beams set against the plain verticals, and to embellish a very ornate cornice which caps the whole composition.

The natural forms of Sullivan's decoration not only recalled those of French Art Nouveau, but also had symbolic importance for him. The energy of organic growth was what Sullivan was attempting to evoke, and in particular, its application to the rapidly developing cities of America. Just as Art Nouveau was self-consciously the 'modern style', so Sullivan was attempting to create a powerful, growing architecture.

GOTHIC FANTASY

His Guaranty Building in Buffalo, New York, extends this Art Nouveau concern for growth beyond the decoration itself, into the structure as a whole. Linked by arches at their peak, the great verticals of the building seem to be enormous stems pushing up to the cornice which curls over in a gentle curve reminiscent of growing form. In this case, the

Far left: In structure, Louis Sullivan's Carson, Pirie Scott department store in Chicago, Illinois, anticipates much of 20th century architecture.

Left: Louis Sullivan's Auditorium Building whose austere facade contrasts with the lavishness of some of the interior decoration.

ornament makes the analogies more explicit.

Sullivan's last work, the then Carson, Pirie & Scott department store in Chicago, seems for the main area of the facade to be too plain for any reference to Art Nouveau to be made, yet in the first two storeys, and particularly around the corner entrance, there is relief work of Gaudí-like extravagance, which, even in this unlikely context, recalls Sagrada Familia. This seems largely based on an elaborate Gothic fantasy, yet its tense spider web lines and twisting foliage can ultimately only be seen as a personal Art Nouveau composition.

Left: The decorative metalwork over the Carson, Pirie Scott store recalls the florid exuberance of Art Nouveau.

Art Nouveau Jewellery and Metalwork

Hallmarks of
Art Nouveau

Art Nouveau, which means 'new art', seems an appropriate description for an art movement that bridges the psychological gap between the 19th and 20th centuries. As the 1900s dawned the historicism inspired by the Arts and Crafts Movement began to give way to a new, forward-looking approach. Art Nouveau, which spanned the period roughly from 1895 to 1905, was caught between the joint influences of the old and new and, stylistically, owes something to each. Many designers and craftsmen seeking new sources of inspiration, looked back to earlier times and outwards to exotic cultures and with new methods of production and novel materials, they created exciting new objects d'art.

Far left: A peacock corsage ornament, c.1898-99 in gold, enamel, opals and diamonds by René Lalique.

Below: Wrought iron from the staircase of Horta's Hotel Solvay in Brussels.

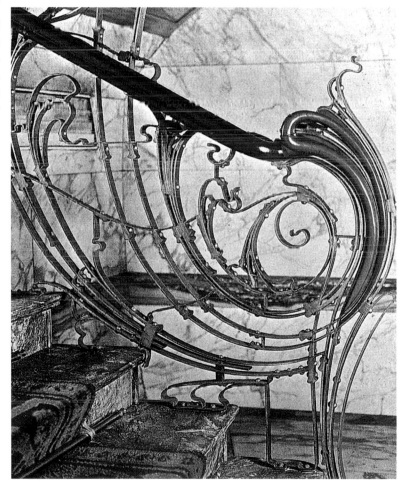

SYMBOLISM

One of the major influences on Art Nouveau was the Symbolist movement which had begun in the 1880s in reaction to the optical realism of the Impressionists. The Symbolists sought to depict the 'idea in sensuous form' and, in protest against the increasing industrialisation of society, drew their subject matter from legend, literature, religion and even the occult. Distinguished by a shared attitude rather than a common style – the movement included artists as diverse as Gustav Moreau, Odilon Redon, Puvis de Chevannes and Ferdinand Khnopff – Symbolist paintings recorded not the observation but the sensation. In both the aim to communicate emotion, and in the subject matter employed to do so, much Symbolist art is closely allied to Art Nouveau: the use of undulating line, the many representations of the nude female figure with, long flowing hair, insects, peacocks, flowers and water-inspired iconography.

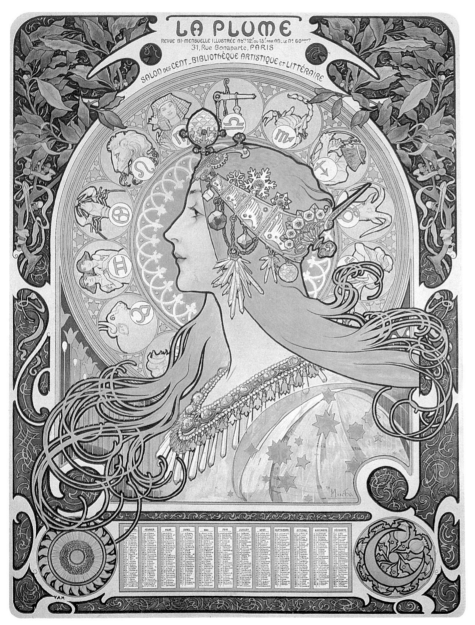

The decadent elegance of Symbolism was in many places, to become the hallmark of Art Nouveau: it informs the graphic work of Alphonse Mucha, the glass of Emile Gallé, the jewellery of René Lalique, the ironwork of Hector Guimard and the furniture of Louis Majorelle. But the flowing, flaring asymmetrical lines, and the motifs largely drawn from nature and natural forms employed by Art Nouveau designers were also linked to a variety of different sources.

INFLUENCES FROM ENGLAND

Many of the origins of the Art Nouveau style are to be found also in Victorian England. Here, one discovers not only the sinuous decorative line that was to characterise the appearance of Art Nouveau, but also many of the ideas that were to become its theoretical base.

The Great Exhibition of 1851 held in the Crystal Palace in London's Hyde Park, had been intended not only to demonstrate new technology and promote international trade, but also to advertise what were generally held to be the finest examples of design. The standards of the exhibits on display, however, were to attract a great deal of harsh criticism, from the influential writer and art critic, John Ruskin in particular.

Ruskin hated the mass-produced and shoddily made products that he had seen, and called for a return to craftsmanship. This was largely inspired by a somewhat romantic vision of the Middle Ages through which Ruskin hoped to develop an alternative to the horrors of factory labour and in which he saw as a means of improving the quality of everyday objects.

Above: La Plume calendar by Alphonse Mucha. The jewels recall his work for Fouquet.

Ruskin advised craftsmen and designers to look to nature for their forms and cast off the historical forms common in Victorian revivalism.

MORRIS AND CO.

Ruskin's ideas were taken up by William Morris who as a student had developed a profound affection for the culture of the Middle Ages – not only its architecture, art and craft, but also the artistic co-operation which had fostered their creation. At Oxford, Morris met several others who shared his passion: the architect Philip Webb and the painters Edward

Burne Jones and Dante Gabriel Rossetti, who were later to become members of the Pre-Raphaelite group.

In his attempt to recreate a medievally-inspired idyll of artists and craftsmen working together on the same tasks, Morris founded a company in 1861 to produce the types of objects he wanted to see in very home. This became Morris and Co. and by employing his Pre-Raphaelite friends to design and decorate furniture, textiles and furnishings, Morris's company was able to produce a complete range of products to furnish a home in a uniform

Above: Cabinet decorated with scenes from the life of St George painted by William Morris. The medievalism of the piece is typical of the furniture produced by Morris & Co. during the 1860s.

Right: Christening mug for Lord David Cecil (1902) produced by the Guild of Handicraft.

style that achieved an overall harmony of effect.

The appearance of the goods made by Morris & Co. was reminiscent of medieval models but the style was also largely derived from natural sources inspired by plant, bird and animal forms. The use of hand-crafted, natural materials, however, inevitably made Morris's goods too expensive for ordinary people, but his example encouraged a number of similar groups of designers to develop. These are generally referred to under the name of the Arts and Crafts Movement.

THE CENTURY GUILD

One of the most important of these enterprises was the Century Guild founded by Arthur Heygate Mackmurdo in 1882. Mackmurdo developed the natural forms that had inspired Morris into elongated, increasingly elegant lines and patterns, and as such, was the first to produce the characteristic vocabulary of Art Nouveau. The new style made its first appearance in the title page design of Mackmurdo's book, *Wren's City Churches,* and the sinuous, rippling pattern of the plants as if they are underwater, were to be the hallmark of the Art Nouveau style for the next two decades.

The theme was rapidly developed by the Century Guild and a number of other bodies such as the Art Workers' Guild founded by Walter Crane and Lewis Day in 1884, and Charles Ashbee's Guild of Handicraft founded in 1888.

THE GUILD OF HANDICRAFT

The work produced by the Guild was simple in design. Its metalwork, in the form of jewellery, flatware, plates and vases was, again, often inspired by medieval sources, with the addition of semiprecious stones and decora-

tive devices. Ashbee was one of the first de-
signers in the Arts and Crafts Movement to
experiment in jewellery.

Initially, there were few trained jewellers
involved in the Guild, though many of the
craftsmen involved were experienced metal-
workers in copper and silver. Ashbee's own
designs were in part inspired by the Celtic
Revival which encouraged the use of Celtic
inspired interlaces and coloured enamels, and
in part by the work of Benvenuto Cellini, per-
haps the greatest goldsmith of the Italian
Renaissance. To these sources, Ashbee added
motifs of his own and produced a range of
metalwork and jewellery that included cov-
ered cups, salvers and ceremonial spoons, and
brooches, buckles, necklaces and even but-
tons decorated with peacocks and flowers, and
enhanced with blue and green enamels and
semiprecious stones.

SPREADING THE STYLE

Public interest grew, largely due to the exhi-
bitions of craftwork organised by the Arts and
Crafts Exhibition Society and the widespread
publicity given to the Arts and Crafts Movement
by art journals such as *The Studio*. The busi-
ness of Liberty & Co., established in 1875 by
Arthur Lazenby Liberty, modified the hand-
icraft guild's original ideal of solely produc-
ing hand crafted goods into another direction
by exploiting both markets and machinery.
Technically, Liberty's factory made commer-
cial products, and although some were hand
finished, they cannot be deemed Arts and
Crafts. Yet many of their designs relate to the
spirit and style of the movement. Liberty &

*Right: A late 19th-century silver and
chrysoprase bowl on stand by C.R. Ashbee.*

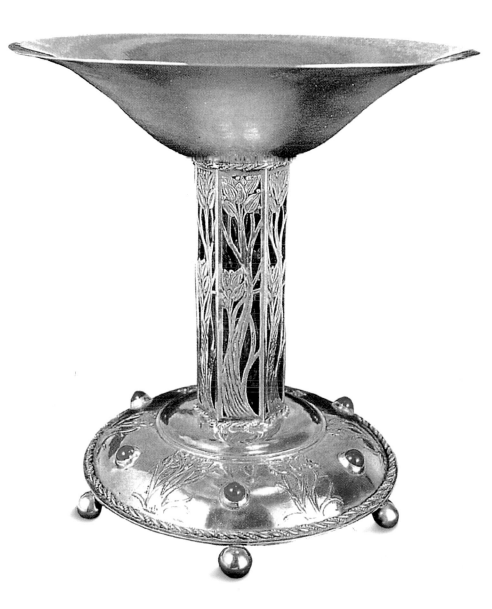

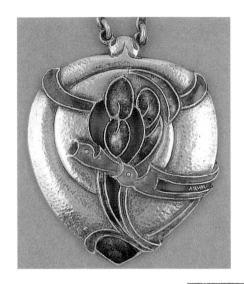

Co. managed to produce and distribute couture, fabrics, furnishings, metalwork, jewellery and furniture to a wider public than either Morris or his followers. Despite the fact that individual handicraft and creative expression often disappeared under Liberty's policy of anonymity for his designers, his employees did include some of the most prominent names in the Arts and Crafts and Art Nouveau design of the time: Charles Voysey, Jessie M. King, Arthur and Rex Silver, Georgina and Arthur Gaskin and Archibald Knox.

ART NOUVEAU ABROAD

This mixture of commerce and art was not restricted to England. The term 'Art Nouveau' itself in fact derives from the Parisian shop of the same name run by a German émigré, Samuel Bing. Bing had been trading for some years in Oriental art and in 1888 had launched a monthly magazine, *Le Japon Artistique*. Japan was a relatively new discovery for the west, having been opened up to trading by the American Commodore Perry as recently as 1853. Artists such as Gallé, Lalique and Tiffany owed a debt to this 'japonisme'.

The formal links between Japanese art, in particular, Japanese prints and Art Nouveau are strong: the emphasis on decorative line, creating flat, patterned work and the delicate balance between decoration and background were immediately found to be sympathetic. The curving, flowing Japanese line was drawn from observation of nature, filtered

Above: A pendant in enamelled silver by Jessie M. King for Liberty & Co. c.1902.

Right: Print by Hiroshige. The Japanese use of expressive line and a combination of simple flat shapes inspired the painters and designers of late 19th century Europe.

Far right: A lady's sitting room in Bing's Pavillion de l'Art Nouveau, by Georges de Feure, 1900.

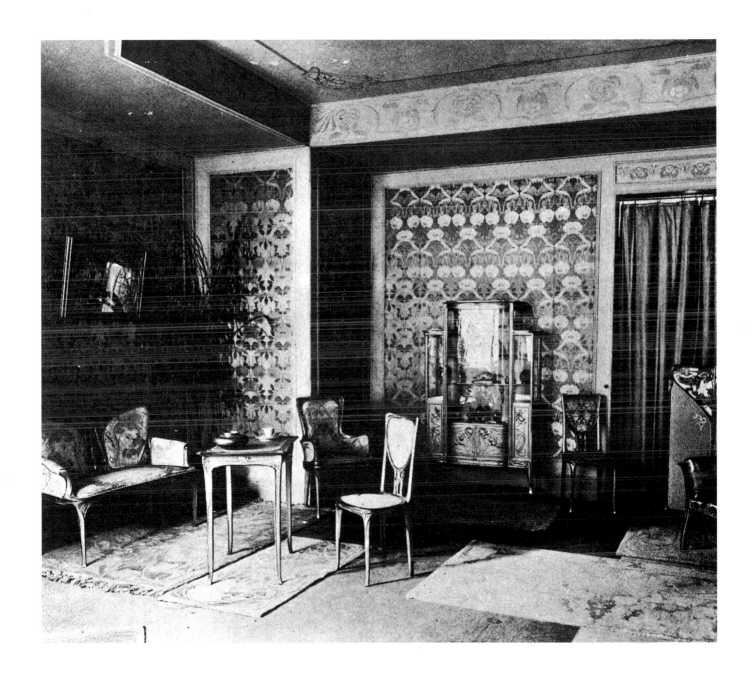

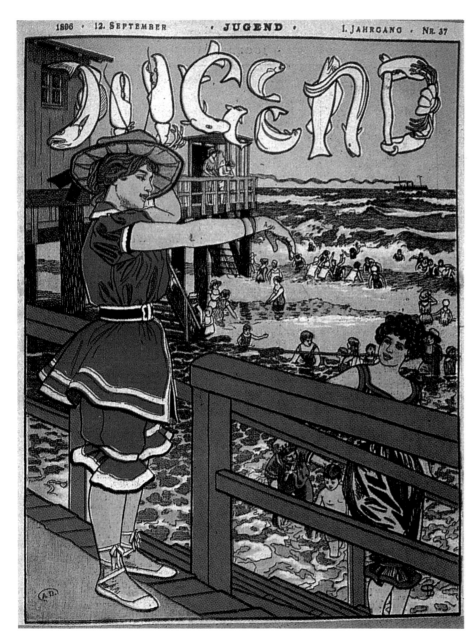

Left: Jugend *magazine, the German journal established in 1896.*

through a developed design sense to create more abstract forms and patterns with the precise degree of artificiality that the Art Nouveau artists found so appealing.

LA MAISON DE L'ART NOUVEAU

When he re-launched his shop as La Maison de l'Art Nouveau in 1895, Bing exhibited the work of contemporary designers and artists including Tiffany, Aubrey Beardsley, René Lalique and Emile Gallé. Bing's mixture of gallery and shop was to become the Paris base for the new style of Art Nouveau and his reputation was sufficient for him to be allotted an entire pavilion at the Paris Exposition Universelle of 1900.

International exhibitions throughout the 19th and early 20th centuries became an increasingly important feature of international commerce and in the dissemination of the new style. The depth of interest among the public in new fashions in decorative art were also reflected in a growing number of magazines and periodicals devoted to the new trends.

VARIATIONS ON A THEME

In Germany, the influential Munich-based journal *Jugend* would lend its name to the German version of Art Nouveau, *Jugendstil*. Sometimes here the style was also called 'Studiostil' after the widely read English, and later American, periodical *The Studio*. In 1907 the *Deutsche Werkbund*, partially inspired by British Arts and Crafts models, was formed by Henry Van de Velde and Hermann Muthesias to promote an alliance between art and industry. The *Werkbund* was not only interested in applying good design principles,

but also in educating the general public to appreciate these principles. Their ultimate goal was to shape the economic and cultural identity of Germany.

AUSTRIA

In Austria the leading organs for Art Nouveau were the periodical *Ver Sacrum* and the members of the *Wiener Werkstätte*. The search for a new style at the beginning of the century was led by Josef Hoffmann and the members of the Secessionist group founded in 1897. The main objective of this group was to improve the status of the decorative arts and in 1903 they established the *Wiener Werkstätte*, a small colony of artists who wished to promote the

Above: A teaset designed by Josef Hoffmann in typical Wiener Werkstätte style. The forms are more traditional than most Art Nouveau ceramics.

Right: A Viking wood carving in an intricate interlaced design.

Far right: A bronze fitting from a Celtic chariot in the form of a horse's head. The combination of stylisation and natural inspiration typified Art Nouveau itself.

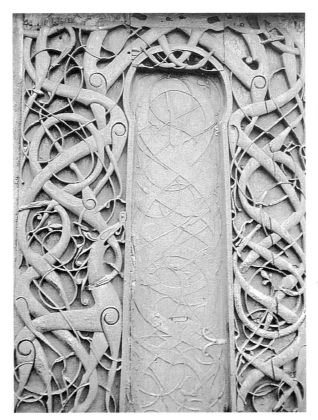

individual creativity of the designer.

NORDIC COUNTRIES

In their search for an aesthetic formula that was in keeping with their cultural traditions, the Nordic countries of Sweden, Denmark, Finland and Norway also drew on the idealised democratic principles of craft production espoused by Ruskin and Morris. Returning to their own indigenous folk art for inspiration, the intricate curves and spirals of this tradition found their way into the local form of Art Nouveau that was even occasionally called the Dragon Style in deference to its Viking sources.

In America, as in England, the Arts and Crafts Movement inspired many individuals to turn to the professional practice of their particular craft. The Arts and Crafts Movement was important in America not only for the fine workmanship it encouraged, but also for the growing awareness it fostered among Americans of the need for a truly national art.

Much of the vitality of Art Nouveau is derived from these and other various centres. Paris and Nancy in France, Munich, Berlin and Darmstadt in Germany, Brussels, Barcelona, Glasgow, Vienna, New York and Chicago were all focal points for a style that was capable of accommodating diversity in regional variations.

ART NOUVEAU JEWELLERY IN FRANCE

Above: Pendants in gold and diamonds. Two anonymous examples of Art Nouveau design featuring the 'femme fatale'.

Overleaf: A gold and enamel belt buckle. French, from around 1900.

The standards of French craftsmanship in the area of jewellery were extremely high, and perhaps unrivalled in any other country. In a period rich in its constant variety of invention, the tastes in jewellery were susceptible to the vagaries and whims of fashion, and serve as an expressive mirror of the period, reflecting the hot-house decadence of the fin-de-siècle. In France, Art Nouveau jewellery had its origins in the work of the French goldsmiths whose creations were to become the inspirations for other European craftsmen and women. The most influential among the French artist-jewellers was undoubtedly the glass maker René Lalique.

ART NOUVEAU JEWELLERY

Most characteristic of Art Nouveau is a tendency to asymmetry, producing a sense of instability which is heightened by the use of the whip-lash curves and tendril forms. Another ubiquitous image is of woman, either in the form of the *femme-fleur* (woman as flower) or the dangerous, man devouring, *femme fa-*

Left: The more traditional style of jewellery seen in a matching bracelet and pendant from c.1835 in gold, diamonds and garnets.

tale. Much of the imagery in Art Nouveau comes from mythology, whether in the form of winged serpents, the gothic horrors of bats and vampires, or more ethereal creatures, such as peacocks, butterflies and dragonflies.

GOLDSMITHING IN FRANCE

The goldsmith's work that was produced in France, and throughout most of the west before the Art Nouveau period essentially followed a long established line of classical, baroque and Rococo jewellery. It was opulent and ostentatious, and often rather unimaginative, although one principle that many of the turn-of-the-century goldsmiths did adopt was of the jewel as a miniature work of art. On the whole, goldsmiths generally subjugated whatever innovative talents they might have had in favour of manipulating the precious gems that were at their disposal, namely, the diamond. In the wake of South Africa's 'diamond rush' of the 1860s, there was a strong demand for cut diamonds throughout Europe and America, and most goldsmiths tended to work exclusively with these cut stones.

Above: Grasshopper necklace, with horn and pearls, c.1902-04. A popular motif in Art Nouveau, the grasshopper appeared on several Lalique jewels.

viously under-utilised, even scorned 'lesser materials' like glass, horn and tortoiseshell, with rare gems and metals, (such hybrid confections are called 'bijouterie', as distinguished from all-precious 'joaillerie') as well as his use of natural, fantastic, neo-classical and literary images in a sublime way, makes his work an outstanding achievement in the history of Art Nouveau and in the goldsmith's art. Lalique did not forsake precious stones like diamonds, sapphires and topaz altogether, but it was his genius to rediscover semiprecious coloured stones such as opal, chalcedony, agate, jade, chrysoprase and moonstone and to use them in exciting combinations with pearls, translucent, opalescent champlevé and *plique-à-jour* enamels.

LALIQUE'S CAREER

Lalique's background was the perfect blend of art and craft. In 1876, at the age of 16, on the death of his father, Lalique was apprenticed to the celebrated goldsmith Louis Aucoc, whilst simultaneously pursuing his studies at the Ecole des Arts Decoratifs in Paris. Aucoc was a high-priced goldsmith whose wealthy and modish clientele demanded exactly what was fashionable at the time. This was primarily neo-Rococo jewellery with heavy and showy cut gems dominating their precious metal settings that was neither technically nor stylistically innovative.

A two year period of study in England, at Sydenham School of Art at Crystal Palace in south London, completed his education, and on his return to France in 1880, he found that the Parisian climate was becoming more sympathetic to the creation of finely crafted objects d'art. In the midst of the machine age, interest had been reawakened to in individual workmanship, an echo of the Arts and

LALIQUE AND JEWELLERY

The jewels of Lalique are among the richest and most telling of all Art Nouveau creations. The myriad brooches, pendants, necklaces, diadems, lorgnettes, hair combs, watch cases and other bijouterie bearing this master's signature comprise a single oeuvre shaped by a vivid imagination and honed by virtuoso technical skills. Lalique's innovative combination of pre-

Crafts Movement that Lalique had witnessed in England.

Lalique worked freelance for the prestigious houses of Cartier, Boucheron, Renn, Gariod, Hamelin and Destape. By 1885 he had taken over Destape's workshop and in the following five years, had expanded the premises. Although he had been exhibiting his jewels as early as the Exposition of 1889, (anonymously, under the names of the large companies for which he was freelancing) it was not until the Paris Salon of 1894 that Lalique displayed his work under his own name. Immediately, he won lavish praise and gained numerous commissions from the 'grandes dames' of the Third Empire. Lalique was well on his way to becoming the most prominent master in his field.

Having opened his own firm, Lalique was free to design jewellery as he wanted, without any restrictions from employers or clients. His designs, which were regularly reproduced in the trade magazine *Le Bijou*, inspired both praise and imitation from numerous colleagues including Alphonse Fouquet and his son, Georges, who took over his father's firm in 1895 and became a well-known Art Nouveau jeweller.

SARAH BERNHARDT

By this time Lalique had already begun to design jewels for his most famous female client, the actress Sarah Bernhardt, and it was she who provided Lalique with the opportunity to apply his talent to relatively large-scale, often audacious, pieces that could be easily seen by the theatre audiences she performed to. Bernhardt commissioned luxurious diadems, necklaces, belts and other stage 'props' which he tailored perfectly to the roles she was playing, such as the Theodora crown of 1884, and

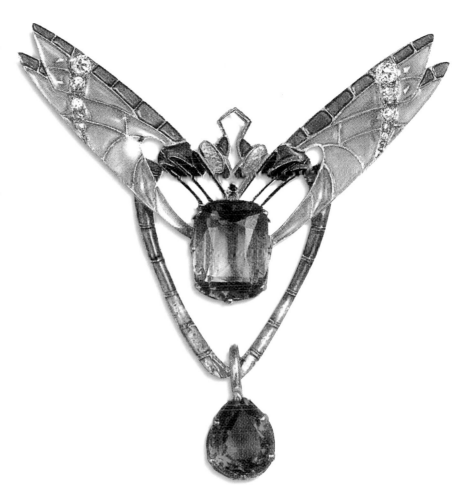

parures for the parts of Gismonda and Iseyl.

Despite the boldness of his theatrical extravagances, Lalique's ruling notion was that a jewel worn by a woman should contribute to the harmony and total effect of her entire ensemble. The stage pieces for Bernhardt and the 140 or so 'museum-pieces' designed for the collector Calouste Gulbenkian, which were never intended to be worn, were exceptions

Above: Lalique pendant brooch in diamond and tourmaline offset by rich plique-a-jour *enamel.*

Right: Lalique's studies for pendants and brooches of dragonflies and butterflies as decorative devices.

Below: A medallion by Lalique of the actress Sarah Bernhardt, c.1900.

to this rule, and they were outnumbered by hundreds of subtler, though no less striking, pieces of bijouterie he produced.

OFFICIAL RECOGNITION

Throughout his three decades as a goldsmith, Lalique continually experimented with new materials and new techniques. He used horn in place of tortoiseshell and elevated that material to a near-luxury status; he employed embroidery techniques on metals, and applied enamels to a variety of surfaces. As his reputation grew, his rebellion against the more usual proliferation of diamonds in joaillerie came to be officially approved by the board of jewellers. By order of the Chambre Syndicale de la Bijouterie de Paris, the use of precious stones or materials alongside semi-precious or 'vulgar' stones and materials was officially sanctioned for the first time.

Without a doubt, the Exposition Universelle of 1900 in Paris, which welcomed the dawn of the new century and commemorated the 30th anniversary of the Third Republic with displays of recent technological achieve-

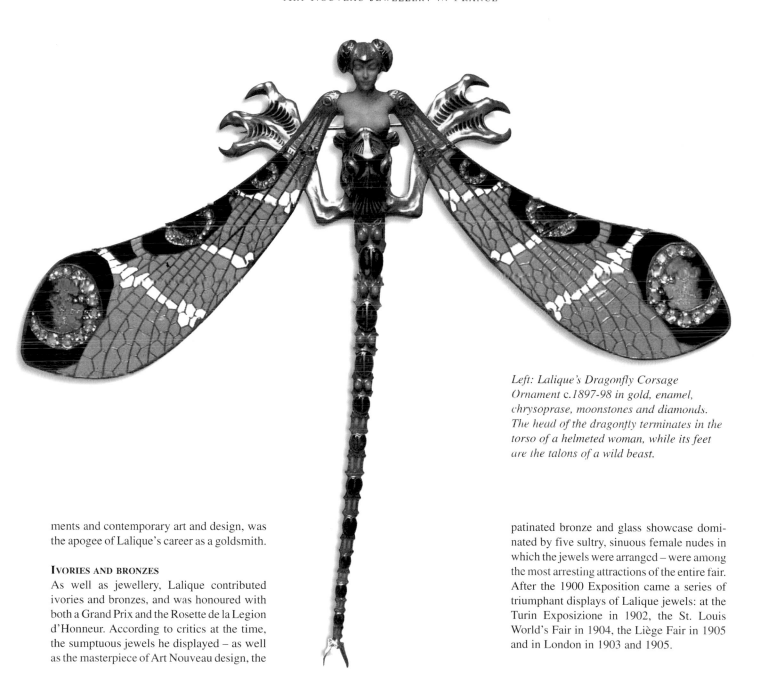

Left: Lalique's Dragonfly Corsage Ornament c.1897-98 in gold, enamel, chrysoprase, moonstones and diamonds. The head of the dragonfly terminates in the torso of a helmeted woman, while its feet are the talons of a wild beast.

ments and contemporary art and design, was the apogee of Lalique's career as a goldsmith.

IVORIES AND BRONZES

As well as jewellery, Lalique contributed ivories and bronzes, and was honoured with both a Grand Prix and the Rosette de la Legion d'Honneur. According to critics at the time, the sumptuous jewels he displayed – as well as the masterpiece of Art Nouveau design, the

patinated bronze and glass showcase dominated by five sultry, sinuous female nudes in which the jewels were arranged – were among the most arresting attractions of the entire fair. After the 1900 Exposition came a series of triumphant displays of Lalique jewels: at the Turin Exposizione in 1902, the St. Louis World's Fair in 1904, the Liège Fair in 1905 and in London in 1903 and 1905.

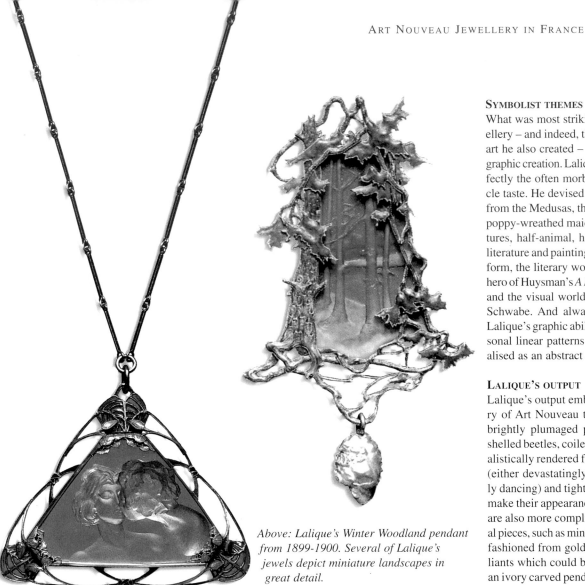

SYMBOLIST THEMES

What was most striking about Lalique's jewellery – and indeed, the multi-media works of art he also created – was the fertility of their graphic creation. Lalique's motifs reflected perfectly the often morbid aspects of fin-de-siècle taste. He devised refined, graphic designs from the Medusas, the Ophelias, the drugged, poppy-wreathed maidens, the grotesque creatures, half-animal, half-human, of symbolist literature and painting. He froze into jewellery form, the literary world of Des Esseintes, the hero of Huysman's *A Rebours* (Against Nature) and the visual world of Khnopff, Redon and Schwabe. And always, whatever the motif, Lalique's graphic ability created distinctly personal linear patterns that could also be visualised as an abstract art in themselves.

LALIQUE'S OUTPUT

Lalique's output embraces the entire repertory of Art Nouveau themes and inspirations: brightly plumaged peacocks and glistening shelled beetles, coiled enamelled serpents, realistically rendered flowers and trees, women (either devastatingly devouring or innocently dancing) and tightly embracing couples all make their appearance in his jewellery. There are also more complicated, multi-dimensional pieces, such as miniature wooded landscapes fashioned from gold, enamel, opals and brilliants which could be attached to a collar; or an ivory carved pendant of a horseman whose steed tramples a nude below, with the entire scene surrounded by three equine heads with stylised manes. Like many of the painters of the second half of the 19th century, such as Whistler, Klimt and some of the Pre-Raphaelites, Lalique created both the work of art and the frame enclosing it, a concept that was revolutionary in the goldsmith's art.

Above: Lalique's Winter Woodland pendant from 1899-1900. Several of Lalique's jewels depict miniature landscapes in great detail.

Left: Lalique's 'The Kiss' pendant, 1904-05. Similar kissing couples appear on other works.

MOTIFS FROM NATURE

The subjects Lalique chose for his bijouterie mostly came from nature. At a young age he had been a shrewd observer of flowers, trees and animals in all their guises and stages of growth. Lalique's floral vocabulary is perhaps his richest, and in the main, the most faithful to nature. Works ranged from a simple hatpin consisting of three silver birch leaves in horn, their gold seed cones enamelled in a complementary autumnal hue, to a bracelet of five, bluish-violet champlevé enamel irises on gold, all on a carved opal background, as well as a lovely diadem in the shape of an apple tree branch which, but for its composition of horn, gold and diamonds, might just have fallen from the tree.

Flowers and other plant forms are displayed on various brooches, bracelets and pendants, though more often than not, these also incorporate insect or other animal life. The animals Lalique depicted in his jewels spanned nearly all the species of the zoological kingdom from grasshoppers to polar bears, to mythi-

cal dragons, sphinxes and bizarre hybrid beasts. Insects, amphibians, reptiles, birds and mammals were all subject to his scrutiny and his craftsman's technique. There was a decided emphasis on creatures favoured by all Art Nouveau designers: the curvilinear swan, seahorse and snake; the brilliantly hued butterflies, peacocks and beetles, as well as more fearful creatures of the night, like bats and serpents.

The snake is one of the strongest subjects in Lalique's Art Nouveau repertory, and the masterpiece among his 'serpent jewels' is the Knot of Serpents pectoral from 1898 comprising nine interlacing snakes whose silver gilt champlevé enamel bodies of blue, green and black fan out from a top knot, their jaws agape. Originally, each serpent was represented as spitting a row of baroque (misshapen) pearls out of its mouth.

BIRDS

Birds of various types – but especially peacocks, roosters and swans – figure in Lalique's

Above: A thistle-inspired pendant by René Lalique.

Below: Rose branches corsage ornament by René Lalique in gold, glass, amethyst and enamel.

Above: The Knot of Serpents corsage ornament, the masterpiece among Lalique's jewels.

jewellery designs as they do in his glass. One of his best known jewels (and perhaps one of the most unwieldy) is the diadem in the shape of a cock's head. Never before in western art and design had such a lowly barnyard fowl been treated so luxuriantly. The cock's golden beak grasps an amethyst and its open-work gold and enamel comb is as delicately wrought as a spider's web. The cock motif was one that Lalique obviously found interesting for it also appears on a belt buckle. Here two cock's heads in enamelled copper are placed in profile, beak-to-beak.

The peacock had been a motif popular with artists from the Aesthetic Movement such as Whistler, but designers such as Morris and Tiffany chose to depict only its brilliantly hued feathers, often to the point of near abstraction. Lalique however, was eager to display the bird in all its glory. He created a stunning chest ornament in which the bird's enamel and gold tail feathers, richly studded with opals, swirls around its body in a bow-like pattern.

FEMALE FIGURES

The figure of woman also stands out in Lalique's work. Indeed it is she, almost to the total exclusion of the male sex, that dominates Art Nouveau. She appears as the long-haired seductress or the flower-crowned innocent. Lalique is believed to be the first goldsmith since the 16th century to represent the female nude in jewellery, and he did so frequently. He carved them in ivory and coupled them in erotic dances; he veiled them in vines and blossoms and he represented them as shameless pagan nymphs sometimes paired with birds and beasts, and even, the occasional male figure!

Lalique's female figures are not always nude: there is Ophelia reclining under a wil-

low tree, angels deep in prayer, regal women with strongly carved profiles, Breton peasants in traditional costume. And even when he does not depict women directly, her spirit is often present, for the animals, plants and flowers he used were often Symbolist allegories of woman in her various guises.

LITERARY INFLUENCES

On occasion Lalique interpreted literary characters. The Owls bracelet from around 1900 was inspired by the poem 'Les Hiboux' from *Les Fleurs du Mal* (The Flowers of Evil) by the Dandy-poet Charles Baudelaire. Along a five part gold frieze, four moulded frosted-glass

Above: A belt buckle in the form of two cockerels' heads by Lalique. Enamel on copper and gold clasp, c.1900.

Below: A bracelet with figures of women in intaglio-moulded glass, diamonds, gold and enamel by Lalique c.1895.

Bottom: The Owls Bracelet by Lalique c. 1900-01, inspired by Charles Baudelaire's poem, 'Les Hiboux'.

owls, symbols of darkness and the night, are perched among pine cones and branches. A collar of 16 strands of tiny pearls surrounding a central rectangular plaque that features a profile of a smiling young woman, may well tell the story of the Frog Prince, for her head is crowned with a huge green enamel frog, while a host of frogs fill the open work field surrounding her. Most of Lalique's creatures are, however, without specific literary allusion and can be appreciated for their sheer beauty, the delicacy of their execution and the imaginative way in which the elements are arranged.

JAPONISME

The combs, diadems and other hair ornaments that Lalique produced, mostly of horn embellished with gold, enamel, ivory, glass and stones, are the most realistically nature-laden of his works. In these designs, Lalique was strongly influenced by the irregular design system of flowers which characterised japonisme. The borrowed Oriental style was, thanks to Samuel Bing's efforts in bringing it to public attention, in vogue at the turn of the century.

GULBENKIAN COLLECTION

One comb in the Gulbenkian collection, Wisteria, exhibits a device often used by Lalique: certain carved areas are left 'blank', that is, in their original hued state, whereas other primary areas are built up or emphasised by means of vividly coloured enamels. One of the most obvious borrowings from Japanese art is a necklace from 1890 made of nine spherical *ojime* in ochre lacquer carved with a stylised wave motif and embellished with mother-of-pearl insets. *Ojime* are part of the traditional Japanese costume and are bell-shaped toggles which separate the little seal container called *inro* from the carved *netsuke*

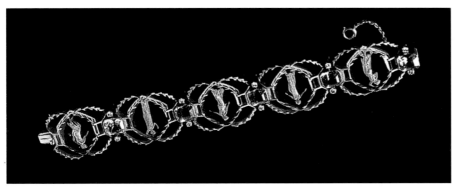

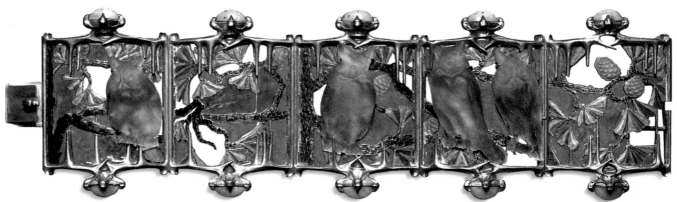

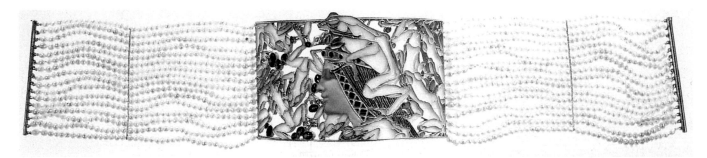

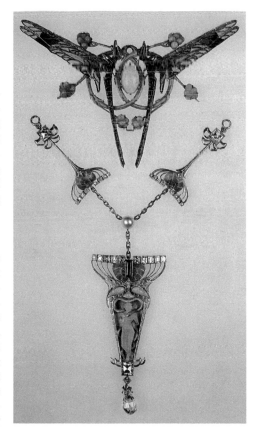

Above. Dog collar depicting the 'Frog Prince' in gold, enamel, glass and pearls by Lalique, c.1900.

Right: A delicately enamelled dragonfly hairpiece by Lalique set against a pendant by Philippe Wolfers.

from which it hangs. In Lalique's piece, the *ojime* beads alternate with 20 pairs of dark green enamelled twisted links. Noteworthy not only for its obvious borrowing of Japanese forms, the necklace also translates the common Japanese motif of crested waves into the curvilinear Art Nouveau vocabulary.

GOLD

Looking at the extensive and varied output of Lalique's career as a goldsmith, it is not difficult to understand that there was a talented genius at work. An innovator, arbiter of taste and perfectionist, Lalique the Art Nouveau jeweller was all these and more. But during the years that he was establishing his reputation in bijouterie, Lalique was feeling the pull of another challenge in a material that he had already begun to incorporate into his jewellery, namely, glass. The possibilities for endless shapes, colours and shadings in this material were endless and he was eventually to devote himself fully to its production. Amazingly, after just a few years, the most acclaimed goldsmith at the 1900 Exposition Universelle in Paris was to become the *maître-verrier* of the 20th century.

LALIQUE'S FOLLOWERS

Writing in *Les Modes* in 1901, the critic Roger Marx noted that Lalique had laid open new and unknown possibilities for jewellery, and that the evolution of design in that area owed its sole debt to him. Lalique's work did indeed inspire a number of designers at the turn of the century in Paris. The brothers Paul and Henri Vever and Lucien Gaillard were among the most gifted.

INHERITORS

The Vever brothers were the inheritors of a family business and first attracted attention at the 1900 Exposition Universelle. They exploited the style and the techniques made fashionable by Lalique, and their workshops became particularly adept at enamelling, especially *plique-à-jour* work, where enamel is contained within a framework of metal but has an open back. This allows light to pass through the enamel and the effect is rather like that of a stained-glass window. The Vever brothers acted as entrepreneurs and many of their designs were commissioned from leading Art Nouveau designers such as Eugene Grasset and

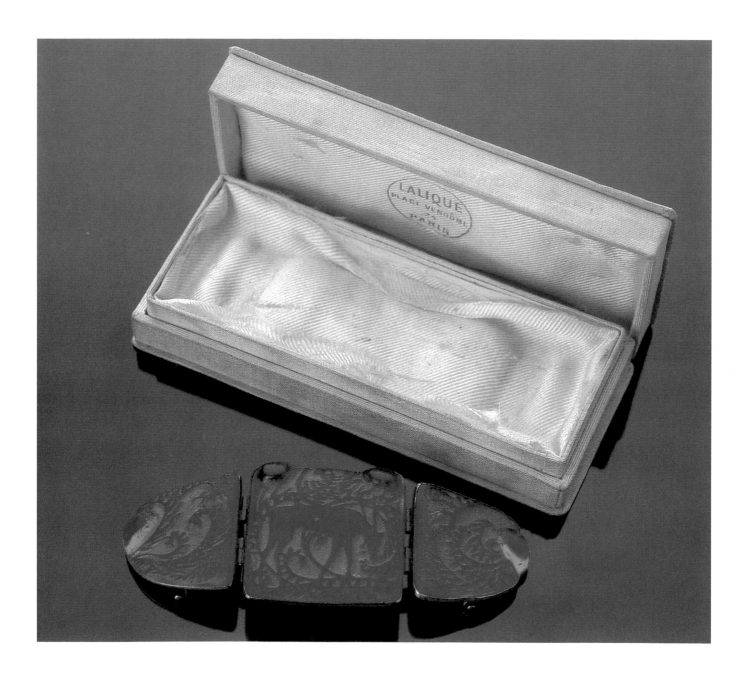

Edward Colonna, whose jewellery designs, usually asymmetrical creations in silver and gold decorated with enamel and stones, were also sold at Bing's Maison de l'Art Nouveau.

GAILLARD

Lucien Gaillard became director of his family's firm in 1892 and his primary interest was in metalwork. Around 1900, the example of Lalique encouraged him to design jewellery, and despite the evident Lalique influence, Gaillard's jewellery was very successful, winning him first prize at the Société des Artistes Français in 1904. His most distinctive work is a series of horn hair combs carved as stylised sprays of honesty and mistletoe and often set with small baroque pearls as flower heads or berries.

FOUQUET

Georges Fouquet, who took over his family firm in 1895, was anxious to express himself in the fashionable Art Nouveau idiom, and found an ideal collaborator in the Moravian-born artist, Alphonse Mucha whom Fouquet had commissioned in 1901 to design his new shop in Rue Royale. The combination of Mucha's luscious and refined graphic sense with Fouquet's ability to translate the artist's designs into exquisite works of art produced only a limited number of jewels, but they are amongst the most extraordinary works created in the Art Nouveau period. The major examples of this fruitful collaboration are works of pure fantasy and are jewels of theatrical proportions. Chief among them is the bizarre bracelet conceived for Sarah Bernhardt, a grotesque enamelled and articulated gold griffin which encircles the forearm and hand, and incorporates a ring. There is also a giant *parure de corsage* incorporating a carved ivory head surrounded by carved ivory and gold arabesques of hair, an enamelled halo, pendant baroque stones and a pendant painted panel of watercolour on ivory within a gold border.

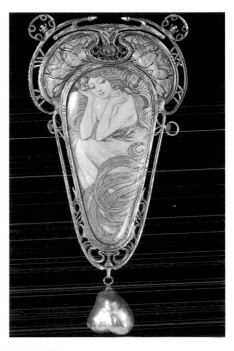

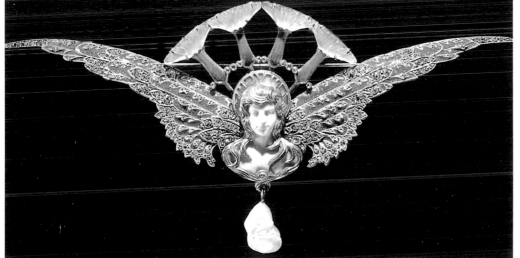

Above: Parure de corsage *designed by Alphonse Mucha and made by Georges Fouquet in gold, enamels, emeralds, watercolour and metallic paint on ivory, c.1900.*

Left: Brooch by Georges Fouquet, c.1904.

Far left: A buckle/clasp with grazing stag design by Lalique in glass and metal, c.1908.

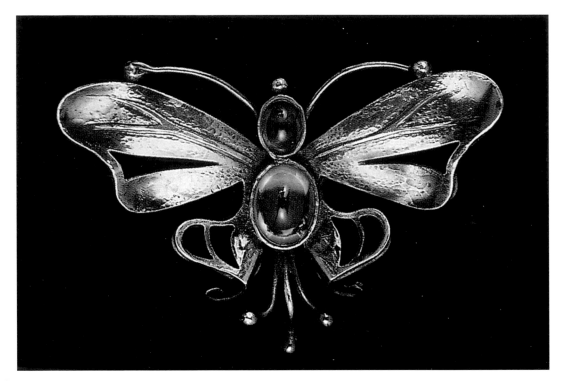

Above: Oxidised silver and cabochon moth pin by C.R. Ashbee.

Overleaf: Eve, a pendant designed by Philippe Wolfers in 1901.

The sinuous shapes and striking use of enamels and semiprecious stones gives a distinctive character to the jewellery of the late 19th and early 20th centuries. Beginning with the Art Nouveau period, there was a fundamental change in the attitude towards jewellery in terms both of its design and its function. The aesthetic merits of form, colour and texture became increasingly important, rather than the financial value of the materials used.

Until this period, much of the jewellery made continued the use of precious materials. It was therefore the prerogative of the rich and its role was to demonstrate a person's position in society. When factory production began in earnest in the mid-19th century, many entrepreneurs and industrialists, turned towards the indiscriminate use of ornamentation in order to satisfy the growing consumer market. Even the most mundane and utilitarian of machine-made goods were embellished to make them more desirable to the consumer. This was not a philanthropic exercise. More often it was done to disguise poor workmanship.

Individuals such as John Ruskin and William Morris questioned the effects of large-scale production on art and design. Their followers in the Arts and Crafts Movement of the 1860s were interested in reinstating the aesthetic values of the artist-craftsman in place of those of industrial production.

JEWELLERY IN BRITAIN

At the end of the 19th century, British jewellery differed from that produced in France because it owed more to the traditions established by the Arts and Crafts Movement.

Perhaps the best known of the Arts and Crafts Movement jewellery and metalwork was the product of the Guild of Handicraft established in 1888 by Charles Robert Ashbee. Ashbee trained as an architect as well as a silversmith and jeweller, and he produced a great many designs in gold, silver, pearls, jade and turquoise, often in the form of that popular motif in Art Nouveau, the peacock. For Ashbee, design was all important, and the gemstones are more often than not, set into the metalwork rather than overwhelming it. The stones themselves reflect the expanding British Empire; the opals are from Australia, the pearls from India, the moonstones from Ceylon and the diamonds from South Africa.

FRED PARTRIDGE

Among the other designers who produced jewellery at the Guild were Fred Partridge, whose work had much in common with the French Art Nouveau designers in his use of horn and steel, and May Hart, a skilled enameller, who later married Partridge.

Enamellers aimed to create a 'people's jewellery' by substituting cheaper glass enamels for gemstones. Moreover, its laws of production appealed to Arts and Crafts idealists: enamel jewellery was made by at most, three people, in place of a whole team of gem cutters, silversmiths and polishers. To a large extent in Britain, enamelling was also a woman's craft, but one which could be both a hobby and a professional discipline: Phoebe Stabler

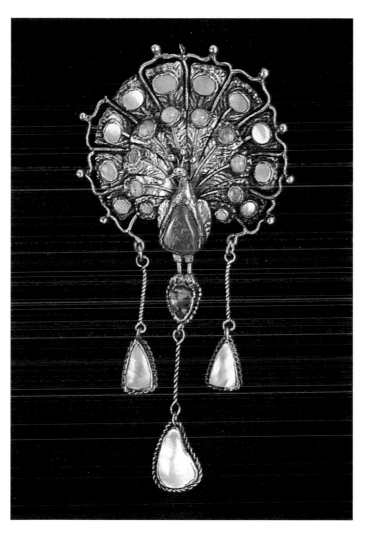

Above: Silver, opal and mother-of-pearl peacock brooch designed by C.R. Ashbee.

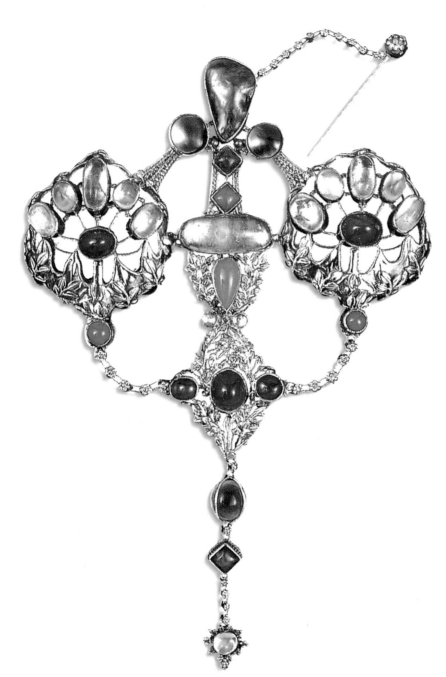

in Liverpool had in fact studied her craft with a Japanese enameller. Like potters, enamellers generally mastered their craft by trial and error and taught each other new skills.

INFLUENTIAL ENAMELLER

Possibly the most influential enameller in Britain was Alexander Fisher. A former pupil of the French master Dalpayrat, Fisher taught enamelling in his London studio to members of the aristocracy and the leisured middle class. Fisher actively promoted painted enamel as a jewel or art form in its own right. These were either in a single or multiple plaque form, set in gold, silver, bronze, or sometimes even steel, and formed belt buckles, coat clasps, brooches, pendant necklaces and rings which were all designed to be worn with the new, simpler, more 'Rational Dress' fashions of the time. Because it came closest to miniature or easel painting, enamelling gained perhaps the widest acceptance of all the newly revived crafts, and was no doubt encouraged by Fisher's popular instructional book, *The Art of Enamelling on Metal*.

BROMSGROVE GUILD OF APPLIED ART

Other guilds were to flourish in Britain including the Bromsgrove Guild of Applied Art founded in 1890, and the Artificer's Guild of 1891. At Bromsgrove were Joseph Hodel, whose silver buckles, brooches and pendants were in foliate and fruit forms and dotted with semiprecious stones. Arthur Gaskin's jewellery contained cabochon (domed, unfaceted) stones, rope borders, silver or gold filigree wires and clusters of silver beads and tendrils. From 1899, Gaskin worked with his wife, Georgina Cave

Left: A pendant in gold, pearls, amethysts and moonstones by C.R. Ashbee from 1902.

France, an extremely talented craftswoman in jewellery and metals. Mrs. Gaskin had been designing in silver since her student days at the Birmingham School of Art and the Gaskins' pieces are marked with a capital 'G'.

THE ARTIFICER'S GUILD

Members of the Artificer's Guild, founded by Nelson Dawson with his wife Edith, produced work in a number of different media. They also explored the potentials in jewellery of base materials like horn and shell, cloisonné, champlevé and the technically challenging method of unbacked, *plique-à-jour* enamelling.

Other British jewellery designers included the Scottish jeweller based in London Sybil Dunlop, Harold Stabler (a founder member of the Design and Industries Association, the forerunner of the Design Council), Henry Wilson, Omar Ramsden and Alwyn Carr. But possibly the most significant contribution to British Art Nouveau was the jewellery marketed by Arthur Lazenby Liberty.

LIBERTY & CO.

Liberty had opened his shop in 1875, initially specialising in the importing and retailing of Oriental goods from India and Japan. By the turn of the century, its affluent clientele were to include the residents of the new garden cities and suburbs of London. Liberty's stocked one-off, hand-made items as well as factory made goods. Demand was such that the store, while continuing to use independent suppliers, also began to operate its own design studios and manufacturing workshops.

Designers from the Arts and Crafts Movement were employed to create innu-

Right: Enamelled triptych made by Alexander Fisher, c.1900.

Above: Enamelled silver buckle decorated with a floral motif by the Arts and Crafts jeweller Nelson Dawson, a founder of the Artificer's Guild.

merable products from furniture and textiles, to ceramics and silverware.

CYMRIC AND PEWTER

Liberty sold silveware under the name of 'Cymric' (silver) and 'Tudric' (pewter) from the 1890s. Both these included a large collection of jewellery designed and manufactured by Jessie M. King, Rex Silver, Georgina and Arthur Gaskin, Oliver Baker and Archibald Knox, who created more than 400 designs for the firm which were in the main, responsible for defining and determining the 'Liberty style'. Knox had studied Celtic design at the Douglas School of Art on the Isle of Man, and applied the Runic interlacing of forms in his designs. There is an affinity between the forms used by Alexander Fisher and Knox, but where Fisher used the style by way of decoration, Knox employed the form in a more integral, structural manner.

Initially their designs were made by hand, but by the end of the 19th century, jewellery and silverware were increasingly manufactured by machine and contracted out to various firms, including the Birmingham firm of W.H. Haseler. They included brooches, pendants, belt buckles and clasps and necklaces. The designers favoured the use of semiprecious stones such as peridot, tourmaline, moonstones and chrysoprase, but in a few instances, precious stones such as rubies, sapphires, emer-

alds, fine pearls and diamonds were used. The use of gems however, was often dependent on the commissions of the purchaser. Often less precious materials were preferred by the designers not just because of cost, but because individual creativity took preference over conforming to traditional aesthetic practices.

DRESS REFORM

The market for such jewellery was however,

limited to the more 'enlightened' and artistic of Liberty's clients who appreciated the new aesthetic and moralistic qualities associated with the Arts and Crafts Movement, as well as with the dress reforms of the late 19th century. Dress reform was concerned with removing the restrictions imposed on the body by Victorian costume. In 1881 in Britain, the Rational Dress Society had been formed, which campaigned against the wearing of corsets and

Above: Silver belt buckle designed by Archibald Knox who worked for Liberty & Co in the first decade of the 20th century. This piece has the same stylised abstract quality found in European Art Nouveau.

Above: A gold and opal necklace by Archibald Knox for Liberty & Co.

advocated the adoption of looser, simpler garments that could be adorned with large and eye-catching pieces of jewellery, such as a robe clasp. Elsewhere, there were important parallel developments: in Germany the leading critic of contemporary dress was Dr. Gustav Jaeger from Stuttgart who introduced his Sanitary Woollen System in 1878, while in the United States, the American Free Dress Society had been founded.

Advocates of the new, free styles of dress for both men and women included the dancers Loie Fuller and Isadora Duncan, and the novelist and playwright, George Bernard Shaw.

THE GLASGOW FOUR
In Scotland the foremost exponents of Art Nouveau were the 'Glasgow Four', Charles Rennie Mackintosh, his wife, Margaret

Macdonald, her sister Frances, and Frances' husband James Herbert MacNair, who worked independently and together from the 1890s. Each was influenced by the formal organisation and economy of Japanese art and their own Celtic heritage and the elongated, gaunt austerity of their work earned them the name of the 'Spook School'. Their jewellery bore some resemblance to English Arts and Crafts, but its repertory of motifs was very much its own and more in the spirit of Vienna Secession (Austrian Art Nouveau). Among the silver and jewellery designs of the Glasgow Four were stylised birds, leaves, blossoms and hearts.

ART NOUVEAU OUTSIDE BRITAIN

The Arts and Crafts Movement assumed many different guises throughout Europe and America with some significant differences. While the British abhorrence of industrialisation was not shared by many other countries – especially those who had not yet been industrialised and had no reason to reject it – two fundamental aspects of Arts and Crafts ideology were embraced. The first was the use of design to express a country's national identity, and the second, was the attempt to reform design by applying certain Arts and Crafts values to machine production.

Left: A silver and enamel belt buckle designed by Jessie M. King for Liberty & Co. in 1906.

OCTOBER, 1902 ONE SHILLING

SCRIBNERS MAGAZINE

CHARLES SCRIBNER'S SONS, NEW YORK. SAMPSON LOW, MARSTON & CO., Ltd., LONDON

THE STUDIO

The two areas most influenced by the ideals of Ruskin, Morris and the other leading lights of the British Arts and Crafts Movement were Scandinavia and the countries in middle Europe, Austria, Hungary and Germany. Their leaders read the works of Ruskin and Morris, subscribed to journals like *The Studio,* and visited Britain and the major international exhibitions to see at first hand the British crafts on display.

SCANDINAVIA

From 1890 onwards, the Scandinavians were to emerge from being merely imitative in the field of the decorative arts to holding a major position in European design. In some fields and at certain points their influence was to spread beyond their own countries.

These developments were led by Denmark and Sweden, which could build on centuries of independent nationhood and a long established court culture with accompanying high standards of taste and workmanship. No such similar traditions existed in Finland or Norway, however, as both were to gain political and cultural independence only in the early 20th century. The political union between Norway and Sweden was dissolved in 1905 and that between Finland and Russia in 1919.

Returning to their own indigenous folk arts for inspiration, and seeking a naturalistic style to soften the edge of the nascent modernity, the Scandinavian countries drew on the idealised democratic principles of craft production and searched for an aesthetic formula in keeping with their cultural traditions. They

Left: A cover for Scribner's Magazine *by Mills Thompson. Magazines such as these helped spread the Art Nouveau style.*

Left: A silver purse frame with Celtic entrelac motif by Archibald Knox.

Above: A piece by one of the most famous names in Scandinavian design, Georg Jensen, known for his abstract forms.

recognised the need to invite industrial sponsorship, not only to maintain links with the market place, but also to provide support for the designers. They hoped that this would eventually lead to the widespread dissemination of well designed and well made goods.

The great name in Scandinavian silver and jewellery was, of course, Georg Jensen, an artist whose fascination with his craft resulted in the creation of some of the most outstanding pieces of silver and jewellery. His designs betray a remarkable sensitivity to form, while the celebrated, almost matt-hammered finish became an international hallmark of the Jensen style.

AUSTRIA AND THE WIENER WERKSTÄTTE

In Austria, the search for a new style at the beginning of the 20th century was led by the architect Josef Hoffmann and the members of the Secession group that had been organised as a rebellion against the official *Kunstlerhaus* (Society of Artists) and its narrow definition of what constituted art. The primary motive of the Secessionists was to bring Austria to the forefront of modern art. Their definition of modern art gave the applied arts equal status to fine arts, but Hoffmann wanted to take the goal of unifying art forms still further. After visiting Ashbee's Guild of Handicraft in 1902, Hoffmann determined to establish a similar craft organisation. In the programme of the *Wiener Werkstätte*, which he founded with fel-

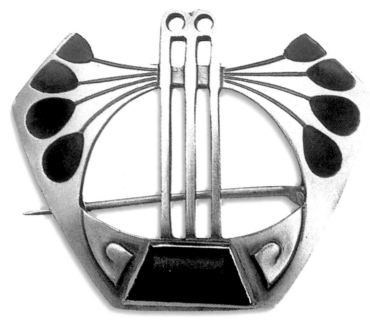

Above right: A later brooch in silver by Georg Jensen.

Above: Scandinavian design during this period was relatively formal as seen in this silver clip by Georg Jensen.

low Secessionist architect Kolomon Moser, Hoffmann declared that their aim was to create an 'island of tranquillity' which amid the 'joyful hum of arts and crafts' would be welcome to followers of Ruskin and Morris.

But Hoffmann was selective in his choice of Arts and Crafts principles. Ignoring the aspects of social reform, Hoffmann adopted only those principles concerned with the reform of design – functionalism and craftsmanship which were most rigorously combined in a reductive geometry of forms. Many historians credit this to the influence of Mackintosh, whose designs were greeted with wild acclaim in Vienna and who was also a close friend of Hoffmann. Regardless of the source of inspiration, the square would become the leitmotif of the *Wiener Werkstätte* designs.

Hoffmann and Moser also championed the use of more modest materials such as semiprecious stones for jewellery in the belief that exceptional design and craftsmanship were more important. Both were passionate about the highest standards of craftsmanship, but, when special commissions were to be undertaken about the finest materials.

Whether plain and simple, patterned, or highly ornamented, privately commissioned or made in multiples, the products of the *Wiener Werkstätte* were expensive. Although they did not shun the use of machinery, the *Werkstätte* members would not compromise their high ideals of craftsmanship to make good design available to all.

THE CRAFT IN GERMANY

In Germany, the equivalent of Art Nouveau was known as *Jugendstil*, which became the

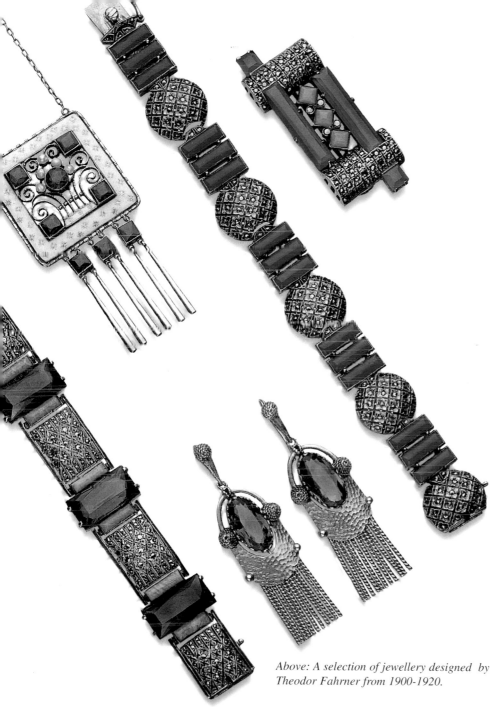

Above: A selection of jewellery designed by Theodor Fahrner from 1900-1920.

major influence on the decorative arts by 1900. The attitude of the Vienna *Werkstätte* was not one shared by most of the workshops established in Germany.

The first and most influential was the United Workshops for Art and Craftsmanship, founded in 1897 in Munich. While the members of this group looked to the example of Britain and its precedent in raising design standards by applying simplicity, integrity and fitness of purpose to making everyday objects, they rejected the belief held by Ruskin and Morris about the sanctity of the hand-made. Like their Viennese contemporaries, the German group was uninterested in social reform, but they also differed strongly in that the German members were also indifferent to individualism in the work process.

Their aim was to make quality goods at an affordable price, and they supported any methods that would improve the standard of German goods to make them more competitive in the international and domestic market. By employing the latest technologies, the designer worked in close co-operation with the makers and manufacturers, a rejection of the Arts and Crafts idea that the designer was also the maker. In jewellery, designers such as Peter Behrens, Henry Van de Velde, Josef Olbrich, Patriz Huber and Carl Otto Czeschka contributed designs for mass production by the firm of Theodor Farhner in Pforzheim, the centre of the German jewellery industry between 1900 and 1930.

JEWELLERY IN AMERICA

The Arts and Crafts reformers' designs were shaped by moral convictions and often prescribed how people should live. The moral aesthetics of American reformers were once again developed from the works of Ruskin

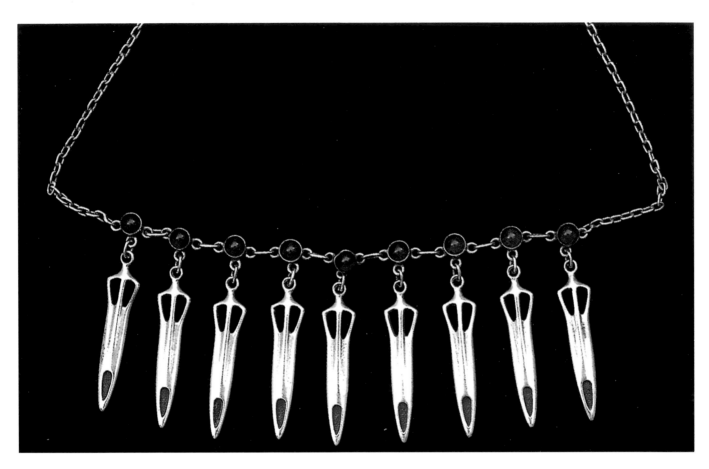

Right: Silver and amethyst necklace inspired by the rectilinear qualities of Art Nouveau. It was manufactured in 1905 by the firm of Theodor Fahrner in Pforzheim, the centre of the German jewellery industry.

and Morris whose writings were best sellers in America. Between 1859 and 1892, for example, Ruskin's only book devoted to the decorative arts, *The Two Paths*, was reprinted 19 times and many reading groups were established across the country to study the works of other writers. Joseph Twyman established a William Morris room in the Tobey Furniture Company of Chicago's showrooms and also founded a William Morris Society.

Although Morris and Ruskin never visited the United States, many other leaders of the British Arts and Crafts Movement made the journey. Among them were Walter Crane, Charles Ashbee and Morris's daughter May, and all gave lectures and toured exhibitions of their work.

ELIZABETH E. COPELAND
Inspired by the movement, many individuals and groups in America followed the British lead and turned to the professional practice of their crafts. In Boston, where the Arts and

Crafts first took hold in America, Elizabeth E. Copeland, after studying in England, combined silver and enamel in her work which clearly showed the handicraft of the maker. Following her, Edward Everette Oakes, also in Boston, designed jewellery and showed at the Arts and Crafts Society's Exhibition in 1923. In Chicago, Florence Koehler made jewellery in the Art Nouveau style that owed a stylistic debt more to France than England.

MADELINE YALE WYNNE

During this period, *The Craftsman* magazine extolled the virtues of simplicity and practicality, and while the latter virtue is always questionable in relation to jewellery, these beliefs were to influence the works of artist-jewellers like Madeline Yale Wynne. Wynne explored the artistic potential of different non-precious materials such as copper, pebbles and rock crystals. This would prove to be a more enduring influence on future jewellery design than those companies and individuals preoccupied with precious metals and stones, since the search for new forms indirectly reflected the modern world. Other American jewellers who practised within the Arts and Crafts arena include Brainerd Bliss Thresher and Josephine Hartwell.

One name, however, that stands out in the design and manufacture of Art Nouveau jewellery in America is that of Tiffany & Co. which produced a prolific amount of jewellery from the latter half of the 19th century, at first inspired by British Arts and Crafts, and later by Continental Art Nouveau in the first decade

Below: A Swordfish brooch manufactured by Tiffany's during the 1930s in diamonds, sapphires, emeralds and rubies.

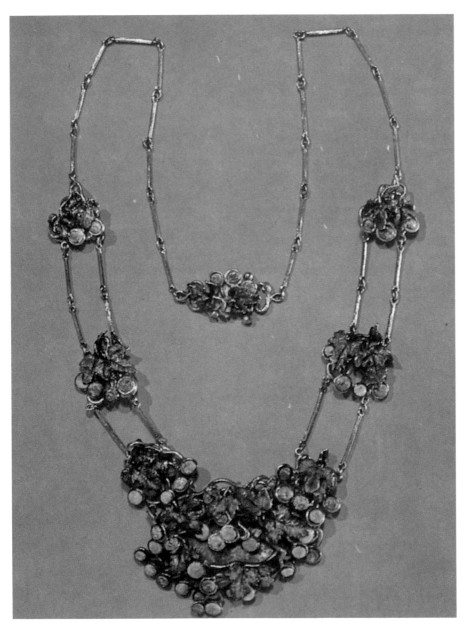

of the 20th century.

Louis Comfort Tiffany, famous for his masterpieces in glass, had been trained as a painter. Louis' father Charles had amassed an enormous store of precious stones over the years and his craftsmen used them in designs for sword scabbards, tiaras and coronets. In collaboration with Julia Munson, Louis opened an 'art jewellery' department in the store and oversaw the production of luxurious Byzantine-inspired designs, utilising such materials as opals and amethysts, rubies, diamonds and emeralds. Jewellery designed by Louis Comfort Tiffany was produced under the auspices of Tiffany & Co. and bore their mark, so verification of Louis' own designs is difficult.

TIFFANY'S JEWELLERY

What distinguishes Tiffany's jewellery from its European counterparts is that Tiffany did not make the gemstones subordinate to their settings, preferring instead a hard, clear design with unobtrusive settings. These pieces were perhaps too expensive and the 'art jewellery' department closed in 1916, although the company of Tiffany & Co. continued to produce fine jewellery.

Above: Tiffany mixed opals with translucent glass in this necklace, but unlike his contemporaries, he did not submerge the gemstones in their settings.

ART NOUVEAU
METALWORK

Overleaf: Silver mounted jug by C. R. Ashbee at the Guild of Handicraft, c.1900. The green glass was made by Powell's of Whitefriars.

Below: The gate of Horta's Van Eetvelde House, whose intricate curving style is repeated inside.

The mid-19th century witnessed the beginnings of an age of individuality and innovation in terms of both precious and non-precious metalwork. The standards of Art Nouveau craftsmanship in this area were extremely high, and the period was rich in its constant variety of invention. Since the essence of Art Nouveau was the curving, sinuous line, its insubstantiality was best exploited in malleable materials.

ART NOUVEAU METAL IN ARCHITECTURE

Metal, particularly wrought-iron was a significant part of Art Nouveau architecture, both structurally and decoratively. Victor Horta had made its structural role clear in his work in Brussels and he had also used it decoratively, exploiting its relative malleability to provide lighter patterns in contrast to the weightiness of stone. In Art Nouveau architecture, metalwork serves as a link between the building itself and the style of its contents, which were often the product of the same designer. From exterior balconies, gates and window mullions, the metal is continued into the interior in columns, beams, banisters and door handles, and even to embellishments on furniture.

The versatile applications for metalwork and the range of metals available encouraged almost every Art Nouveau architect and interior designer to turn their hand to metal at some stage. As with glass or furniture, it is important to visualise metalwork as part of its context in the interior scheme. It could appear in the form of candlesticks, flatware, clocks, light fittings, mirrors, caskets and in fanciful, decorative sculptures.

EXTERIORS AND INTERIORS

Hector Guimard's Métro entrances emphasise the versatility of the medium, as they can be seen both as architecture and as sculpture, or even as enormous decorative pieces. They use

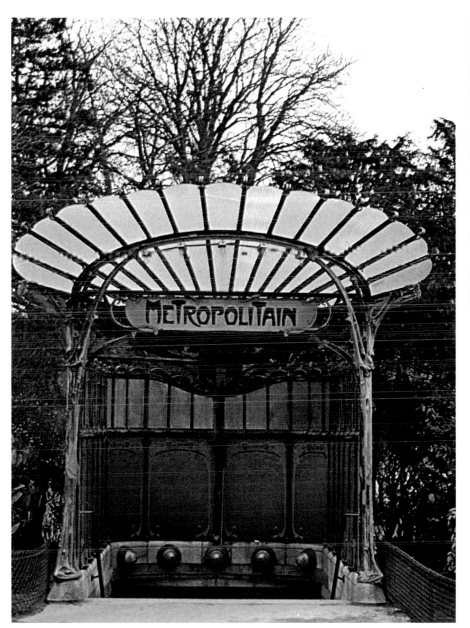

Above: The whiplash line is evident in Guimard's ironwork entrance to the Castel Beranger.

Left: The Paris Métro, Bois de Boulogne station by Hector Guimard, who also designed the typography.

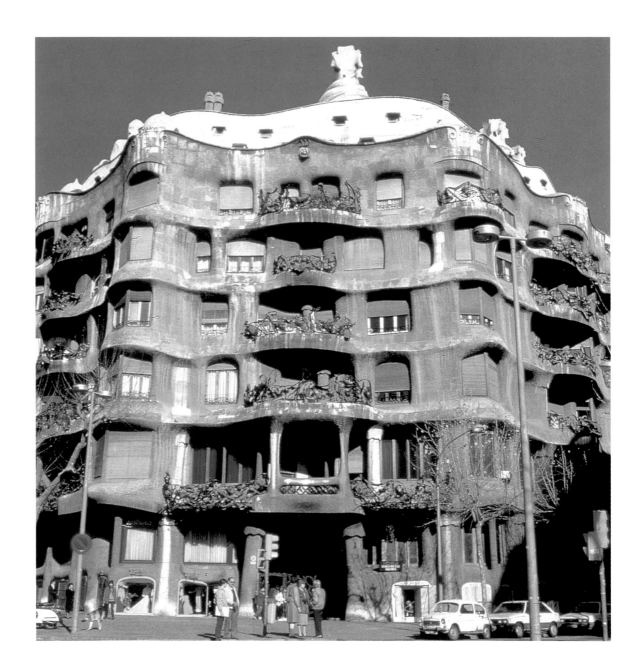

the same forms as the great iron gates of the Castel Beranger apartments, as well as for the banisters within. In Belgium, Horta carried the same continuity of form from the iron balconies to the banisters for the staircase, the main feature of his own home and studio in the Rue Americaine in Brussels.

Comparable in function, yet even more fantastic in form, were the balconies of Gaudí's Casa Milà, modelled like tangled seaweed. In his early work for the Casa Vicens, Gaudi achieved the effect of palm fronds with the spikes cut at the top bent in every direction as if they were dropping leaves. The entrance gate to the Güell Estate in Pedrables is even more outstanding. Here, almost the entire piece is treated in the form of a writhing dragon whose gaping jaw reaches out to ensnare the hand of the visitor who reaches for the handle.

METAL OBJECTS D'ART
Work in the traditional precious metals, particularly silver, had, through the processes of industrialisation and mass production, sunk

Above: An ornate set of metal fittings for furniture produced by Georges de Feure.

to a low level of design and workmanship until it was revived by the Arts and Crafts Movements, first in England and then later abroad.

These craftsmen emphasised the virtues of handmade objects, and at times even sought to underline this method of production by deliberately leaving the surface of their metal objects 'unfinished' – that is, with their hammer marks left visible and unpolished. Less precious materials were also explored for their aesthetic qualities: bronze, brass, tin and copper were all used, and a revival of interest in pewter also occurred. At times, Art Nouveau craftsmen combined a range of metals and mixed them with ivory, enamels, semiprecious stones or any other material required to produce the appropriate effect. Some designers produced handmade and therefore very exclusive items, while others were to tailor their designs to large-scale production and found themselves more in tune with the future course of design in the 20th century.

ART NOUVEAU METALWORK IN FRANCE

Guimard was largely an isolated talent in France with regard to architectural metalwork, and the French reputation in metalwork is largely confined to the area of jewellery and orfeverie. In France, the Nancy school concentrated more on furniture, glass and ceramics, although Louis Majorelle, who had used gilt trimmings on his furniture, produced some gates and banisters, as did Victor Prouve. More metalwork was produced by the Parisian craftsmen working for Bing, and Julius Meier-Graefe, who had opened his retail outlet La Maison Moderne in Paris in 1898. The elegant Georges de Feure was one of the most versatile of these designers and produced objects from candelabra to walking cane

handles, based on stylised, fluid plant forms. Others, like Colonna and Selmersheim, turned to metalwork for a complete room setting, designing table-lamps or chandeliers in the form of drooping plants whose flowers were the glass shades.

CARDEILHAC

The firm of Cardeilhac was a leading producer of exciting Art Nouveau designs, in particular by Lucien Bonvallet. The company also produced a series of mounts for vases by the leading glass makers and potters, and the firm's most characteristic pieces were those in silver or silver-gilt, decorated with stylised yet restrained plant motifs.

Like many Art Nouveau designers, Lucien Gaillard, a name most often associated with jewellery, also explored a range of media. Gaillard had studied in depth the various aspects of metalworking, patination, plating and alloying, as well as Japanese techniques of decoration. He produced a variety of objects from parasol handles to hairpins which combined his fine workmanship with a strong sense of design, using precious and non precious materials with equal respect.

SCULPTURE IN METAL

Another branch of the decorative arts which enjoyed a particular vogue at the end of the 19th century was decorative sculpture. Small, domestic scale sculptures could be found in a variety of functions, including supporting lamps, as well as being created in a purely ornamental capacity. This was principally a French-inspired fashion pursued by such figures as Eugène Feuillatre, Raoul Larche, Théodore Rivière and Rupert Carabin, who generally produced nude or lightly-draped female figures whose hair and drapery was ex-

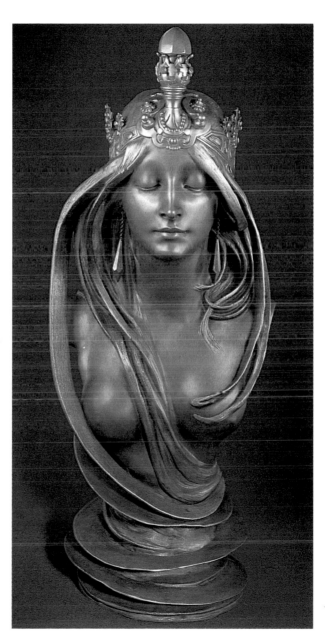

Left: Decorative sculpture enjoyed a particular vogue around 1900. One of the most popular motifs of the Art Nouveau period was the figure of a woman as the 'dream-maiden'.

Right: A candlestick in painted copper, brass and wood by Christopher Dresser made by Perry & Co. in 1883.

Below: A teapot by Christopher Dresser in silver and wood from 1881.

In Germany there was a great deal of very ornate Art Nouveau metalwork, especially that produced by firms such as J. P. Kayser & Sohne of Krefeld who manufactured a range of pewter under the trade name of Kayser-Zinn. It was this pewter range, designed by Hugo Leven, that Liberty's in London sold until it developed its own Tudric pewter. WMF in Geislingen produced some of the most outrageous curvilinear Art Nouveau metalwork, usually in thick pewter or nickel-silver and often with green glass liners. On of the largest and most important firms was P. Bruckmann & Sohne of Heilbronn, whose designers included Peter Behrens, Friedrich Adler, George Roehmer and Bernhard Wenig. Bruckmann

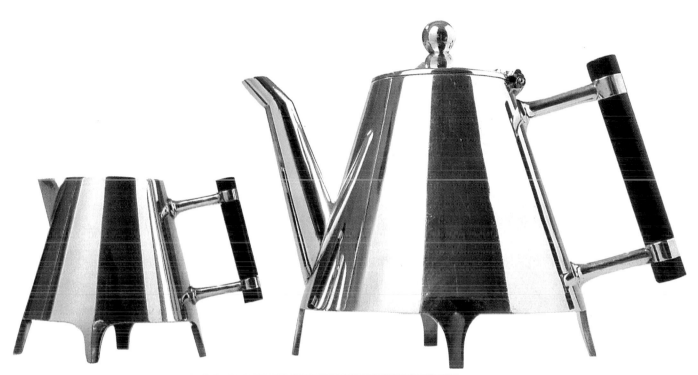

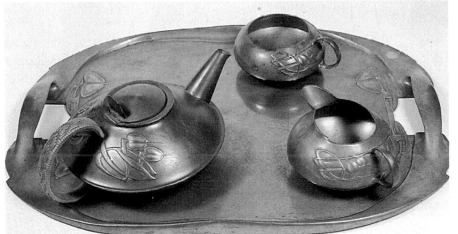

Above: A teaset of almost oriental refinement by Christopher Dresser.

Left: Teaset by Archibald Knox for Liberty & Co., part of the Tudric range he designed which continued the Celtic theme.

was also one of the major industrial firms to produce the designs of the *Deutsche Werkbund*.

HENRY VAN DE VELDE
Possibly the most impressive of the metalwork designers active in Germany in the early years of the 20th century was Henry van de Velde. His early silver is in a style that is often described as 'geometric-curvilinear' and can be compared to some of the earliest designs by the Dane, Georg Jensen.

OTHER EUROPEAN COUNTRIES
Italian-born designer Carlo Bugatti created both outstanding furniture and magnificent silver objects which were made by the Parisian craftsman Adrien A. Hebrard. In true Art Nouveau style, they combined various subjects, materials and techniques in an unusual manner. For example, one tea and coffee service comprised a long tray with a bizarre animal head at each end, both terminating in long, ivory tusks. The coffee pot, teapot, creamer and sugar bowl were also in the shape of boar-like animal heads, also with ivory tusks.

In St. Petersburg, master jeweller Peter Carl Fabergé included Art Nouveau pieces in his outstanding oeuvre, including gold cigarette cases and flower- and leaf-shaped mounts for the glass made by Tiffany in New York and Loetz in Germany.

METAL IN AMERICA
On the whole, silver in America had tended to be dominated by the old established firms such as the Gorham Manufacturing Co., or the internationally famous, Tiffany and Co.

Left: A jewellery box designed by Charles Rennie Mackintosh.

Left: Metal baskets designed by Josef Hoffmann, the founder of the Wiener Werkstätte.

Below: An electric kettle designed by Peter Behrens for AEG, c.1908.

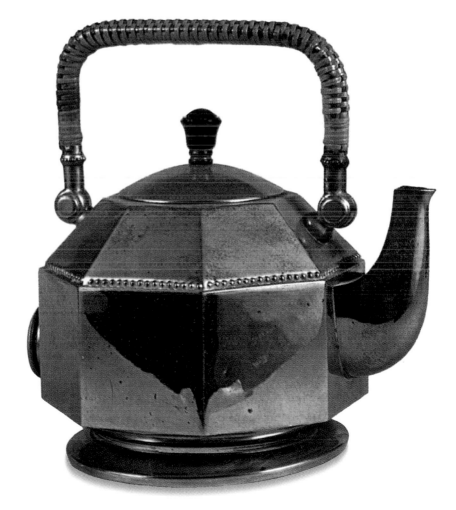

At the luxury end of the market these two firms were the dominant force, and both were influenced by the changes in style created by the craft revival and Art Nouveau.

TIFFANY & CO.

Tiffany & Co., the New York jeweller, silver manufacturer and retailer was established in 1837 and it produced outstanding silver in Japanese, Indian and Moorish styles, and, from the 1880s, in the Art Nouveau style. When Louis Comfort Tiffany opened his own Tiffany Studios, he began experimenting with enamels, often used on repousse copper bowls or vases. Opaque and translucent layers were used, fired separately and often finished with an iridescent coat which gave the pieces an effect similar to his glassware.

GORHAM MANUFACTURING COMPANY

The Gorham Manufacturing Company, founded in 1831, in Providence, Rhode Island, was Tiffany's chief rival in silverware, and also produced electroplated silver. In the late 1880s, its fine quality silver included Japanese-style wares and later, hand-crafted pieces in the French Art Nouveau and English Arts and Crafts style which were marketed as 'Martele' (hammered) silver.

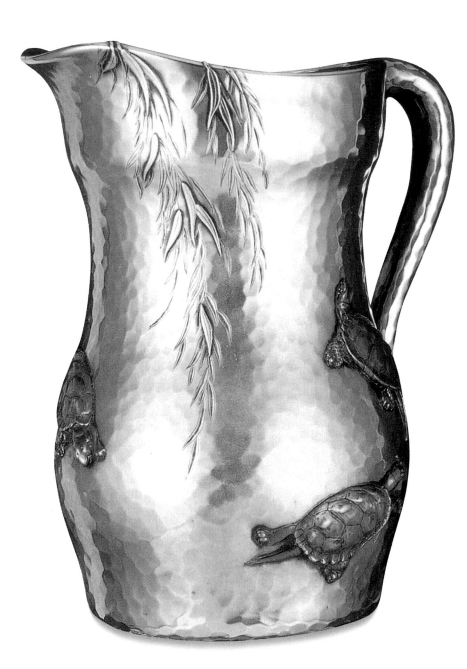

The Arts and Crafts Movement inspired numerous followers in America and several communities fostered a revival in metalwork. The Roycrofters made wrought iron, and the Roycroft Copper Shop was headed by Karl Kipp from Vienna. Kipp designed bookends, candlesticks, trays, vases and other household items which were then made by other members of the Shop. The hammered copper was decorated with stylised designs, usually of flowers or trees and was advertised and sold through the Roycroft catalogues.

Left: Silver, silver gilt and copper jug, decorated with hammered turtles by Tiffany & Company, late 19th century.

Below: A hammered bowl with the same applied turtles, typical of Tiffany's Japanese-style wares.

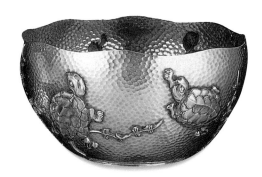

ART NOUVEAU
GLASS AND CERAMICS

AN EXPRESSION
OF STYLE

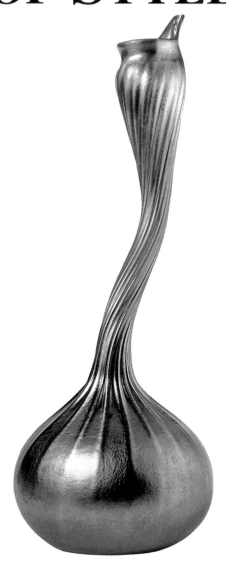

Art Nouveau glass and ceramics were closely linked in both style and technique and much the same kind of ware was produced in each medium. In both crafts, the innovations of Art Nouveau increased the range of colour and the possibilities for relief decoration, as well as changing the actual shape of the piece itself. For the Art Nouveau craftsman, glass and clay were, in their own way, as malleable and tractable as metal, and the fluid contours of the style could be equally well expressed.

Far left: A goose-necked vase by Louis Comfort Tiffany, inspired by a Persian perfume flask.

THE STYLES OF THE CENTURY

Art Nouveau developed in the late 1880s and was at its creative height in the subsequent decade. By 1905 it had declined into being a much diluted ingredient in commercial design, soon to be replaced by an aesthetic felt to be more in keeping with the new century.

The 19th century had seen enormous changes in society in both Europe and America, with the spread of industrialisation

Below: New machinery at the 1851 Great Exhibition, London, which had introduced the mass production of everyday artefacts and threatened the role of craftsmen.

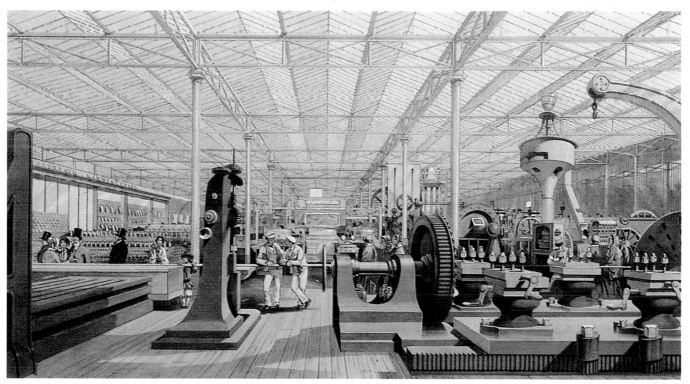

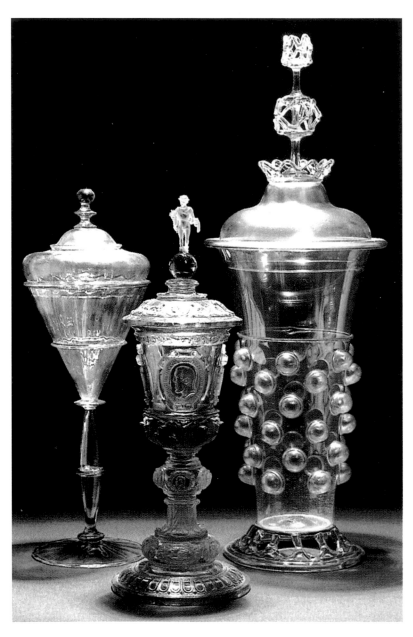

resulting in great wealth mainly concentrated in the new manufacturing and commercial cities. Mass production methods in factories not only produced a wider range of goods that were more widely available than ever before, but also created an entirely new class of workers. At the same time, major advances in technology such as railways, steamships and the telegraph, were easing the problems of communication. The world had changed, yet it seemed as though there were no corresponding changes in the styles employed to shape its appearance. In the design of everyday objects, just as in the design of buildings, the new age was simply offering revivals of old styles: Classical, Gothic, Renaissance, Baroque or Rococo. While technology advanced, the quality of design seemed to have stagnated or even regressed.

NEW ART

The Art Nouveau – the 'new art' – was the first style that did not seem to have its roots sunk deep into European history. Art Nouveau was the first new style of the 19th century – despite the fact that it did not emerge until its closing years.

ART AND INDUSTRY

The Art Nouveau style was made possible by a number of outstanding writers on aesthetics during the 19th century, notably John Ruskin and William Morris in Britain, and Léon de Laborde and Eugène Viollet-le-Duc in France. What all these writers had in common was a rejection of the crass materialism which had reached its peak in many of the exhibits that were on display at the 1851 Great Exhibition

Left: Three 'Historical Revival' Goblets from Germany, c.1890.

at the Crystal Palace in London's Hyde Park. The long-forgotten truth that art should be in harmony with the age which produces it was rediscovered around 1850 by these men.

John Ruskin was especially responsible for a number of advances in the field of aesthetics: he rejected the distinction between the so-called major and minor arts. Consequently, interior decoration, which had formerly been entirely in the hands of artisans, now took on the dimensions of a major social and artistic mission to be accomplished. According to Ruskin, the decorative arts should once again assume the central position in artistic concerns they had occupied at the time of the Renaissance.

INSPIRATION FROM NATURE

It was also Ruskin who called upon architects to draw their inspiration from nature. This concept was to be central to the movements in the decorative arts at the end of the nineteenth century. The translation of the 'secrets' of nature into design are evident in the works of Art Nouveau architects like Victor Horta in Belgium and Hector Guimard in Paris, in the glass of Gallé, the Daum Brothers, Lalique and Tiffany, and in the ceramics of Chaplet, Carriers and Delaherche.

Count Léon de Laborde had been in charge of organising the French participation at the 1851 Great Exhibition and although many of the 1,756 French exhibitors won awards, Laborde was not uncritical of their works. Unlike many of his contemporaries, he did not make a cult of the past and he was against artists who killed art by making a fetish of copying the masterpieces of past ages. At the

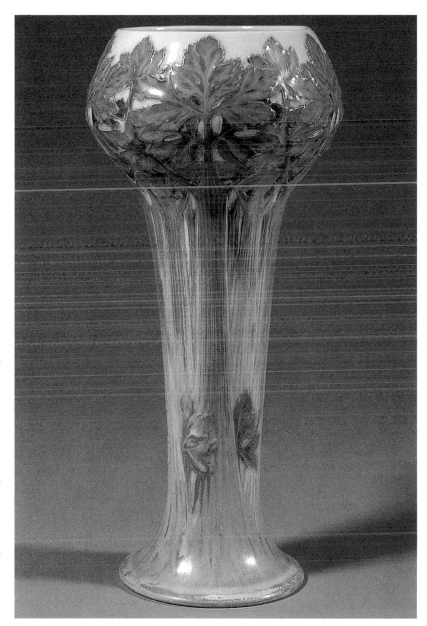

Right: Sevres 'De Monteforte' vase, c.1908, a fine example of the Art Nouveau style.

orate furniture, create tapestries, fabrics, printed books and wallpapers. In so doing, Morris was able to produce a complete range of goods to furnish the home that were in a uniform style and created an overall harmony of effect. In this, and in his insistence that it was the observation of nature and its forms that was the basis for all design, Morris anticipated the versatility of the Art Nouveau artist-craftsman.

HIGH IDEALS

Throughout his career, Morris struggled to reconcile his high artistic ideals with his social and political inclinations. His commitment to the creation of products that reflected the highest standards of design and construction were constantly at odds with his desire to produce them at a cost that consumers could

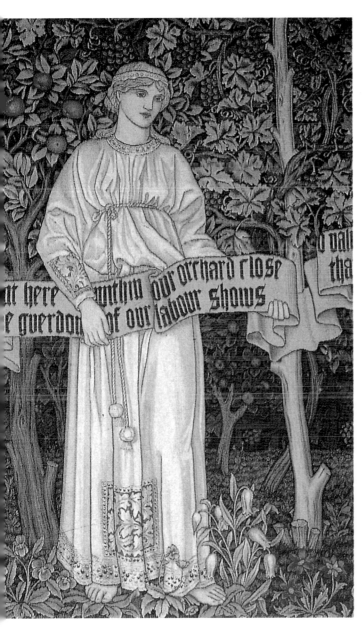

reasonably afford. His dedication to the principles of handcrafting conflicted with the need for machine production which could reduce the drudgery of certain tasks and reduce production costs. The successful marriage of art and industry was a dilemma that he was never to fully resolve. Nevertheless, his example encouraged many similar enterprises in Britain and overseas, usually referred to under the general term 'Arts and Crafts Movement'

Left: The Orchard Tapestry, designed by Morris and woven at Merton in 1890 for Jesus College Chapel, Cambridge, is an example of Morris's use of high warp, or vertical, tapestry technique.

MACKMURDO AND THE CENTURY GUILD

Chief among the Arts and Crafts Movement groups was the Century Guild, formed in 1884 by Arthur Heygate Mackmurdo. Influenced by the flowing natural forms used by Morris, Mackmurdo developed these further into more elongated, sinuous and increasingly elegant patterns. In his illustration to the title page of *Wren's City Churches*, where the stems of the flowers undulate in an asymmetrical, rippling pattern like marine plants gently animated by unseen currents, Mackmurdo created the sinuous shapes and lines that were to become the hallmark of Art Nouveau for the next 20 years.

THE CRAFTS REVITALISED

As with the other crafts revitalised by Morris and his followers, the histories of glassware and ceramics of the 19th century were the stories of technical advances which resulted in an impressively consistent quality of mechanical production. However, this was achieved largely at the expense of aesthetic distinction.

To the Arts and Crafts Movement glass meant, above all else, the stained glass of their neo-medieval church windows. It was not until the 1890s, when Christopher Dresser began designing for the Clutha range of James Couper & Sons of Glasgow, that distinguished con-

temporary glassware was to be seen in Britain with an Art Nouveau sense of line and colour. In ceramics, the reaction against industrialisation occurred a little earlier. In France, Théodore Deck, who set up his workshop in Paris in 1856, can be considered as the first of the 'art-potter' craftsmen. Deck was inspired principally by Near-Eastern and Persian designs and experimented with high-tempera-ture glazes and oriental shapes and designs.

In England, this was echoed by W. Howson Taylor at his Ruskin Pottery near Birmingham, and by Bernard Moore in Staffordshire, but the first true art-potter, and the one most closely attuned to Morris's principles was William de Morgan, who produced earthenware pieces in lustre, and bright, Persian designs from the 1870s.

Above : Morris & Co. painted glass from Wightwick Manor. The figure of Chaucer emphasises the medieval inspiration for Arts and Crafts glass.

Right: William de Morgan was associated with Morris, and in 1872 founded his own pottery and showroom in Chelsea, London.

Far right: Earthenware vase and cover by William de Morgan painted with a brightly coloured floral and foliate design, inspired by Iznik pottery of Persia.

Art Nouveau emerges

When he chose it as the name for the shop, La Maison de l'Art Nouveau, which he opened in 1895, Samuel Bing did not invent the expression 'Art Nouveau'. In fact, the term had been around since 1884 when the two Belgians, Octave Maus and Edmond Picard, who had created the review *L'Art Moderne,* proclaimed themselves as 'believers in Art Nouveau', an art which refused to accept the prevailing cult of the past. At first, the term was attached to the works of painters who rejected academicism. The more specialised use of the term Art Nouveau, for architecture and art objects, was to come later. At the same time different countries were to create their own specific versions of the term: Jugendstil, Sezessionstil, Modern Style, Stile Liberty, Modernismo or even Belgische Stil.

Despite the different names, each movement has a number of common features. Firstly, there was the rejection of academic traditions. For anyone wishing to create Art Nouveau, the cult of antiquity was a thing of the past. The rejection of antiquity went hand in hand with a return to the observation and imitation of nature. The straight line was abandoned in favour of the curve, the essence of Art Nouveau. The characteristic curving forms of Art Nouveau which first appeared in England were to spread rapidly throughout Europe and America to a range of centres each with their own distinctive interpretations of the style.

The new art in full flower

While the 1890s saw the development of Art Nouveau, the fully evolved characteristics of the style which enjoyed their greatest success were to be seen at the 1900 Paris Universal Exhibition. It was here that the concept of Art Nouveau design as a 'total' one emerged.

Above: 'Rose de France' glass vase by Emile Galle, c.1900.

Left: This Tiffany vase demonstrates his passion for the colour and texture of glass.

Designers were seen as 'ensembliers', rather than as creators of individual pieces. In truth, Art Nouveau could only be seen at its best in a complete ensemble, something, once again, that only a limited number of patrons desired or could afford. As manufacturers quick to cash in on the popularity of the style attempted synthetic versions for mass production, Art Nouveau was inevitably to deteriorate.

European
Art Nouveau
Glass

As with other crafts revitalised by the Art Nouveau, the history of glassware in the earlier part of the 19th century, was the story of technical advances, resulting in an impressively consistent quality of mechanical production. The technique of press moulding was invented in the United States in the 1820s and steam power was applied to the process of glass cutting. More important was an accelerating interest in the chemical compositions of glass recipes and moves to increase the efficiency of firing. Stylistically, until Art Nouveau emerged at the end of the century, glass in the 19th century was once again marked by eclecticism and stylistic revivalism.

Above: Rock crystal ewer made in Stourbridge in 1886. The elaborate aquatic motifs were engraved by William Fritsche.

Overleaf: Art Nouveau stained glass. Sinuous lines end in a whiplash.

ART NOUVEAU GLASS IN FRANCE

By the 1890s, French luxury glass production had reached a remarkably high standard of technical and creative inspiration. This major achievement can be traced back to a small, but significant number of talented artists, notably, Philippe-Joseph Brocard, Auguste Jean and Eugène Rousseau and his friend and collaborator, Ernest Léveillé.

Rousseau began his career as an art dealer before starting up as a craftsman himself. In 1878, the year that Gallé unveiled his 'clair de lune' glass with its delicate sapphire tinge, Rousseau created an equivalent sensation with his glass that imitated agates, jades and other semiprecious stones, which were sometimes enhanced by internal craquelé effects. Jean showed enamelled pieces, but his most notable innovation was in his free-form applications of glass, and in his vases of free-blown organic forms.

Above all however, it was the genius of Emile Gallé who inspired an entire generation and made the Paris Universal Exhibition of 1900 a wonderful showcase for creations in glass of unprecedented technical and artistic virtuosity.

EMILE GALLÉ

Although it produced furniture, ceramics, textiles and metalwork, the Nancy School with Gallé as its chief designer, mainly based its reputation on the production of Art Nouveau glassware. Glass was in fact the traditional industry of the city and Gallé had inherited his father's workshops in 1874. In addition to an extensive education which included botany and literature, Gallé also had a technical apprenticeship in glassworks at the Meisenthal glassworks (now in Germany). The inspiration for Gallé's own work was rich and varied. As with so many of the avant-garde of his generation, an introduction to Japanese art helped him to create a new visual language. His ability to create elegant, almost abstract graphic designs from the plant and insect life that were his most constant source of motifs owes a debt to Oriental art. The motto over his studio door however, 'My roots are deep in the woods' demonstrated that his greatest source of inspiration was nature.

Gallé's more personal creations also reflect his literary interests; he often used the works of contemporary French poets directly on his glass. His *verreries parlantes* (talking glass-

Right: Emile Gallé in 1889.

Far right: A brush holder that is also an early example of Gallé's verreries parlantes.

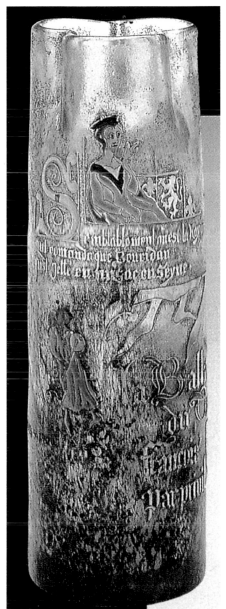

ware) were inscribed with extracts from the verses which had inspired their decoration, verses from Hugo, Baudelaire, Mallarmé, Verlaine, Gautier and Rimbaud, as well as other sources as diverse as Shakespeare and the Bible.

GOLD MEDAL

Gallé's great success came in 1889, when he won a gold medal and the Grand Prix at the Paris Exhibition. His major innovation of this time was his cameo glass, whereby glass of two or more layers was carved or etched back, leaving the design in relief in one or more colours, against a contrasting background. The technique was copied from that of Chinese Chien Lung cased glass that Gallé had studied in the South Kensington Museum in London. It was on a mass-produced, acid-etched version of his cameo technique that Gallé was to base the prosperity of his business. The com-

bined effects of colour and translucence provided Gallé with the marvellous colour effects which suggested submarine creatures against drifting seaweed, beetles crawling through long grass or a butterfly settling on a flower.

1897 saw him introduce another new technique, *marqueterie-sur-verre*, which involved inlaying semi-molten glass details of decoration into the semi-molten body of the piece being worked on. A combination of several different ingredients might also be used, as in the example of champleve, in which the cavities created in the glass were lined with gilt, before being filled in with layers of translucent enamels whose glow would be enhanced by the gold backing.

The 1900 Paris Universal Exhibition was perhaps the finest hour for Art Nouveau glass, it was also to be Gallé's last major showing before his death in 1904. By the turn of the century Gallé was showing more sculptural

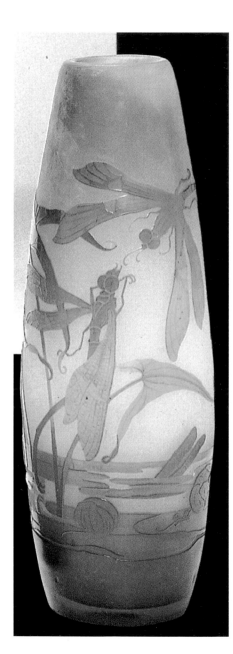

Left: Gallé's cameo glass, where two or more layers of glass were fused together and engraved.

freedom, producing pieces of completely organic form, or worked in high relief with fluid applications of glass. Two of his greatest masterpieces, the *Main aux Algues,* and the extraordinary and beautiful lamp, *Les Coprins*, date from this later period.

FUNCTIONAL DESIGN

In the best tradition of Art Nouveau, Gallé's glassware was prized far more as an artistic creation than for its functional design, and as such was collected by aesthetes and writers. His reputation rested upon a limited production of works which required an enormous number of man hours. A growing demand for his works encouraged him to increase capacity, but the more numerous workshop designs inevitably lacked the degree of finish of his earlier works. Nevertheless, Gallé's influence on contemporary glass makers was considerable, and he led a great renaissance of the industry in Nancy.

THE NANCY SCHOOL

In 1901 a group of artists allied themselves as the Ecole de Nancy, Alliance Provinciale des Industries d'Art. With Gallé as their guiding light, Louis Majorelle, Eugène Vallin and the Daum brothers were vice-presidents of the union. The Nancy School style of glass became prevalent in France produced by local firms such as the Muller brothers, the Verrerie de Nancy of the Daum brothers, and that of Auguste Legras who had taken over the Cristaleries of Saint Denis and of Pantin.

THE DAUM BROTHERS

Although Legras was operating the largest glassworks, employing some 1,500 people, the most notable rivals to Emile Gallé were the Daum brothers, Auguste and Antonin, who

were also more dependent than Gallé on the creativity of their employees. Nevertheless, the Daums turned this to their advantage as they counted among their contributors Jacques Gruber (who later turned his interest to furniture making), Eugène Goll (their most talented glass worker who was responsible for some of the most sculptural and inventive pieces), and Alméric Walter, who developed the *pâte-de-verre* technique for the company.

ACID ETCHING

The Daum brothers were, like Gallé, concerned with opacity, colour and relief, and used acid to etch away layers of glass to reveal the colours beneath and create delicately modulated backgrounds for relief work. To produce a glowing, opaque finish in a variety of colours, powdered enamels were fused onto the surfaces of pieces during firing.

PÂTE-DE-VERRE

The Daum brothers were also involved in the development of glassware produced by a more lengthy process in which pre-manufactured, ground-down glass was used as an ingredient. By manipulating the oxidation process, an opaque glass known as *pâte-de-verre*, could be produced which had a similar appearance to alabaster. The technique of *pâte-de-verre* was first revived in the 19th century by artist-sculptor Henri Cros as a sort of mock marble. Cros made reliefs and free standing sculptures on a small scale and largely based on classical themes. The Daum brothers were the first to exploit the rediscovery on a commercial scale and produced designs by Alméric Walter, but the greatest exponent of the technique was François-Emile Décorchemont. His earliest pieces had thin bodies with trailing

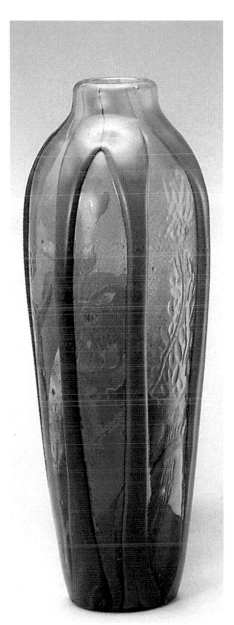

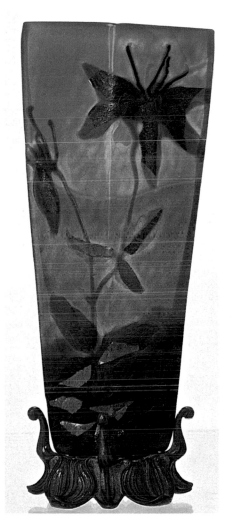

Above: Glass vase by Emile Gallé with decoration in marqueterie-sur-verre, *c.1900.*

Left: Gallé vase with marqueterie-sur-verre *on a translucent base engraved with irises.*

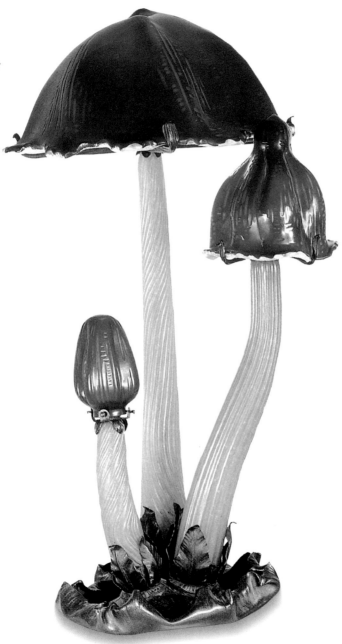

Art Nouveau motifs such as seaweed and other natural forms.

RENÉ LALIQUE

The great maestro René Lalique's interest in glass also dated to the 1890s when he began using cast glass in multi-media works of art. Around 1900 he began to use glass in his exquisite jewellery, caring little for the lack of intrinsic value of glass if its qualities were appropriate to the design. Around this time, Lalique began experimenting with the creation of all glass *cire perdue* pieces, including vases and panels such as the ones he used as decorations in his own home.

In 1902 Lalique set up a small glassworks and his first commercial commission was from the parfumeur, François Coty, who approached him to design scent bottles. Concentrating on large scale production, by 1912 Lalique's career as a jeweller was over and a new career in glassware design opened. Until the final close of production in 1939, the firm of Verrerie d'Art-René Lalique & Cie., at Wingen-sur-Moder produced an extensive range of vases, glasses and other tableware, as well as scent bottles and the famous motor car mascots. Lalique's greatest distinction was not for any remarkable quality of work, but the stylish repertoire of designs ranging from elegant evocations of the Art Nouveau age through the modern motifs of Art Deco. Combining modern techniques of mass production with a high level of artistic involvement, Lalique raised glasswork to the level of fine art in an idiom as appropriate to the 20th century as that of Gallé to the fin-de-siècle.

ART NOUVEAU GLASS IN BRITAIN

In England, while William Morris and his followers had sought to redress the imbalance

between mechanical production and the poor quality of contemporary design by reviving traditional crafts, to a large extent, glassware did not benefit from the same outpouring of interest.

STAINED GLASS WINDOWS

To the Arts and Crafts Movement, glass meant stained glass windows, and within the movement the two most famous makers of decorative glass were the firms of Powell's of Whitefriars, and James Couper & Sons of Glasgow. From 1890 to 1900, Powell's had pioneered forms of glass which relied more on firing techniques and upon the form itself rather than the decoration. The firm had earlier produced stained glass for Morris & Co. and simple, uncut table glass for the architect Philip Webb, and were happy to absorb the Arts and Crafts principles of beauty lying in shape and method of production rather than applied decoration.

CLUTHA GLASS

Truly distinguished glassware was developed by Christopher Dresser for Couper & Sons in the mid-1890s when the firm produced a range called Clutha glass. Freed by the nature of glass from an adherence to strict principles of utility, Dresser's forms are irregular, following the sinuousness and rhythms of organic growth that is the central motif of Art Nouveau.

The blown Clutha glass uses opaque green glass, often shot with translucent streaks of gold or cream, and was the result of Dresser's interest in ancient Roman and Middle Eastern glass. Similar Art Nouveau forms were also used by the firm of Stuart & Sons of Stourbridge, which specialised in furnace decoration, and Stevens & Williams, also of

Above: The Daum Brothers' glass is clearly influenced by Gallé.

Above: The Daums achieved a consistently high standard, decorating their surfaces with a charming, light touch.

Stourbridge who experimented with crackled glass and silver deposit decoration.

ART NOUVEAU GLASS IN AUSTRIA

If the great names of Art Nouveau glass in France and America are Gallé and Tiffany, in Austria the greatest of the Art Nouveau glass makers was the Loetz factory. Surprisingly, Loetz glass is the least highly valued today in terms of the art market largely because the glass remains 'anonymous': it relates not to a named, individual or personality but to a corporate image.

THE LOETZ FACTORY

The Loetz factory was founded at Klostermühle in 1836. In 1879 Max von Spaun became head of the factory and for the next eleven years he oversaw the production of seven varieties of decorative glass, many of which attempted to imitate the surface appearance of different types of hardstones. The firm produced its first iridescent pieces in the 1880s and in 1898 at the Vienna Jubilee Exhibition, Loetz showed a major group of iridescent glass. In addition to the designs by von Spaun himself, Loetz also commissioned designs from Joseph Hoffmann, Kolomon Moser, Otto Prutscher, Dagobert Peche and Michael Powolny. The members of the Wiener Werkstätte were involved as designers with most of the leading Austro-Hungarian glass houses at this time, as they were with most of the potteries and in this period, Loetz executed pieces on commission from members of the Werkstätte.

Two other prestigious firms in Austria, J. & L. Lobmeyr and Graf Harrach, were located in Vienna. Lobmeyr produced high-quality

Left: Daum Brothers' glass chalice.

table glass but they also marketed decorative items including engraved and etched work on enamelled pieces in a rather Middle-Eastern style. The company also produced pieces designed by the members of the Werkstätte and Joseph Hoffmann designed what is probably his best known range of decorated glass for Lobmeyr. These pieces of clear or matt glass were decorated with opaque black or grey motifs in a type of decoration known as 'bronzidecor'.

HARRACH GLASS HOUSE
In 1898 at the Vienna Jubilee Exhibition, the Harrach glass house showed glass that was obviously in imitation of the great American glass maker, Louis Comfort Tiffany. But, by 1900 the company had widened its scope to include cameo glass in the style of Gallé and enamelled pieces decorated with designs inspired by Alphonse Mucha.

Below. Owls Bracelet by René Lalique, c.1900-01 in gold, glass, chalcedony and enamel

GERMAN GLASS
In Germany there were a number of important Art Nouveau designers, the most significant of whom was Karl Koepping. He had trained as a painter and etcher in Munich but began experimenting in glass around 1895. To execute his designs, Koepping hired an expert glass blower Friedrich Zitmann but after a disagreement in 1896, Koepping's pieces were made by the impressively named, Grossherzogliche Sachsische Fachshule und Lehrwerkstätte für Glasinstrumentmacher und Mechaniker. Koepping's tall, spindly pieces with extraordinary curving stems, were greatly admired and were sold by Bing in Paris at La Maison de l'Art Nouveau. Zitmann continued his own glass-making enterprise, and around 1897 began making iridescent glass with bubbling and pitting which imitated the amazing surface effects of recently excavated ancient Roman glass. Glass of this type

Right: A Lalique 'Styx' flacon for Coty, 1910-13.

15

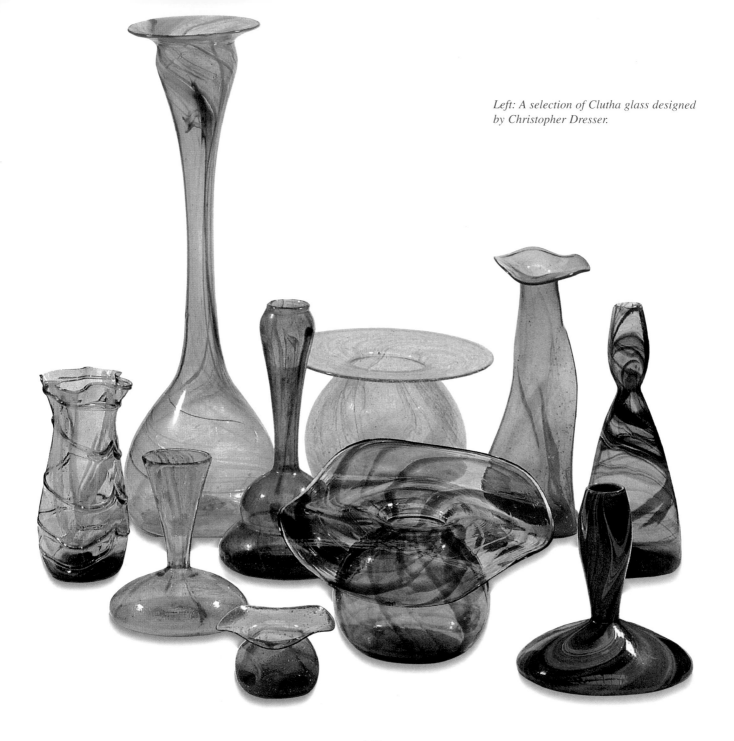

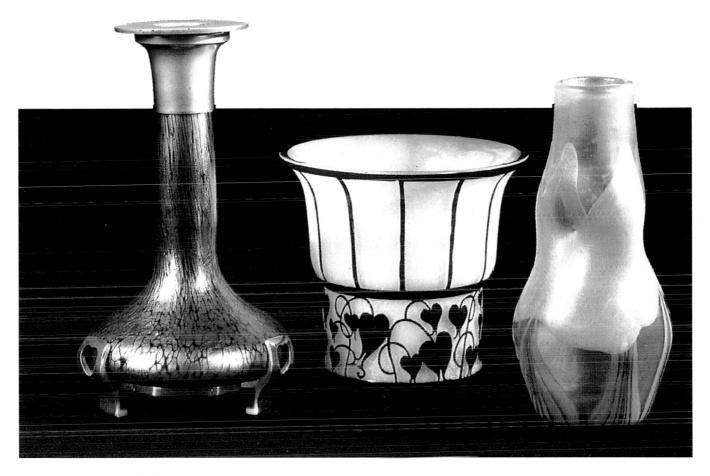

was also to be the inspiration for Tiffany's Cypriote glass which he first made around 1895-96.

The German Secessionist involvement in glass was not as influential or as widespread as in Austria. The WMF glass factory, established in 1881, principally made glass liners for its metalwork. In 1883 it did establish a serious glass concern but did not produce art glass until the 1920s when they marketed iridescent pieces called Ikora-Kristall and Myra-Krystall.

A NEW CHALLENGE

The invention of the incandescent electric lamp by Thomas Edison in the 1880s gave a new challenge to glass designers, who were no longer bound by the need to create lamps that could shield users from a flame. Louis Comfort Tiffany was among the first to recognise the potential of electricity for the Art Nouveau style and his name was to become synonymous with the style of lamp which used coloured glass set into leaded panels rather like a stained glass window.

Above: Austrian Art Nouveau glassware by (left to right) Zasche, Powolny and von Harrach.

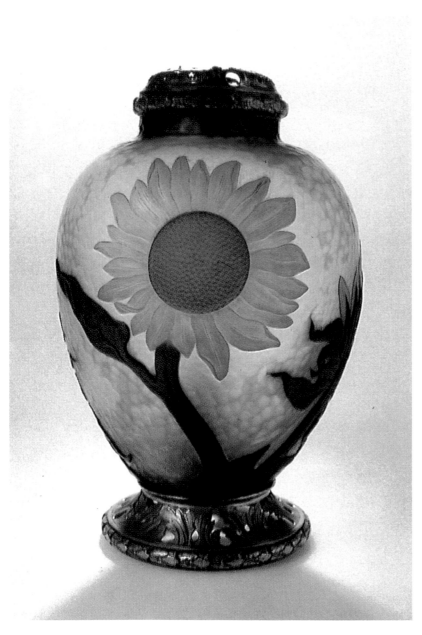

MIXED MEDIA

The opportunity for mixed media work in glass, metal and ceramics was to give the electric lamp an instant appeal for Art Nouveau, quite apart from the bright, even light that it could harness as part of the overall composition. It is a typical tendency of Art Nouveau that the modernity of the electric light, with its startlingly technological aspect heralding the dawn of a new age, was to be ignored by many designers. Instead, filtered by coloured glass, the electric light became a gentle glow, a part of the fantastic idylls of decorative lilies, swans and butterflies that kept the Art Nouveau interior separate from, and unsullied by, brutish technology.

The treatment of the electric lamp in the hands of the masters like Gallé or Tiffany parallels the use of wrought iron in architecture by Horta or Guimard. It is used willingly, but, although playing a major part in the whole, it is masked by its conversion, against its very manufactured nature, into the organic world of Art Nouveau.

Both Gallé and the Daum brothers produced lamps in a style very similar to their other glassware. Glass figured as both base, neck and shade, and, typically, the form of the mushroom was used as the most analogous form in nature. While other table, bracket and standing lamps did use more metalwork, the plant form naturally remained part of the design.

METAL PLANTS

In works by Louis Majorelle, Hector Guimard, Eugène Vallin and Emile Gallé, sinuous metal plants or tree saplings are created which flower

Left: A Daum Brothers' night-light. The combination of glassware and electric light was irresistible to Art Nouveau designers.

into electric bulbs. These were used in the same way in which an Art Nouveau designer set a precious stone in a piece of jewellery: the whole setting, whether a vine, a tree or a flower, constitutes the bulk of the work, while the light bulbs are scattered around the metalwork as highlights.

LAMPS

While many Art Nouveau lamps feature glowing flowers, the bronze or gilt statuettes of nymph-like figures that were produced by many craftsmen could also be adapted to carry an electric light. In so doing, these pieces provide an interplay between function and ornamentation. The lightly-draped female figures which supported desk lamps are perhaps, an indication of Art Nouveau's retreat from the challenge of the new medium, for they have an escapist charm. To the next generation of designers, they revealed only a retreat into the impractical fantasies at odds with the nature of the artefact itself. From the wide range of Art Nouveau craftsmen and designers, only the Belgian Henry Van de Velde, commissioned by Bing, produced an electric lamp that took as its starting point the functional, practical and scientific nature of the medium.

ARCHITECTURAL GLASS

If the 1900 Paris Universal Exhibition marked the high point for luxury and elaborately wrought glass into works of art, it was also the occasion for a prediction by Eugène Houtart that 'Steel and glass are without doubt the two elements which will characterise the twentieth century and will give their name to it.' After the First World War, Houtart's prediction seemed to find its fulfilment when glass became the chosen material for designs of every scale, from the mass production of

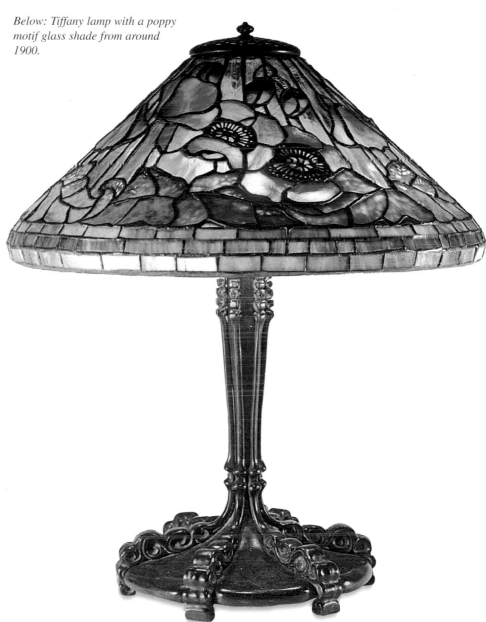

Below: Tiffany lamp with a poppy motif glass shade from around 1900.

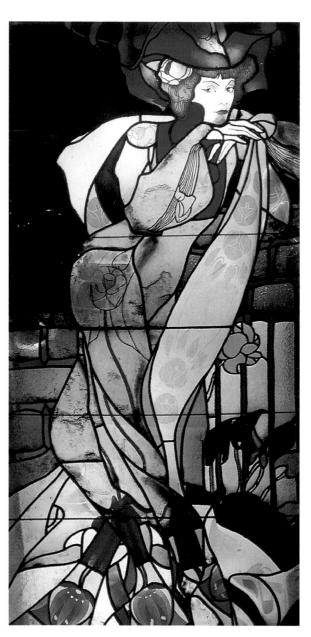

Right: A window by Georges de Feure. The elegant and alluring female is derived from the work of Aubrey Beardsley and relates strongly to de Feure's graphic work.

Lalique's perfume bottle, to the glass curtain-walled architecture of the Modernists.

At the end of the 19th century, however, a more traditional part of glass design was that of stained glass. A huge revival of interest in its design and manufacture had accompanied the Gothic revival and it continued to be an important art form with the medievally-inspired English Arts and Crafts Movement.

MORRIS & CO.

In its early years, the firm of Morris & Co. had depended financially on their stained glass. Dante Gabriel Rossetti, Henry Holiday and William Morris had all designed stained glass to meet the ecclesiastical demand created by the Gothic revival, but the firms' most notable designer was the painter Edward Burne-Jones who adopted a free flowing style in both lead lines and painting with strong, vibrant colours and naturalistic form.

INFLUENCES

The Art Nouveau treatment of stained glass grew from this revival, and profited by the growing decorative similarities between stained glass, embroideries and paintings. The first two crafts ,by their very nature, were concerned with two-dimensionality, and, took their cue from the craftsmen, painters and graphic designers of the 1890s such as Paul Gauguin, Toulouse-Lautrec, Aubrey Beardsley, Alphonse Mucha, Will Bradley and Gustav Klimt were also exploring the flat decorative arrangement of colour in their work.

For the Art Nouveau designer then, stained glass was not so much a revivalist anachro-nism, but a medium that was perfectly suited to the flatness, linearity and love of light and colour that were common to all the contem-porary decorative arts. As an ensemblier, the

Art Nouveau designer often wanted to control the quality and strength of the light cast on his interiors by making it harmonise with the flowing plant forms of the furniture, wall paper and table ornaments. Tiffany even believed that stained glass in architecture played an important social role. In an age when city dwellers were often looking out onto a bare wall, a stained glass window could shield the owner from such a brutal sight and provide him with an idyllic Art Nouveau world of flowers, butterflies and birds to gaze upon instead.

Widely manufactured, stained glass was evident to some degree in almost every well-to-do home of the period. Yet most Art Nouveau stained glass did not represent the highest levels of craftsmanship, but rather, regularly shaped, painted or enamelled panes that were easy to produce and assemble. Only in the finest quality designs was the traditional method of production retained in which each motif was carefully outlined in lead, using panels of different shapes and sizes. In Nancy, Jacques Gruber produced his stained glass in this way as did Hector Guimard in Paris.

For many of the Art Nouveau architects, glass was designed as part of an architectural whole. Charles Rennie Mackintosh's designs for Miss Cranston's Willow Tea Rooms in Sauchiehall Street, Glasgow featured five tea salons, a dining gallery and a billiard room. All were decorated with a willow-leaf motif and abstracted forms related to tree shapes. The Room de Luxe was painted white with a dado, above which on three sides, was a mural made of mirror glass panels. The doors and windows were of leaded glass with the dom-

Right: The Angel Musician stained glass window designed by Edward Burne-Jones.

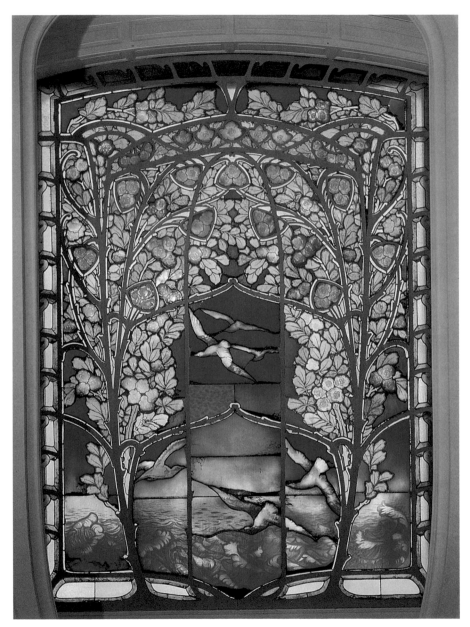

inant colours of purple and rose and a chandelier made of glass bubbles.

HECTOR GUIMARD

In Paris, one sees in Hector Guimard's stained glass the same abstract arches, bows and ripples evident in his ironwork. The Swiss typographer Eugène Grasset, who was also based in Paris, produced stained glass designs, too. His, however, were more traditional in subject matter than Guimard's and were strongly related to his and other's contemporary graphic art, with Art Nouveau maidens idling in summer landscapes.

Left: A window at the medical school in Nancy, France, designed by Jacques Gruber.

ART NOUVEAU GLASS
IN AMERICA

Towards the end of the 19th century, many contacts were made across the Atlantic in the field of the decorative arts. In 1876 Christopher Dresser gave a series of lectures in Philadelphia; in 1882 Oscar Wilde arrived preaching not only aesthetic ideals, but also that America should find the inspiration for her art in her own lands and not copy the styles of the past from dissimilar countries – a healthy attitude for a relatively young country. In 1893 Samuel Bing, the founder of La Maison de l'Art Nouveau, the showcase for the new style in France, visited America. In 1896 C.R Ashbee made his first visit and in 1901 met with Frank Lloyd Wright.

Above: Louis Comfort Tiffany in his middle years.

Overleaf: The John Harvard Memorial Window by John La Farge in St John's Chapel, Southwark Cathedral, London.

The flow of ideas was not only one-way, however. In the same year that Wilde toured America, the Boston architect Henry H. Richardson visited England and met William Morris and Burne-Jones. In 1889 an exhibition of American arts, including Rookwood faience ceramics and designs by John La Farge, was held in London.

GLASS IN AMERICA

While the middle of the 19th century in England had seen a considerable revival in the art of stained glass, America had not had a Gothic revival that brought with it a re-emergence of ecclesiastical art. Consequently, in America it was not until the end of the century that stained glass was seen as a promising art form.

In 1872 the illustrator and watercolourist John La Farge visited France and England where he not only admired, but met with some of the Pre-Raphaelite painters and saw the work of Morris & Co. La Farge produced his first stained glass in New York in 1876 and worked with Boston architect Henry H. Richardson and also Stanford White, who was part of the team of architects responsible for the Boston Public Library.

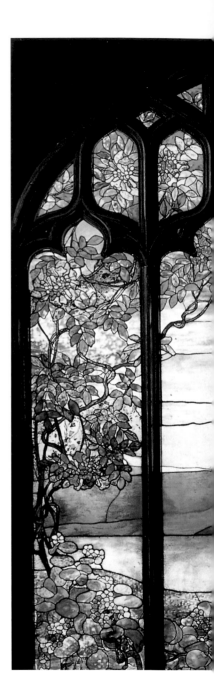

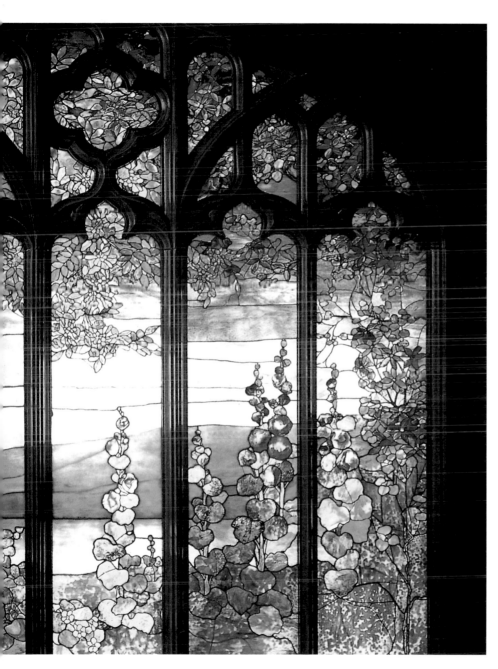

For Richardson's Holy Trinity church in Boston, often considered the finest example of 'Richardson Romanesque', La Farge designed the panels. Around 1887 he began to experiment with different techniques which resulted in an opalescent glass which lent itself to Art Nouveau forms and no longer required painting or etching for its effects.

THE UNDOUBTED LEADER: TIFFANY

The undoubted leader in the medium, however, was Louis Comfort Tiffany. A true child of Art Nouveau, his designs and his sense of beauty matched exactly the ideals of his time. But Tiffany was no mere imitator of a fashionable artistic creed. Instead he was one of the most original designers of the Art Nouveau style and as such, his work set the standard for his peers.

TIFFANY

Tiffany's technical virtuosity is compelling. In his stained glass windows, the stippling of a bird's feather, the roughness of the bark of a tree and the gleam of water are all reproduced in the great pictorial windows he made, but none of these textures is drawn or marked into the glass. Tiffany used the mosaic system of the medieval craftsman, but his pieces of glass were not of pure colour. Instead they were a collage of colours – striped, mottled, patterned and spotted – and the colour variations themselves were contained within the glass. All the pieces in the designs are matched to allow the colours and textures to flow in a painterly manner, and the absence of brushstrokes allows the light to pass

Left: In this Tiffany stained glass window entitled 'Hudson River', plant forms dominate a vivid landscape.

157

unhindered through the glass.

Tiffany worked unceasingly towards the aim of creating paintings in glass and it is in his abstract designs that he proved a master in stained glass. Before 1890 he designed stained glass windows that made perfect use of glass as an artistic medium. In his abstract work, in which the geometry of coloured glass is delineated by the black line of the lead, Tiffany conveyed perfectly the use of light and design that made glass its own medium and no longer an imitation of painting.

THE TIFFANY GLASS COMPANY

Tiffany also perceived a social need for decorative stained glass to create interiors full of light and warmth, where perhaps otherwise a window, especially in the city apartments, might have looked out only onto a brick wall.

Tiffany was the son of the founder of the legendary New York store, Tiffany & Co. He had studied painting under George Innes and had travelled extensively in Europe before he set up L.C Tiffany and the Associated Artists in 1879 with the help of Candace Wheeler. By the early 1880s they were the most successful New York decorating firm, and in 1882 were commissioned to decorate the White House. By 1885, however, the Association had come to an end and the independent firm of the Tiffany Glass Company was founded.

EARLY INFLUENCES

Louis Comfort Tiffany grew up in the shadow of the Tiffany workshops, and even as a child was privy to the techniques and methods of the craftsmen employed there. In

Far right: Toulouse-Lautrec's painting translated into glass by Tiffany.

particular, Edward C. Moore, a remarkable craftsman, designer and art connoisseur of whom Samuel Bing said 'his country should forever shrine him in grateful memory', was uniquely influential. Moore did not look to Europe for inspiration but rather to the East. He admired Persian and Islamic art with their geometric abstractions of natural forms and sumptuous intricacy of design. Later he became absorbed in Japanese art and its masterful use of metals. The first American to win a European award for his craft as a silversmith (the Gold Medal at the 1878 Paris Exposition), Moore was a great collector and amassed a significant collection of Oriental and antique glass which was to be of great interest in later years for Tiffany.

SOCIETY OF AMERICAN ARTISTS

Tiffany began his artistic career as a painter and exhibited regularly. Although he rarely sold his paintings, he was also active in promoting the works of other artists and helped to found the Society of American Artists which included George Innes and La Farge. Among his closest friends, however, was Samuel Colman a watercolour artist whose real interest lay in textiles. It was Colman who was directly responsible for moving Tiffany away from painting into the field of applied art.

THE FIRST EXPERIMENTS IN GLASS

Although he began as a painter, Tiffany's wealth allowed him to pursue other interests, and in 1875 he began his glass experiments in the Thill glass house in Brooklyn. He also travelled widely and collected antique Greek

Right: Not painted on glass, but an opaque glass mosaic that contained colour and texture within itself.

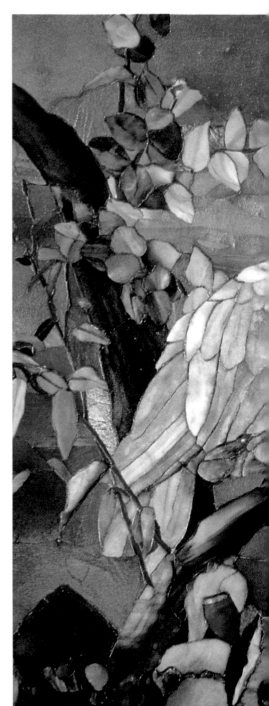

Above: A silver teaset, embellished with etching and enamels, is characteristic of the work of Edward C. Moore, the master silver smith whose taste was to influence the young L.C. Tiffany.

and Roman glass, and Oriental domestic ware which represented good craftsmanship or illustrated particular working techniques. Often they carried designs from nature and thus the objects were both functional and decorative.

LOUIS C. TIFFANY AND ASSOCIATED ARTISTS
In an effort to demonstrate his own ideas regarding the unity of the arts and especially on the intermarriage of architecture and design, Tiffany invited Candace Wheeler, Samuel Colman and the collector Lockwood de Forest to join him in a design venture. The group operated under the name of 'Louis C. Tiffany

and Associated Artists', and negotiated with the Society of Decorative Art for the exclusive rights to design, supervise and sell the works of its members. The overall aim was to provide 'perfect interiors' and among the many commissions they undertook were the private homes of Cornelius Vanderbilt II, the Metropolitan Museum's founder J. Taylor Johnston, the writer, Mark Twain, as well as decorating the White House. The *piece de resistance* of this scheme – unfortunately demolished in 1902 – was an opalescent glass screen that reached from floor to ceiling and which featured an intricate interlaced motif

of eagles and flags.

Tiffany also continued his own work in glass and in 1878 established his own glass house. Unfortunately, this burnt down twice and it was subsequently closed down. He then began experiments at the Heidt glass house in Brooklyn and applied for a patent for a new character of glass in coloured windows. The glass tiles and lighting fixtures in many of the interiors he had designed had already attracted attention. In 1881 *Scribner's Monthly* devoted an article to glass mentioning Tiffany and La Farge as the leading exponents of the craft in America.

GLASS TILES

Towards the end of the 1880s, Tiffany began to design a great deal of mosaic work and the glass tiles were the results of his early experiments in opalescent and iridescent glass. In 1880 he made patent applications which specified three types of glass: one for use in tiles and mosaics, another for plating windows and the third to give a metallic lustre. This metallic lustre developed into his famous Favrile glass, but it is important to remember that Tiffany did not invent the iridescent lustre: in 1873 the Austrian glass makers Lobmeyr was selling iridescent glassware, and from 1878 in England Thomas Webb & Sons were producing similar glass. Tiffany never pretended to invent it, but he did believe that he made the best glass of this type.

In his early experiments Tiffany achieved many accidental effects which were quite beautiful, and later he deliberately produced irregularities of surfaces to vary and enhance the qualities of light transmission. Dissatisfied

Right: Antique Persian glassware. Tiffany envied the flowing lines, lustre and textures.

with the 'thin' colours produced by most commercial glass houses, Tiffany produced thick, dense colours ranging from ruby reds to emerald greens while abstract patterns or designs of rosettes and other plant forms were moulded onto the surface of the tiles.

TIFFANY AND ART NOUVEAU

In 1888 Tiffany undertook the commission for the decoration of the Ponce de Léon Hotel in St Augustine, Florida. The results met with high praise from the public and led to many more orders for the interior decoration department of Louis C. Tiffany and Co., the name of his company after he had parted from the Associated Artists. Many artists complained as they watched his workshops flood the market with ever more fashionable art glass windows, that Tiffany had betrayed his talent and opted for commercial success. But in 1892 Tiffany dumbfounded his critics when for Samuel Bing he executed and exhibited a stained glass window, *Four Seasons*. This piece was far removed from the popular designs heavy in pictorial content that Tiffany had produced in such quantities in the United States and marked the arrival of Art Nouveau in his work.

In 1889 Tiffany had visited Paris where he saw the work of the French master glass designer Emile Gallé. Gallé's engraved vases with their free-flowing shapes caught Tiffany's imagination, and in 1893 Tiffany acquired his

Right: Tiffany used glass wherever he could in his interiors. Glass tiles and stained glass dominate Mark Twain's dining room.

Far right: Tiffany's initial experiments in glass making were concentrated on glass tiles.

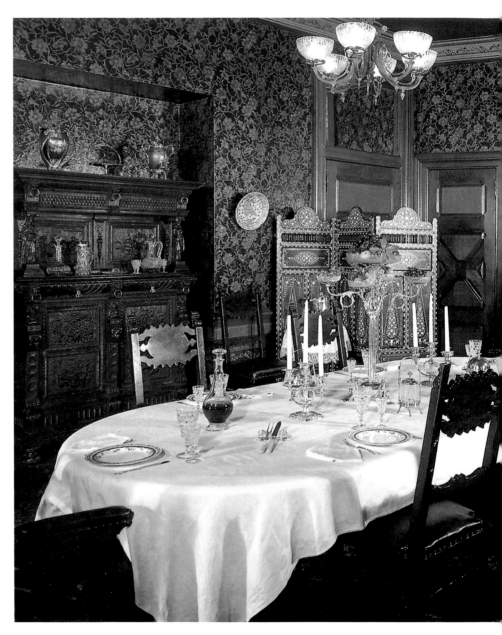

own glass house, the Corona furnaces on Long Island. Between this time and the end of the century, Tiffany was at his most creative and made his own unique contribution to Art Nouveau.

He turned to making what he called 'small glass' that was varied, beautiful, novel qual-ity and that expressed all the principles of Art Nouveau. Essentially organic forms abstracted into decorative surfaces were endowed with an asymmetrical linear quality. Tiffany's favourite motifs for vases were the peacock feather, the iris, morning glories, gladioli, ten-drils and trailing leaves. But no lines were

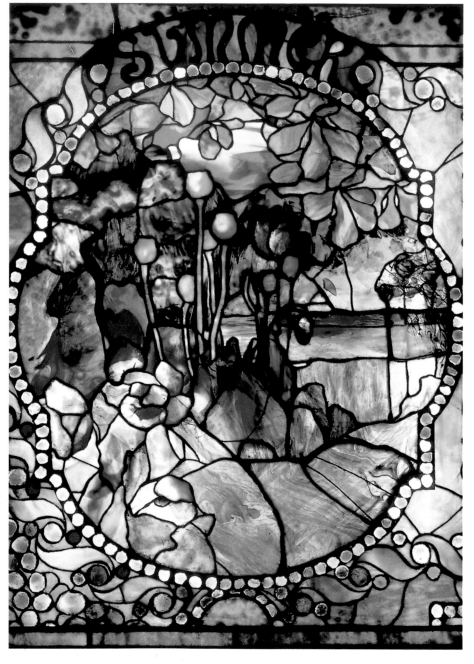

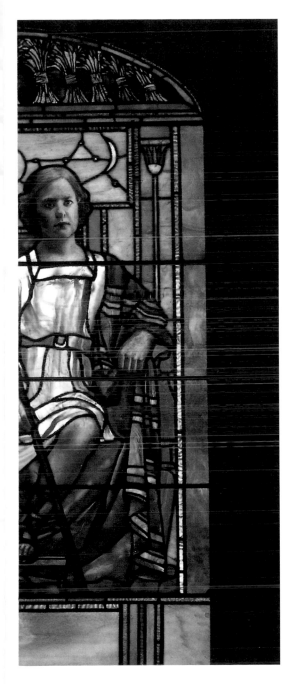

FAVRILE

Far left: The 'Four Seasons' window. Here, 'Summer' is represented in Tiffany's masterly stained glass window.

Centre: Equally popular were Tiffany's religious subjects.

Left: Tiffany registered several trademarks. He designed two seals for his Favrile glass and in 1894 registered a logo for the Tiffany Glass and Decorating Company.

to create different surface textures from a smooth matt to a burnished glow. Tiffany's glass rarely had the modelled plasticity of Gallé or Daum. Its decoration, far more abstract in its depiction of natural forms, rarely rises out in relief, but appears as more of an applied surface pattern.

FAVRILE GLASS

Favrile glass is a generic name: it can be divided into categories based on the various techniques used to make it. Types include Agate Ware, a thick glass which resembled marble; Lava Glass, a dark opalescent glass which had basalt or talc added to the molten glass and the surface then gold-lustred; Cypriote Glass, where the hot yellow glass of the object was covered with pulverised crumbs of the same material and then lustred. Paperweight or Reactive Glass is the term that is applied to all of Tiffany's translucent glass that had changed colour and become iridescent when it was reheated in the furnace. This was Tiffany's most technically complicated glass and no other glass maker has ever sought to imitate it.

In addition to these, Tiffany also made another kind of Favrile glass called Cameo Glass. It was the only type of Tiffany glass

drawn or painted onto the vases, instead the molten glass was blown with small amounts of coloured glass of different textures and colours were combined and manipulated to form the decoration.

FAVRILE GLASS

In 1894 Tiffany registered Favrile as a trademark. The name is derived from the Old English word 'fabrile', meaning belonging to the craft, or 'hand-made'. The first year's production had gone straight into museums and it was not until 1896 that the first Favrile glass was offered for public sale. Favrile glass exploited the use of chemical soaks or vapours

Below: Three Chinese blue-and-white vases dated c.1640 (left) and 1662-1722 (middle and right).

helped Art Nouveau designers to create new artistic effects in ceramics. Supporting the works of the pioneering French ceramicists, in 1881 the Haviland workshop moved from Auteuil to Paris where it was managed by Ernest Chaplet. Here, Chaplet re-discovered

the technique for producing the much envied *sang-de-boeuf* (oxblood) glaze of Chinese stoneware, which was, as its name implies, deep red in colour. The secret of the process Chaplet never divulged, but versions were developed by contemporaries such as Adrien-

Pierre Dalpayrat, the inventor of a similar, copper based 'rouge Dalpayrat'. Dalpayrat is best known for his stoneware vases, sculpted either in strange twisted shapes, or in the form of animals, fruit or vegetables.

CHAPLET AND HAVILAND'S

In 1885 Chaplet bought the firm from Haviland's and together with Edouard and Albert Dammouse, Ringel d'Illzach, Hexamer and many others, Chaplet made dark red-brown stoneware with incised decoration, the coloured glazes encircled with gold in the manner of cloisonné enamels. It was at this time that the painter Paul Gauguin started experimenting with ceramics which were fired by Chaplet. Gauguin produced works which were free from the conventions of a specialist. His lack of inhibition in handling the clay resulted in primitive vessels of swelling and flowing forms many with gnarled and twisted handles. These works, which were few in number, were produced in the late 1880s, both before and after Gauguin's trip to Martinique and predate the development of the Art Nouveau proper of the 1890s.

PÂTE-SUR-PÂTE

Dammouse, who trained as a sculptor before devoting himself to ceramics, began his career by decorating in *pâte-sur-pâte* (paste on paste) in which decorations were built-up in low relief with layers of porcelain slip. The varying thicknesses give the effect of shading in the design. When Chaplet sold Haviland on to Auguste Delaherche, Albert Dammouse set up his own studio in the village of Sèvres where he made stoneware, faience and porce-

Right: Stoneware vase by Adrien-Pierre Dalpayrat with ormolu mounts by Keller.

lain ornamented with flowers and leaves. He then turned to making vases and bowls in a distinctive translucent paste of his own invention, and which were first exhibited in 1898.

Chaplet's decision to sell Haviland was based on his desire to continue his research into flambé glazes. The remarkable results ranged from the shiny *sang-de-boeuf* to veined, spotted and pitted turquoise and white.

AUGUSTE DELAHERCHE

Auguste Delaherche was a more prolific ceramicist than Chaplet. Between 1883 and 1886 he worked in saltglaze stoneware, but his aim to sell art ceramics at low prices met with little success. He began to use drip glazes which he had seen on Japanese stoneware, with engraved or raised floral decoration, which won him a gold medal at the 1889 Universal Exhibition in Paris. In 1894 Delaherche began a ten year period of experimentation in deep, pure, monochromatic glazes on simple forms. After 1904, he made unique pieces, only keeping those which were perfect and refusing to accept any result, however beautiful, that was accidental. At the age of 68, Delaherche began to make delicate white porcelain vases with a pierced decoration of stylised flowers, now very rare.

CARRIÈS AND THE SCHOOL OF SAINT-ARMAND

A second centre for the production of stoneware was in the Nivernais region at the School of Saint-Armand-en-Puisaye. The leader here was the charismatic but short-lived figure Jean Carriès, who died aged 39. Out of his hands grew grotesque masks, goblins and fanciful animals. These bizarre creations are

Above: A hard-paste vase (1885-1904) by Ernst Chaplet, inspired by oriental sang-de-boeuf.

Right: A stoneware dish by Ernst Chaplet.

Far right: A stoneware vase by Albert Dammouse, c. 1900..

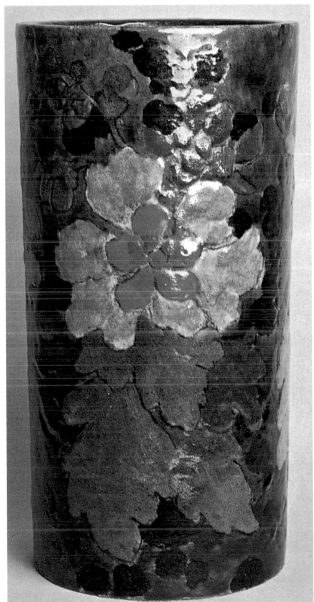

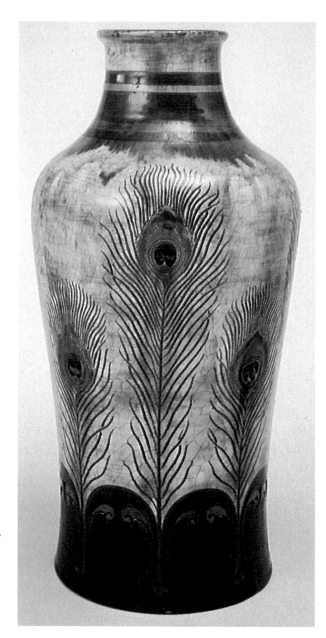

Right: Auguste Delaherche vase with blue drip glaze and peacock feather motif.

Far right: A selection of pierced stoneware vases by Auguste Delaherche.

some of the best examples of the fanciful and almost surreal side to much of the Art Nouveau borrowings from nature. All his work was left to his great friend Georges Hoentschel, a celebrated decorator, who also began to make stoneware for himself. Closer to the Japanese originals than Carriès, vases in sober blue, green, grey and beige were sometimes finished with ivory stoppers, and others were sometimes mounted in ormolu.

CERAMIC SCULPTURE AND ARCHITECTURE

Art Nouveau ceramic production was not simply limited to vases and bowls, but extended to the production of editions of sculptures. The application of stoneware to architecture was an important feature of the style. The leading figures in this field were Alexander Bigot, Emile Muller and Edmond Lachenal.

From 1894 Bigot produced plates with newts, frogs and mermaids in low relief swimming among deep translucent glazes, but from 1900, he turned towards making stoneware for both inside and outside buildings, among them Guimard's Castel Béranger, as well as editing sculptures.

IVRY

Muller's factory at Ivry produced stoneware sculptures and he was responsible for the edition of the well-known portrait of Yvette Guilbert by Toulouse-Lautrec. Muller, together with the firms of Gentil et Bourdet and Hyppolyte Boulanger, made much of the architectural ceramics of the time. Lachenal was a painter, sculptor and decorator whose stoneware vases ornamented with flowers and animals had a certain success, but he became particularly well known for his stoneware editions of Art Nouveau sculptures by Rodin, de Frumerie, Dejean, Fiz-Masseau and Saint-Marceaux.

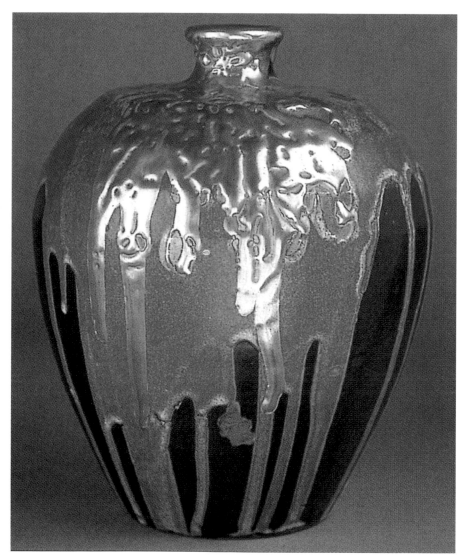

Above: A gourd-shaped vase by Jean Carries exploiting poured glazes and enamel rich in oriental colours.

BRITAIN

The three principal influences in the applied arts in Britain in the second half of the 19th century were Gothicism, japonisme and Islamic art, and British ceramics of the late 19th century show these three very strongly. The willowy 'whiplash' curves of French Art Nouveau had a minor effect.

The 1870s had seen the foundation of a number of art-potteries which attempted to produce ceramics based on new ideas in design outside of the industrial factories. Of these the most important were Minton's Art Pottery Studio in London, the De Morgan Pottery, the Doulton factory of Lambeth, London and the Linthorpe Pottery of Middlesbrough in Yorkshire founded by John Harrison and Christopher Dresser in 1879.

SALTGLAZE

Doulton was concerned principally with the revival of medieval saltglaze stoneware, but also produced painted wears called Impasto and Faience, the latter based on the poster art of Alphonse Mucha. It was this type of pottery that was also the main product of Minton's Art Pottery Studio.

One of the most important British designers of the period was Christopher Dresser who began his career as a botanist before designing wallpaper, furniture, textiles, metalwork, glassware and ceramics for a number of companies. At the Linthorpe Factory most of Dresser's ceramic pieces in dark, green-brown streaky abstract glazes, were influenced by his extensive knowledge of Japanese ceramics, while his monochrome yellow, green or blue wares were influenced by Chinese examples which Dresser also designed for Ault in the 1890s.

Art pottery was perhaps the area of design

where Arts and Crafts ideals were most widespread. Practically and financially, art pottery was – and is – a form where the artist-designer and craftsman could be one, and it is interesting to note that in America, many art potteries were established either for therapeutic purposes, or to provide a useful, but suitably lady-like occupation for women.

CERAMICS IN AMERICA

The initial impetus for American pottery came with the Philadelphia Centennial Exposition of 1876 where the first Oriental exhibits could be seen alongside works from the Doulton factory and Ernest Chaplet. Both the Robertson family from the Chelsea Ceramic Art Works, and Mary Louise McLaughlin visited the ex-

Below: Stoneware vases and pears by Georges Hoentschel, Emile Grittel and Henri de Vallombreuse, c.1900.

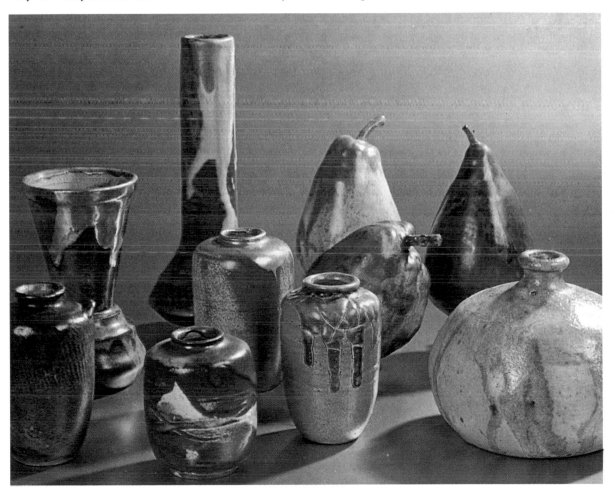

hibition of ceramics and returned to their home states of Massachusetts and Ohio to put what they had seen into practice.

The development of American ceramics ran parallel to experimentation with the use of exotic glazes on simple stoneware shapes that occurred in France. The Roberstons specialised in Greek terracotta forms at first, but by 1877 had introduced their Chelsea faience, using simple shapes and soft colours. Around the

Above: A ceramic bust by Gustave Obiols. The dreamy maiden returns, this time in clay.

Left: Stoneware bust, 'Flore', by Louis Challon and Emile Muller, c. 1901.

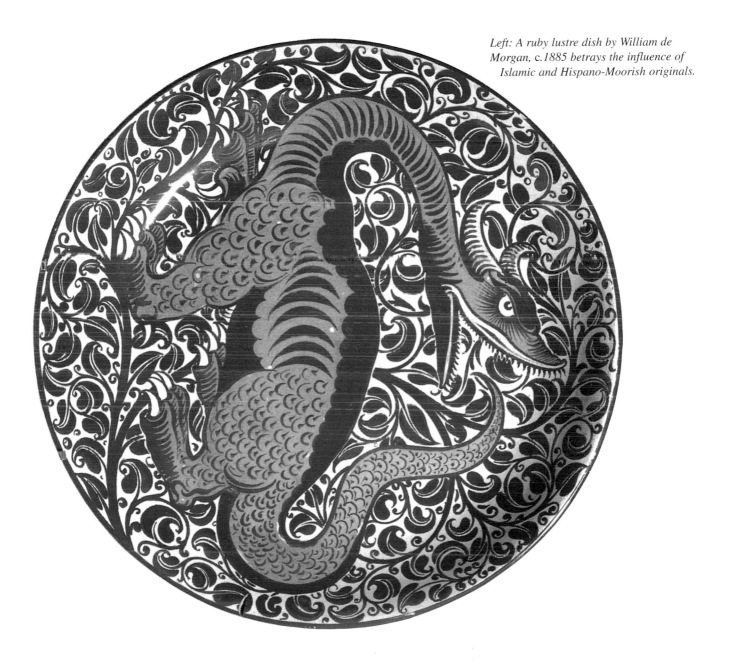

Left: A ruby lustre dish by William de Morgan, c.1885 betrays the influence of Islamic and Hispano-Moorish originals.

same time the process known as barbotine, painting with coloured slips, usually on a blue or green background was introduced. Further experiments resulted in an American version of *sang-de-boeuf,* but also in financial trouble. The Chelsea works closed, but were re-opened in 1895 along more commercial lines as the Dedham Pottery, best known for its crackleware with blue-in glaze borders decorated with flowers and animals.

UNDERGLAZE

In Cincinnati, McLaughlin, an amateur enthusiast and another exponent of the underglaze technique, developed her Limoges glaze, which became known as Cincinnati Limoges. In 1879 she founded the Cincinnati Pottery Club to encourage other women in the craft. From 1881, the club used the firing facilities at the Rookwood Pottery, one of the most famous of the 30 or so potteries in Ohio. Rookwood was started by Maria Longworth Nichols Storer with support from the ladies at the Cincinnati Pottery Club, and from 1880 to 1884 the output at Rookwood mainly consisted of the ladies' experiments, usually with much gilding and heavy relief or incised decoration. After this Rookwood was reorganised on a more commercial footing, but always maintained the tradition of allowing individual artists a free hand in their designs.

Rookwood ceramics were often characterised by underglazing, a difficult technique requiring mild firing to maintain the warm coloured glaze. When the pottery won a Grand Prix at the 1900 Paris Exhibition, a craze started for its elegant wares. Best known perhaps

Left: Grotesque vase designed by Christopher Dresser for William Ault, c. 1892.

are the vases, decorated with floral themes, animals and flowers – especially orchids and lilies – where the Art Nouveau style was seen to some degree in the elegant, elongated vase forms and curving plant-like handles.

DOAT

One of the most remarkable examples of the ascendancy of American pottery was the University City Pottery in Missouri. The pottery belonged to the Art Institute of the People's University started by the entrepreneur Edward Garner Lewis. Lewis was himself interested in ceramics and self-taught using a translation of French ceramicist Taxile Doat's *Grand Feu Ceramics* a treatise on new techniques in firing and glazing.

Doat was a ceramicist who made his name working in Sèvres, while at the same time, maintaining an independent production. Doat treated porcelain to the techniques of the stoneware innovators using dripped glazes and even the vegetable shapes of gourds, pumpkins and pears which had also been used by Carriès at Saint-Armand. Doat also varied the texture of his works by having pâte-sur-pâte medallions, like ancient cameos, applied to the surface, which proved to be popular.

Offered an extremely fine porcelain clay that had been found in the area, Doat was lured from his native Sèvres – along with his ceramics collection – by Lewis to University City in 1909 where he stayed for some five years giving Missouri stoneware an international reputation.

Although more usually associated with glass, Louis Comfort Tiffany began experimenting with pottery in 1898 at his Corona works in New York but from its inception, Tiffany's pottery was overshadowed by his Favrile glass and none of his ceramic wares

Left: Blue and white serving bowl by Dedham Pottery who were best known for their animal and floral border patterns.

Below: A Rookwood Pottery tile, c.1911, features a pair of rabbits flanking a tulip tree.

Left: A stoneware vase by Jószef Rippl-Rónai for Zsolnay of Hungary. The Hungarians introduced a distinctly central European element to forms and colour.

Below: A Rookwood Pottery vase, exhibited at the Paris Exposition Universelle in 1900.

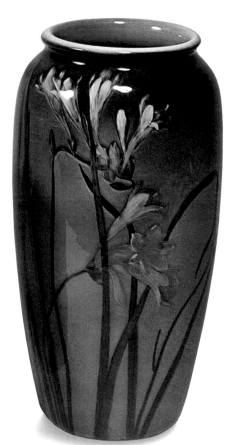

were offered for public sale until 1905. The pottery bases for his famous lamps were in fact purchased from the Greuby Pottery.

EASTERN EUROPE

Throughout the whole of Europe, ceramics followed much the same pattern as in most other countries. There were studio potters experimenting with new techniques, many small art potteries, as well as some fine work produced by some of the large established firms such as Meissen and Berlin in Germany, Joseph Bock in Vienna, the Rozenburg pottery in The Hague, and the two great Swedish factories, Rorstrand and Gustavberg.

An outstanding example of Hungarian Art Nouveau ceramic production is Zsolnay Pottery. Founded in 1862 by Vilmos Zsolnay at Pécs, in its early days it produced earthenware in a semi-industrial, semi-folk style. In 1893 Vinsce Wartha was appointed artistic director and it was he who developed with Zsolnay the famous iridescent lustre glaze called Eosin.

Stylistically, Zsolnay's products can be divided into six groups: those in a traditional style; those in Lustre resembling Tiffany or Loetz glass; the figures; the dishes painted with flowers and landscapes in red, green and blue; the pots with animals sculpted in high relief and the pieces made early in the 20th century which show the influence of the Vienna Secession. In artistic terms, the designer Jószef Rippl-Rónai marks the high point in the factory's history for his flowing floral patterns and designs are most evidently Art Nouveau.

MAJOR CRAFTSMEN AND DESIGNERS

ASHBEE, Charles Robert (1863–1942)
British Arts and Crafts architect, designer
and writer; he founded the Guild of
Handicraft in 1888.

BAILLIE SCOTT, Mackay Hugh
(1865–1945)
British architect and designer, he worked
extensively abroad.

BEARDSLEY, Aubrey (1872–98)
British decadent writer and illustrator
famed for his consummate graphic skill.

BEHRENS, Peter (1868–1940)
Austrian architect and designer and
member of the Deutscher Werkbund.

BING, Samuel (1838–1905)
German writer and entrepreneur who
opened his shop, La Maison de l'Art
Nouveau, in Paris in 1895.

BRACQUEMOND, Felix-Henri
(1833–1914)
French painter, etcher and ceramicist.

CHAPLET, Ernest (1835–1909)
French ceramicist.

CHARPENTIER, Alexandre (1856–1909)
French Art Nouveau designer and
decorator; he was associated with
Samuel Bing.

COLONNA, Edward (1862–1948)
German designer and decorative designer
working in the United States and France.

CRANE, Walter (1845–1915)
British designer, painter, illustrator and
writer; a socialist, he was president of both
the Art Workers' Guild and the Arts and
Crafts Exhibition Society.

CZESCHKA, Carl Otto (1878–1960)
Austrian painter, architect and designer;
member of the Wiener Werkstätte.

DAUM, Auguste (1853–1909)
DAUM, Antonin (1864–1930)
French glass designers, brothers.

DAY, Lewis F. (1845–1910)
British arts and crafts designer and
writer. A founder member of both the
Art Workers' Guild and the Arts and
Crafts Exhibition Society.

DECK, Theodore (1823–91)
French art potter.

DELAHERCHE, Auguste (1857–1940)
French ceramicist in the Art Nouveau style;
he was associated with Samuel Bing.

DOAT, Taxile (1851–1938)
French ceramicist working at Sèvres and
the University City Pottery, USA.

DRESSER, Christopher (1834–1904)
British industrial designer; after achieving
a doctorate in botany he turned to design
for industrial production.

DUFRÊNE, Maurice (1876–1955)
French designer in the Art Deco style;
worked for Julius Meier-Graefe who
opened 'La Maison Moderne' in 1898.

ENDELL, August (1871–1925)
German architect and designer.

FABERGÉ, Carl (1846–1920)
Russian jewellery designer; jeweller to
the Russian Imperial Court.

DE FEURE, Georges (1869–1928)
French Art Nouveau decorative artist
and designer.

FISHER, Alexander (1864–1936)
British Arts and Crafts enameller; he
studied in France and subsequently set
up his own school in Kensington, London.

GAILLARD, Eugène (1862–1933)
French Art Nouveau designer and writer,
connected with Samuel Bing.

GALLÉ, Emile (1846–1904)
French designer; his Nancy workshops
produced some of the finest examples of
Art Nouveau glass and furniture.

GAUDÍ, Antoni (1859–1926)
Spanish Art Nouveau architect and designer.

GAUGUIN, Paul (1848–1903)
French painter, sculptor and graphic artist; leader of the Pont-Aven group.

GRASSET, Eugène (1841–1917)
Swiss architect, writer and designer working in France in the Art Nouveau style.

GUIMARD, Hector (1867–1942)
French architect and designer working within the Art Nouveau style to create the total environment.

HOFFMANN, Josef (1870–1956)
Austrian architect and designer; a founder member of the Vienna Secession, he founded the Wiener Werkstätte in 1903.

HOLIDAY, Henry (1839–1927)
British painter and stained glass designer.

HORTA, Victor (1861–1947)
Belgian architect and designer in the Art Nouveau style.

JENSEN, Georg (1866–1935)
Danish silver and jewellery designer.

KLIMT, Gustav (1862–1918)
Austrian painter and designer associated with the Vienna Secession.

KNOX, Archibald (1864–1933)
British silver designer who was the inspiration behind Liberty and Co.'s 'Cymric' and 'Tudric' lines.

KOEHLER, Florence (1861–1944)
American Arts and Crafts jewellery designer.

KOEPPING, Karl (1848–1914)
German Jugendstil glass designer.

LALIQUE, René (1860–1945)
French designer, trained as a goldsmith. He opened his glassworks in 1909 and was best known for his jewellery and glass designs.

LOOS, Adolf (1870–1933)
Austrian architect and designer and pioneer of Modernism.

MACDONALD, Frances (1874–1921)
Scottish artist and designer and a member of the Glasgow Four.

MACDONALD MACKINTOSH, Margaret (1865–1933)
Scottish artist and designer and a member of the Glasgow Four. Wife of Charles Rennie Mackintosh.

MACKINTOSH, Charles Rennie (1868–1928)
Scottish architect and designer; leading figure of the Glasgow Four.

MACKMURDO, Arthur (1851–1942)
British Arts and Crafts architect and designer; founded the Century Guild in 1884.

MACNAIR, James Herbert (1868–1955)
Scottish artist and the lesser known member of the Glasgow Four.

MAJORELLE, Louis (1859–1926)
French designer and cabinet maker in the Art Nouveau style.

McLAUGHLIN, Mary Louise (1847–1939)
American pottery and porcelain decorator.

MORRIS, William (1834–96)
British writer, poet and designer; founder of Morris and Co. and the Kelmscott Press; leader of the Arts and Crafts Movement.

MOSER, Koloman (1868–1918)
Austrian painter, designer and graphic artist; involved in the founding of both the Vienna Secession and Wiener Werkstätte.

MUCHA, Alphonse (1860–1939)
Czech artist and poster designer.

MUTHESIUS, Hermann (1861–1927)
German architect and designer; he founded the Deutscher Werkbund in 1907.

ORBRIST, Hermann (1863–1927)
Swiss designer working in Germany.

OLBRICH, Josef Maria (1867–1908)
Austrian Art Nouveau designer, architect and artist. One of the co-founders of the Vienna Secession.

PECHE, Dagobert (1887–1923)
Austrian artist and metalwork designer; co-director of the Wiener Werkstätte.

POWOLNY, Michael (1871–1954)
Austrian pottery decorator and teacher.

PRUTSCHER, Otto (1880–1949)
Austrian architect, furniture designer, jeweller and designer. Worked at the Wiener Werkstätte.

REDON, Odilon (1840–1916)
French painter, lithographer and etcher and an associate of the Symbolists.

RIEMERSCHMID, Richard (1868–1957)
German architect and designer and founder member of the Deutscher Werkbund.

ROHLFS, Charles (1853–1936)
American furniture designer and craftsman working within the Art Nouveau idiom.

ROSSETTI, Dante Gabriel (1828–82)
British painter and poet and leading light of the Pre-Raphaelites. He was also involved in the formation of Morris, Marshall Faulkner and Co.

RUSKIN, John (1819–1900)
Influential British social critic, his writings were the main inspiration for the Arts and Crafts movement.

STICKLEY, Gustav (1857–1942)
American writer and furniture designer, he founded *The Craftsman* magazine in 1901, publicising arts and crafts ideals.

SULLIVAN, Louis (1856–1924)
American architect, the pioneer of the modern office block and father to the Prairie school of architecture.

TIFFANY, Louis Comfort (1848–1933)
American designer and interior decorator; he specialised in stained glass and art glass as well as mosaics, jewellery and metalwork. Acknowledged as a genius and innovator of the Art Nouveau style.

VELDE, Henry van de (1863–1957)
Belgian theorist and designer; he helped found the Kunstgewerbeschule in Weimar in 1906.

VOILLET-LE-DUC, Eugène-Emanuel (1814–79)
French writer and architectural theorist.

VOYSEY, Charles Annesley (1857–1941)
British Arts and Crafts architect and designer.

WAGNER, Otto (1841–1918)
Austrian designer; member of the Deutscher Werkbund.

WEBB, Philip (1831–1915)
British architect and designer; he was associated with Morris and Co. from their foundation. He designed many country houses.

WILSON, Henry (1864–1934)
British Arts and Crafts architect, sculptor and silversmith.

WOLFERS, Philippe (1858–1929)
Belgian Art Nouveau jeweller and sculptor.

WRIGHT, Frank Lloyd (1867–1959)
American architect, writer and interior designer, pioneering an integral, structural style of interior decoration; he was the first major 'modern' American architect.

INDEX

Page numbers in italics refer to captions

Adler, Friedrich 122
Aesthetic Movement 88
American Free Dress Society 102
Art et Décoration 11
art magazines 11
Art Moderne 137
Art Nouveau:
 name 9-10
 origins 11-13
Art Pottery 172-3, 180-1
Art Workers' Guild 37, 72
Artificer's Guild 98, 99
Arts and Crafts Exhibition Society 37, 39, 73
Arts and Crafts Movement 13-14, 36-7, 46-7, 59, 61-2, 69, 72, 73, 78, 97, 101, 103-4, 107, 116, 135, 173, 181
Ashbee, Charles Robert 37, 38, 39, 45, 72, 73, 73, 96, 97, 97, 98, 108, 112, 119-20, 121, 121, 156, 187
Aucoc, Louis 82
Ault, William 184

Baillie Scott, Mackay Hugh 38, 45, 187
Baker, Oliver 100, 120
Balat, Alphonse 22
Barrias, E. 118
Bauhaus 25
Beardsley, Aubrey 76, 152, 187
Beaudelaire, Charles 89-90, 90
Behrens, Peter 21, 45, 107, 122, 125, 187
Belgische Stil 12, 137

Bernhardt, Sarah 83, 84, 93
Bertsch, Karl 44-5
Bigot, Alexander 178
Le Bijou 83
Bing, Samuel 10, 11, 25, 30, 74, 74, 75, 90, 93, 137, 147, 156, 158, 162, 187
Birmingham Guild of Handicraft 37
Blackie, Walter 40
Bock, Joseph 186
Bonvallet, Lucien 117
Boucheron, Frederic 94
Bouval, Maurice 118, 119
Bracquemond, Félix-Henri 173, 187
Bradley, Will 152
Brocard, Philippe-Joseph 140
Bromsgrove Guild of Applied Art 98-9
Bruckmann, P. & Sohne 122-3
Bugatti, Carlo 124
Burne-Jones, Edward 71, 152, 153

Carabin, Rupert 117-18
Cardeilhac 117
Carder, Frederick 166
Carr, Alwyn 99
Carriès, Jean 176-8, 180, 185
Carson, Pirie Scott 65, 66, 66
Cellini, Benvenuto 73
Celtic art 18, 40, 73, 78, 100, 103, 105, 120
Century Guild 14, 37, 72, 135
Challon, Louis 182
Chaplet, Ernest 131, 174-5, 176, 176, 181, 187
Charpentier, Alexandre 30, 118-19, 187

Chevannes, Puvis de 69
Chicago School 61-2
Chinese porcelain 173, 174
Cincinnati Limoges 184
Cincinnati Pottery Club 184
Colman, Samuel 158, 160
Colonna, Edward Eugène 30, 31, 93, 117, 172, 187
Cooper, James, & Sons 135
Copeland, Elizabeth E. 108-9
Couper, James, & Sons 145
Craftsman 61, 61, 62
Crane, Walter 72, 108, 187
Cros, Henri 143
Cuzner, Bernard 120
Czeschka, Otto 107, 187

Dalpayrat, Adrien-Pierre 98, 174-5, 175
Dammouse, Albert and Edouard 175-6, 176
Dampt, Jean 30
Daum brothers 131, 142, 145, 146, 150, 150, 165, 187
Dawson, Edith 99
Dawson, Nelson 99, 100
Day, Lewis 72
de Forest, Lockwood 160
de Morgan, William 136, 136, 183
De Morgan Pottery 180
Deck, Théodore 136, 187
Décorchemont, François-Emile 143-4
Dedham Pottery 185
Delaherche, Auguste 131, 175, 176, 178, 187
Design and Industries Association 99
Deutsche Kunst und Dekoration 15

Deutsche Werkbund 45, 76-7, 124
Deutsche Werkstätten 45
Doat, Taxile 172, 185, 187
Doulton 180, 181
Dresdner Werkstätten 44, 45
Dresser, Christopher 12, 120, 122, 123, 135, 145, 148, 156, 170, 180, 184, 187
Driscoll, Clara 168
Dufrêne, Maurice 94, 187
Duncan, Isadora 102
Dunlop, Sybil 99

Eckmann, Otto 13
Ecole des Beaux-Arts 25
Edison, Thomas 149
Eiffel, Gustave 22
Endell, August 17, 43, 45, 187

Fabergé, Peter Carl 124, 187
Farhner, Theodor 107, 107, 108
Feuillatre, Eugène 94, 117
Feure, Georges de 30-1, 30, 74, 116-17, 116, 152, 172, 187
Fisher, Alexander 98, 99, 100, 187
Follot, Paul 94
Fouquet, Alphonse 83
Fouquet, Georges 83, 93, 93, 94
France, Georgina Cave 98-9
Freschel, Mrs Curtis 167, 168
Fritsche, William 140
Fuller, Loie 102, 118

Gaillard, Eugène 21, 30, 30, 31, 187
Gaillard, Lucien 91, 93, 117
Gallé, Emile 31-2, 31, 32, 33, 70, 74, 76, 131, 138, 140-4, 147,

150, 162, 165, 172
Garnier, Charles 25
Gaskin, Arthur 74, 98, 100, 120
Gaskin, Georgina 74, 100
Gaudí, Antoni 21, 52-9, 52-9, 115, 188
Gauguin, Paul 152, 175, 188
Gilbert, Sir Alfred 119, 120
Glasgow Four 38-42, 102-3, 120-1
Goll, Eugène 143
Goncourt, Edmond 24
Gorham Manufacturing Co. 124-5
Gothic style 14-16, 17, 21-2, 36, 53, 58, 152, 180
Grasset, Eugène 21, 91-3, 154, 188
Greuby Pottery 186
Grittel, Emile 181
Gruber, Jacques 33, 143, 153, 154
Güell, Eusebio 52, 53, 54, 54
Guilbert, Yvette 178
Guild of Handicraft 37, 38, 72-3, 72, 97, 105, 119-20
Guimard, Hector 21, 25-6, 27-9, 27, 28, 29, 48, 56, 70, 112, 113, 116, 131, 150, 153, 154, 172, 178, 188
Gustavberg 186

Hadley-Read, Charles 94
Handel & Co. 169
Harrach, Graf 146, 147, 149
Harrison, John 180
Hart, May 97
Hartwell, Josephine 109
Haseler, W.H. 100
Haviland 174, 175, 176
Hebrard, Adrien A. 124
Hiroshige 74
Hirtz, L. 94
Hodel, Joseph 98
Hoentschel, Georges 34, 178, 181
Hoffmann, Josef 39, 45, 47, 49, 49, 77, 77, 105-6, 121, 125, 146, 188

Hokusai, Katsushika 173
Holiday, Henry 152, 188
Horta, Victor 9, 21, 22-4, 23, 24, 25, 25, 27, 40, 56, 69, 112, 112, 115, 131, 132, 150, 188
Houtart, Eugène 151
Hubbard, Elbert 60
Huber, Patriz 107

Illzach, Ringel d' 175
Industrialisation 129-30
Innes, George 1, 158
Islamic art 180

Jaeger, Dr. Gustav 102
Japan, influence of 41, 74-6, 90-1, 173, 173, 180
Japon Artistique 74
Jean, Auguste 140
Jensen, Georg 105, 105, 106, 124, 188
Johnston, J. Taylor 160
Jones, Owen 170
Jugend 11, 13, 14, 76, 76
Jugendstil 11, 17, 42-3, 76, 106-7, 137

Kayser (J.P.) Sohne 122
Knopff, Ferdinand 69
King, Jessie M. 74, 74, 100, 103, 120
Kipp, Karl 126
Klimt, Gustav 47, 152, 188
Knox, Archibald 74, 100, 101, 102, 105, 120, 123, 188
Koehler, Florence 109, 188
Koepping, Karl 147, 188

La Farge, John 156, 156, 157, 161
Laborde, Léon de 130, 131-2
Lachenal, Edmond 178
Lalique, René 16, 27, 69, 70, 74, 76, 80, 82-91, 82-91, 93, 131, 144, 147, 152, 188

Larche, Raoul 117
Léveillé, Ernest 140
Leven, Hugo 122
Lewis, Edward Garner 185
Liberty, Arthur Lazenby 73, 74, 99
Liberty & Co. 73-4, 74, 99-100, 101, 101, 102, 103, 120, 122, 123
Limoges 172
Linden Glass Company 170
Linthorpe Pottery 180
Lobmeyr, J & L 146-7, 161
Loetz 124, 146, 166
Loffler 25
Loos, Adolf 49-50, 188

Macdonald, Frances 38, 121, 188
Macdonald Mackintosh, Margaret 15, 38, 39, 102-3, 121, 188
Mackintosh, Charles Rennie 18, 18, 21, 38-42, 40, 42, 43, 46, 46, 49, 102-3, 106, 121, 124, 153
Mackmurdo, Arthur Heygate 12, 14, 15, 37, 72, 135, 188
McLaughlin, Mary Louise 181-2, 184, 188
MacNair, James Herbert 38, 103, 188
Majorelle, Louis 26, 32-3, 32, 70, 116, 142, 150, 188
Marx, Roger 91
Maus, Octave 137
Medievalism 71-2, 71
Meier-Graefe, Julius 25, 26, 94, 116
Meissen 186
Minton 180
Mission style 60
Modern Style 12, 137
Moderne Stile 12
Modernismo 53, 55, 137
Les Modes 91

Moore, Bernard 136
Moore, Edward C. 158, 160
Moorish style 52, 53
Moreau, Gustav 69
Moroccan style 53
Morris, Marshall, Faulkner & Co. 36
Morris, May 108
Morris, William 12, 13-14, 37, 37, 59-60, 71, 71, 72, 78, 88, 97, 104, 108, 130, 133-5, 134, 135, 144-5, 152, 188
Morris & Co. 13-14, 16, 38, 71-2, 71, 133, 136, 145, 152
Moser, Kolomon 45, 46, 49, 50, 106, 121, 146, 188
Mucha, Alphonse 70, 70, 93, 93, 147, 152, 180, 188
Muller, Emile 178, 182
Munson, Julia 110
Muthesias, Hermann 76, 188

Nancy School 16, 31, 32, 33, 116, 140, 142
Neo-Gothic style 43-4
Niemeyer, Adelbert 44-5

Oakes, Edward Everette 109
Obiols, Gustave 182
Obrist, Hermann 9, 17, 43, 48, 188
Olbrich, Josef Maria 45, 47, 47, 107, 189
Orazi, Manuel 94

Pan 11, 14
Pankok, Bernhard 43
Partridge, Fred 97
Paul, Bruno 43, 44
Peche, Dagobert 146, 189
Picard, Edmond 137
Plumet, Charles 26, 30
Powell's of Whitefriars 145
Powolny, Michael 146, 149, 189
Pre-Raphaelites 36, 71